friends

Imagine

# ANIMATION NATION

# ANIMATION NATION

## How We Built a Cartoon Empire

### MICHAEL HIRSH

**sh.**
SUTHERLAND
HOUSE

**TORONTO, 2024**

Sutherland House
416 Moore Ave., Suite 304
Toronto, ON M4G 1C9

Copyright © 2024 by Michael Hirsh

All rights reserved, including the right to reproduce this book or portions thereof in any form whatsoever. For information on rights and permissions or to request a special discount for bulk purchases, please contact Sutherland House at sutherlandhousebooks@gmail.com.

Sutherland House and logo are registered trademarks of The Sutherland House Inc.

First edition, June 2024

If you are interested in inviting one of our authors to a live event or media appearance, please contact sranasinghe@sutherlandhousebooks.com and visit our website at sutherlandhousebooks.com for more information.

We acknowledge the support of the Government of Canada.

Manufactured in Turkey
Cover designed by Ken Steacy
Book composed by Karl Hunt

Library and Archives Canada Cataloguing in Publication
Title: Animation nation : how we built a cartoon empire / Michael Hirsh.
Names: Hirsh, Michael, 1948- author.
Description: Includes bibliographical references.
Identifiers: Canadiana 20240300734 | ISBN 9781990823695 (hardcover)
Subjects: LCSH: Nelvana (Firm)—History. | LCSH: Hirsh, Michael, 1948- | LCSH: Animated film industry—Canada—History. | LCSH: Animated films—Canada—History. | LCSH: Animated television programs—Canada—History. | LCGFT: Autobiographies.
Classification: LCC NC1766.C32 N44 2024 | DDC 384/.80971—dc23

ISBN 978-1-990823-69-5
eBook 978-1-990823-70-1

# CONTENTS

| | | |
|---|---|---|
| 1 | The Call That Changed My Destiny | 1 |
| 2 | Off the Boat, to the Library | 6 |
| 3 | Manhattan Transfer | 16 |
| 4 | College Daze | 23 |
| 5 | Northern Lights | 30 |
| 6 | Voulez-Vous Coucher Avec God? | 33 |
| 7 | The Canadian Whites | 41 |
| 8 | New Entity, New Identity | 51 |
| 9 | Love At First Sight | 57 |
| 10 | Stars Align | 61 |
| 11 | The M Factor Kicks In | 67 |
| 12 | Rock and Rule | 74 |
| 13 | Inspector Gadget Saves the Day | 79 |
| 14 | Winning Cast of Characters | 86 |
| 15 | The Elephant on the Mezzanine Level | 99 |

| | | |
|---|---|---|
| 16 | Weathering the Storm | 116 |
| 17 | Growing Pains | 129 |
| 18 | Riding High | 139 |
| 19 | The Big Sale | 144 |
| 20 | Life in a Cookie Jar | 155 |
| 21 | Tales From the Cookie Jar | 158 |
| 22 | A Visit to the Workout Room | 165 |
| 23 | Like Wow! | 183 |
| 24 | Scenes of the Crime | 190 |
| 25 | Taking Stock | 201 |
| | *Acknowledgments* | 207 |
| | *Index* | 209 |

*This book is dedicated to my wife, Elaine Waisglass,
and my parents, Jack and Tauba Hirsh*

CHAPTER 1

# THE CALL THAT CHANGED MY DESTINY

*A sudden journey to Marin County
has major repercussions*

T HE YEAR WAS 1978. Nelvana was busy producing an animated television special *The Devil and Daniel Mouse*, based on the 1936 short story "The Devil and Daniel Webster." Out of the blue, I received a phone call from the production office of Lucasfilm inquiring whether we were the producers of *A Cosmic Christmas*. We were—it was our first fully animated television special. The movie industry's leading producer George Lucas had seen it and was thinking of hiring us for a new animated short he was producing for a CBS *Star Wars* television special.

I was stunned. *A Cosmic Christmas* had been syndicated in the US at odd hours and was hard to find, so for the *Star Wars* creator to have seen it was a wonder in itself. That I was invited to visit him at his studio in San Francisco in order to be considered for the project was a Christmas miracle.

Nelvana was a small company with limited resources and only one company credit card, but this was too great an opportunity to pass up, so I flew to San Francisco on Air Canada, the only airline our credit card would cover. I was told to rent a car and drive to a small suburban strip mall in San Rafael and find a public telephone booth—this was the late 1970s, long before mobile phones. Once there, my instructions were to call a number they had given me.

I found the phone booth and called. The person on the line told me to look over at a parking lot. I saw someone waving their hand at me from a small unmarked building. As I walked toward it, I felt like I was approaching a Prohibition speakeasy. It turned out to be a secret studio. Inside, I was asked to close my eyes as I walked through a room where they were preparing a special effect shot for *The Empire Strikes Back*, the second film in the *Star Wars* series.

After some wandering around, it turned out that George had changed his plans and was no longer planning to visit the studio that day. I was now asked to drive to his house. A production assistant who knew the way would drive ahead of me, I just had to follow.

My heart was pounding all the way down the road. I couldn't stop thinking about how George Lucas was a *big deal*. Still in his thirties, he was already the most successful person in the film industry. He'd written and directed *American Graffiti*, one of the biggest films of the decades, nominated for five Academy Awards, and followed it up with *Star Wars*, a completely transformational film for the industry and for me personally. It brought back memories of being six or seven years old and going to the triple bill at the Marvin Gardens cinema on Toronto's College Street, all those Buck Rogers and Flash Gordon serials—the same films that inspired George to make *Star Wars*. Now we had a chance to

## THE CALL THAT CHANGED MY DESTINY

work with its creator directly and make our own contribution to the Star Wars Universe. Lucasfilm was the biggest potential client we could win. I was uncertain how I was supposed to land the deal, yet somehow I was totally confident that it would all work out. I told myself that no one but us could give George what he was after . . . whatever that was.

It was only a short drive to George's house. It had what looked like an antique WWI tank stationed in front. We met and had a good conversation about what he had in mind for the short film. He loved the illustrations of the French graphic artist Moebius, and so did I. He wanted something close to that style, distinct from the American Saturday morning cartoons of the day, but CBS was pushing for our primary competitor Hanna Barbera to get the work. At the time, Hanna Barbera produced about three quarters of the TV animation in the US.

I told George the story of Nelvana, how with my partners Clive Smith and Patrick Loubert, I had started the company with sweat equity. We did all of our animation and ink-and-paint in our Toronto studio, unlike Hanna-Barbera, which was outsourcing to the Philippines and Taiwan. I shared our hopes to eventually make animated movies.

It was a great meeting—he related to my interest in comic books and studio building—and we got the job. George is a very direct straightforward artist who knows what he wants. He convinced his production partners at 20th Century Fox and CBS to go along with his choice and we began working on the ten-minute short with Ben Burt, who had designed the sound for *Star Wars*, and Joe Johnson, who had developed a lot of the big effects scenes and scripted the short, although George personally added an opening homage to *Star Trek*. The cartoon tells the story of the *Star Wars* characters

3

encountering a disease spread by an evil talisman and a mysterious stranger, Boba Fett, who pretends to be their friend. The short is often known by fans because of its introduction of Boba Fett to the Star Wars Universe.

One of my personal highlights of working on the short was directing the voice sessions in Los Angeles for the *Star Wars* stars: Mark Hamill (Luke Skywalker), Carrie Fisher (Princess Leia), Harrison Ford (Han Solo) and Anthony Daniels (C3P0). While Carrie and Harrison essentially gave me a single take, Mark and Anthony worked on their voice sessions, providing alternative takes and readings. Mark had done a lot of voice work as a kid performer and Anthony did a lot of radio work in the UK, so they understood what I needed.

Around Thanksgiving 1978, CBS aired *The Star Wars Holiday Special*, an attempt to turn *Star Wars* into a variety show. It was a Thanksgiving turkey, poorly reviewed and quickly relegated to a minor role in the Star Wars Universe. Our cartoon was the exception. It worked really well and was praised as the highlight of the two-hour program. The character we introduced, Boba Fett, became a major figure in *The Empire Strikes Back* and later in the 2021 series *The Mandalorian* on the Disney+ streaming service, where our *Star Wars* cartoon has been given new life as a stand-alone short.

After the *Star Wars* cartoon was finished, I approached George about securing the rights to distribute it theatrically. The idea was to include it in an anthology science fiction feature with our own specials: *A Cosmic Christmas, The Devil and Daniel Mouse, Romeo & Julie-8* and *Intergalactic Thanksgiving, or How I Learned to Stop Eating the Planet*. After a lot of hard work, we got the rights. I pitched the idea to distributors and they all turned us down. Nothing came of the idea.

## THE CALL THAT CHANGED MY DESTINY

Still, the Lucasfilm short was a breakthrough for Nelvana. We now had a relationship with one of the most successful filmmakers in history. George would be an invaluable mentor to me and Nelvana over the next ten years. The geniuses at his company would help us build up different departments at our studio. Interacting with the world's best talent was nothing but a boost for Nelvana's design, production, and post production groups and we benefitted from that exposure for the next three decades.

The collaboration also got us on a US network, which was very difficult for a new studio, especially one based in Canada. At that time, Americans knew nothing about the Canadian animation scene, apart from the National Film Board of Canada. Thanks to our *Star Wars* short, we made the list of companies that the US networks and studios were prepared to work with, eventually becoming the leading independent animation company in the world. That ten-minute short opened the door to a bright future not only for Nelvana but set in motion the dynamics that would make Canada one of the world's great centres of animation art with great studios like Nine Story, Boat Rocker, Atomic, Mercury, WildBrain, Fresh and Nelvana. Today Canada is an animation nation and is recognized for its excellent contributions to the art and industry.

CHAPTER 2

# OFF THE BOAT, TO THE LIBRARY

*An immigrant's childhood in Toronto
and an early love of comics*

WHEN I WAS FIVE years old, one of my favourite places to hang out was the Children's Public Library on St. George Street, Toronto. Most Saturday mornings, my sister Lily and I would walk hand in hand from our home on Borden Street, past the bakery and the movie theatres. We would try to cross Spadina the busiest boulevard before the lights turned red and avoid the cars as well as the horse drawn vehicles busy delivering ice and milk, and finally arrive at the library for their special Saturday morning events.

We would borrow books to take home, but the highlight of the visit was the program by an innovative and influential librarian named Lillian Smith, who promoted the reading of books out loud to kids and puppet shows that brought the books alive. One book I loved was *Babar*, by Laurent de Brunhoff, an imaginative

picture storybook about an elephant who returns to the jungle after being educated in Paris. I read other great picture books like *Curious George* and the children's stories of Enid Blyton (*The Famous Five*) and other British authors, as well as the Freddy the Pig series by the *New Yorker's* Walter R. Brooks. Pretty soon I graduated to more sophisticated stories from Greek mythology and Grimm's fairy tales, as well as *The Hardy Boys* and *Nancy Drew* series.

*Babar* would later become a passion project for me when I went into animation and many of the other books I loved as a kid were useful literary properties, but I wasn't thinking about film then. I wanted to write. I tried my hand at comic strips as early as First Grade and mystery novels in Sixth Grade. Mostly I escaped imaginatively into the fantastic worlds of these books while in real life my family and I were busy adjusting to a new world called Canada.

My father moved his family from Belgium to Canada when I was three years old. We moved at the suggestion of my Aunt Gertie, who had taken her family to Toronto after the Second World War. When the Korean War started, my Aunt convinced my father that Belgium was the worst place he could be. Korea was likely the start of World War III, she insisted, and Belgium had been one of the first countries defeated and occupied in the previous world wars.

As native Francophones, we might have fit better into Montreal than Toronto but Aunt Gertie had spent part of her childhood in London and spoke English with a British accent. That, along with her perception that there was more anti-Semitism in French Canada, was how we landed in Toronto. Gertie was influential. It was also on her advice that my parents stopped speaking French to my sister and me so that we would learn to speak English without an accent. This was long before Canada became officially bilingual.

Relying on a language that none of us spoke fluently didn't foster good communications at home, but we learned English. I had no choice if I wanted to speak with other kids. It would take time for me to pass as a native speaker, though. I had a tendency to translate French terms literally into English, saying things like "open the lights."

The family name in Belgium was Hiczerowicz. When we came to Toronto my father changed the name to Hirsh. When I asked him why he had changed the name, he would joke about how he could never remember how to spell it.

Toronto was a small provincial city at the time, population around 1,200,000 (today it's about 7 million). Back then, everything closed down early at night, most of the city was closed on Sundays, and women weren't allowed to sit in the same side of a pub as men. It was quiet and small townish compared to Brussels.

Still, there were a lot of things to do living in downtown Toronto. There were movie theatres, like the Bellevue with its double bill for 25 cents, or the Marvin Gardens cinema, which charged 15 cents admission for a triple bill with those Buck Rogers or Flash Gordon shorts and serials.

There were also great Jewish bakeries and delicatessens, like Shopsy's, a classic Jewish deli that served smoked meats, bagels, kishka and a lot of other popular dishes. I was a non-meat eater, but I went anyway because the atmosphere was its own reward. There was sawdust on the floor and pictures of celebrities like Dean Martin and Jerry Lewis eating at Shopsy's and pictures of Shopsy himself, a large man posing with his guests and his smoked meats. Shopsy's was also next to the Victory Burlesque house, whose exterior walls had intriguing photos promoting their strip tease artists.

## OFF THE BOAT, TO THE LIBRARY

In other places, it was sometimes hard to fit in. We noticed early on that Canadian kids dressed a little more simply. My dad didn't buy me T-shirts or denim until I was eight. I was wardrobed European-style, like a little adult, and it made me stand out from the other kids. We also ate like Europeans at home as compared to a Canadian home. Eventually, I started to feel more and more Canadian and I also became aware that many of my friends were immigrants like the Hungarians who came to Toronto in 1956 fleeing the Russian invasion. I befriended some of them and tried to help them acclimatize to Canada. I started to self-identify as both a Canadian and an immigrant. Today, many of my friends are immigrants and I am drawn to them through our common background.

I have fond memories of Kindergarten and First Grade, although fitting in was still a challenge. One of my teachers didn't like green skies or pink grass or anything that wasn't realistic. I continued doing my own comic strips, putting both French and English words in the bubbles. It was more fun than music education, where I was relegated to a group called "The Crows," for kids who could not sing on key. We were instructed to move our lips but not let a sound out. My lack of music skills made me dread my Bar Mitzvah, where I had to chant a recitation using the same notes the Rabbi or Cantor would, but somehow I got through it without too much pain. After that, I left the music to professional singers and songwriters.

As if that wasn't enough school, I had to put in two hours of Hebrew school four afternoons a week and on Sunday. Many of the teachers were Holocaust survivors who were tough on us for being so light and carefree when Jews had been so viciously oppressed just a few years earlier. It was very important to my parents that I learn Hebrew and learn about the Bible, but I never bought into

religion. I could not make much sense of a God that reputedly chose the Jews as his chosen people and then threw Hitler and World War II at them. I didn't think my father truly believed either; he was carrying on traditions his parents had followed and taught him. But he also wanted me to recognize that whether I believed in God or not would not distinguish me in the eyes of an anti-Semite, so I had to learn about my Jewish identity. And learning the Old Testament helped me in other ways, since it is such a big part of Western culture and storytelling. One story in particular, the story of Abraham being ordered by God to sacrifice his son Isaac, would inspire two different films I made at age 15 and 19.

In Belgium, my father had a successful business manufacturing duffel bags, but before he re-started his business in Toronto, he spent about a year running a corner variety store on College Street. That meant I was the first to read comic books when they arrived, bundled up and fresh from the distributor. Superman, Batman, Plastic Man, Archie, Scrooge McDuck. When he got back into duffel-bags and started his own downtown factory, it was better for him but not as much fun for me. He gave me a job counting the buttons in a barrel taller than I was. I would inevitably lose count and have to start over again, so the job lasted a whole afternoon.

Fortunately, there were plenty of comics in my parents' *Toronto Star*. I would devour them every day when I came home from school: Little Orphan Annie, Mandrake the Magician, Gasoline Alley, Peanuts, Family Circus, Jiggs and Maggie, and Alley Oop. Often the newspaper ink was fresh and would smear my fingers, so everyone in the family knew that I had read the newspaper. But I wasn't ashamed and I continued to read the strips as an adult, along with classic strips that were a bit before my time like *Krazy Kat*.

Of course, there was television, too, still in its infancy. Some of my favorite memories are of sneaking out of bed, sitting on the stairway and secretly watching my parents watch their favorite shows. My favorites were the comedies such as *Sergeant Bilko* with Phil Silvers and *Your Show of Shows* starring Sid Caesar. I later had the privilege of working with both Phil and Sid on animated specials.

Other memories are not so clear. I don't know if I remember my childhood in Brussels or just the stories my parents told me. That beach at Knokke—is it only in my mind because my parents showed me the photographs? I think I remember my father taking me with him on a sales trip around the Belgian countryside, but I have clearer memories of Saturday in Toronto's Kensington Market, where he would set up a table outside a store and sell surplus goods directly to shoppers and passers-by. My sister and I would play together beside the table, while he, undistracted, made his sales pitches. I would be dressed as a miniature of my father. I wanted blue jeans like the other boys, but I kept that thought to myself. Sitting at my father's feet while he hawked his product was my introduction to salesmanship, which ultimately gave me confidence to go out and sell my cartoons.

There were other facets of my father's experience that were beyond memory and almost beyond my imagination. From the time I was a toddler, I knew that during the war he had been put in concentration camps, where he and his fellow prisoners were physically and mentally abused, starved, stuffed together like sardines, made to sleep on wooden boards without mattresses on which they would wake up to find dead bodies among them every day. There were a number of other Holocaust survivors in our neighborhood, including my Aunt Gertie and her family the

Karwasers, the only relatives either of us had in Canada, who we visited on weekends. When the board games were done and it was time for cake and cookies, the grown-ups would start talking about their experiences during the war and I would try to blend into the background and listen. Their discussions often began with their numbers that had been tattooed on their arms upon entering the camps to identify them. My father wore his number like a proud emblem of his survival. Friends and acquaintances would ask him if he wanted to have his tattoo removed cosmetically and he would get indignant. He was proud to speak out as a survivor.

Gertie's daughter, Sylvia, who was nine years older than me, didn't share her stories with me until we were both grown-up. Before he was captured and sent to Auschwitz, dad told Gertie about a stash of diamonds he had hidden in the family home in Antwerp. He was later overjoyed when he found out she had used some of them to hide her daughter. Sylvia had to be hidden twice, because the first time she was hidden with other children who were all murdered by a Belgian Nazi who had brought a gift of candy to the house in which they were hiding. The candy was green and Sylvia didn't like green food. She was the only one who didn't eat the candy. All the other kids died that night. Sylvia was returned to her parents, who were successful in finding another hiding place for her.

No wonder my father always had a smile for Sylvia. They also shared a characteristic twinkle in their eyes. She represented hope to him. She was the miracle child who had survived the war. As a fellow Holocaust survivor she shared a bond with him that his own children, born after the war, could not. I respected that, while my sisters were jealous of that relationship, often complaining about the pedestal our father put her on praising her intelligence and

her academic achievements. We were no less important to him, but different.

Somehow Sylvia was able to overcome the trauma she experienced as a child to lead a constructive life and raise her own family. She has made Holocaust education an important part of her work in addition to teaching French and giving back to the community. As an adult, Sylvia and her children Noam, Ayala, and Rachel were successful in having the family that hid her recognized by Yad Vashem as Righteous Gentiles and acknowledged for the great care they provided for her at high risk to themselves.

While that was the closest family relationship we had in Toronto, once a year we would get a visit from Uncle Charlie, who lived in South America. Uncle Charlie was married to my mother's sister, Regina, her only surviving sibling. He was far more religious than us, sent his sons to the Yeshiva in Chicago for their education, and when in Toronto would always consult Rabbi Gertner, a well-known Hassidic Jewish Rabbi, about his latest business ventures. Charlie Poler had a great influence on me. As part of his import/export business, he traveled the world, to Asia and Europe and the Americas. He was the only person I knew growing up who lived that kind of life and he prepared me for the life I would live in the development of Nelvana, jumping on a plane and traveling around the world.

Many things were changing in Toronto as I grew up. The old Bellevue movie theatre had been transformed into a burlesque, replacing Hopalong Cassidy with Gypsy Rose. Many of our neighbors were escaping these unwelcome changes and moving north to the suburbs. When I was nine, so did my family.

My parents were happy. They were able to buy their own house, a bungalow. It was a sign of upper mobility and there were no

burlesque houses for my sister or me to walk past. I was nevertheless devastated. Sultana Avenue, west of Bathurst Street, was a cultural wasteland. There were no movie theatres within walking distance. There was no library within walking distance. Once a week I could get books from the bookmobile, a library bus on wheels parked twenty minutes away. They didn't have the selection I was used to at the main library in Toronto, and while I could request books, it took weeks for them to arrive. The school was so overcrowded, thanks to all the baby boomers, that they had us learning in fields and mobile classrooms. I felt I had left civilization and moved to the wilderness.

I especially missed Kensington Market. It was more than just a place where my dad sold his surplus. It was the neighborhood many new immigrants moved to when they first came to Toronto: after waves of immigrant Jews like me, it was the Italians, the Portuguese, followed by the Chinese, all of them starting new lives in Toronto in Kensington Market. Each wave transformed the neighborhood with its bakeries, fishmongers, and butchers. I can recall chickens being taken out of coops and handled by the butcher and the customer so that they could appreciate the quality of the bird. The vegetables and the fruits were displayed out on the streets as well. The aroma of all this food commingled to make a perfume that was the essence of Kensington Market.

The market was also where we went to buy inexpensive clothes, there or Honest Ed's, the three-story emporium whose proprietor, the future theatre proprietor Ed Mirvish, was famous for his self-deprecating joke signs on the walls—"the holes in the clothing are free." It was a store that reflected the personality and humour of its proprietor. Now Honest Ed's and many other stores have been torn down, sold for the land development of condos for Toronto's

ever-growing population. The city that once seemed like a small town to me is now North America's third largest city. Things keep changing.

# CHAPTER 3

# MANHATTAN TRANSFER

*Moving to America as a teen, adjusting to big-city life and the culture of the 1960s*

WHEN I WAS THIRTEEN, my family moved to New York City.

My father's factory in Toronto had seen its business decline because of a sudden drop in the exchange rate between the US and Canadian dollars (the newly-strong Canadian dollar was tagged "The Diefendollar" after then-Prime Minister John Diefenbaker). With the Canadian dollar worth $1.10 US, exports to the US declined dramatically. So my father accepted an offer from a US client, Certified Creations, to run its slipper manufacturing plant in Manhattan on 34[th] Street near the West Side Highway. The offer was attractive, and we found ourselves living in New York City, in the Pelham Parkway part of the Bronx.

It was the first time in our lives living in an apartment building. The building was called the Sans Souci, "without sorrow." That wasn't true at first for my mother, who had a new baby, my sister

Susan, and kept changing her mind about how she felt about the move. She wasn't sure she could make friends in the new neighborhood. My father offered to give up the job and return to Toronto if that was what she wanted, and after one month in New York, we actually started planning a move back. But she finally agreed to give it more time and see how it worked out.

And it did work out. There was a house next door to our apartment building where my sister Lily and I both found friends: she befriended Richard "Dickie" Stram and I became friends with Daniel "Danny" Stram. Through us, my mother met and became friendly with their mother Kitty, who had two young babies who were around Susan's age. That made it easier on my mother.

Across the street from our apartment building on Williamsbridge Road, was a small Italian pizzeria and ice shop. No matter the weather, there was a small card table set up in front of the store. A couple of old men would sit at the table and visitors would drop by and sit with them. They would have cups of espresso while they talked quietly amongst themselves. I didn't realize what was really happening there till I saw the movie *The Godfather*. Then it became clear. Because of the Mafia presence, the neighborhood was one of the safest in the Bronx, which appealed to my dad who found the apartment. This was an Italian neighborhood bordering on a Jewish neighborhood Lydig Avenue. All of the Jewish food stores and specialty stores were to be found on Lydig near White Plains Road and the Italian bakeries and specialty stores were on Williamsbridge Road and Morris Park Avenue.

As for me, Danny and I were both entering Christopher Columbus High School in Grade Nine, but even with a friend, my first days at an American school were surprising for me. Kids sometimes addressed teachers as "Hey, Teach!" while I was still

calling teachers as Mr. and Miss and Mrs., generating stares from the rest of the classroom. The greatest shocker to me was going into a Geography class where the majority of the class did not know that New York City was on the Atlantic Ocean or that Canada was a country directly north of the US.

Things got boring at Christopher Columbus pretty quickly for me. I was acing my courses academically and was not being challenged sufficiently. My father's boss Bob Lehr suggested I try his old school, the Bronx High School of Science, which enrolled kids from all of the NYC Boroughs. I took the entrance exam and got in, although this meant I had to take a forty-five-minute bus trip to get to school, and it was hard to make friends because so few students were from the same neighborhood.

Still, even if I didn't have a lot of friends, I now had a lot of peers: we were all there because we were smart kids in the top percentile of IQ scores. I believe that the kids at Bronx Science inspired the movie *Revenge of the Nerds*. Our best math students walked around with slide rules attached to their belts, dummy strings for their eyeglass frames, and plastic pocket inserts to protect their shirt front pockets from the pens and pencils they kept there. We even had a rival school, De Witt Clinton High, a block away from us, with 40,000 kids to our 2,800. We generally felt threatened by the Clintonites, although I never suffered any personal incidents.

There was a lot of pressure on smart kids. This was the early 1960s, the time of the space race, when the Soviets had managed to get ahead of the US by putting a dog and then a man into orbit, and President John F. Kennedy and the Congress had vowed to spare no expense to beat the Russians to the moon. At morning assembly, our principal made speeches telling us that we were an important part of the space race and that the US was counting

on us. The school had spared no expense, either. It had a space observatory and a computer, which back then was the size of a large room.

Not all the kids at Bronx Science were nerds. Over on a patch of grass known as Red Hill, you could find the cool kids who smoked pot and were fans of folk music and political activism. There was a tradition of activism at the school. Stokely Carmichael, co-founder of the Student Nonviolent Coordinating Committee (SNCC) and a leading light of civil rights activism, was a Bronx Science grad.

I made friends on Red Hill. One of them, Elia Katz, taught me to cut classes and introduced me to the American experimental film scene through screenings at Hunter College in the Bronx. We would have philosophical discussions after seeing movies or discussing books. Even when we were cutting class, there was a real sense of community for the students at Bronx Science. We knew we had a lot in common and were proud of our school.

I saw a lot of film. It was a golden age of arthouse cinema, with experimental filmmakers like Stan Brakhage, Bruce Connors, Jack Smith, and Kenneth Anger. Like many people, I had dreams of being the next arthouse genius. I made a film about Danny's brother Robert and his motorcycle, which we screened at Filmmakers Co-Op. There was no soundtrack, so Danny played the sound on a tape recorder. At one point we played the Four Seasons song "Walk Like a Man" backwards and the other filmmakers, all adults, congratulated us on that brilliant choice.

Next I went to Eventorium, a hangout for experimental filmmakers and screened *Abes and Izzy*, which I shot on an 8mm camera in the Bronx Botanical Gardens. It was a modern retelling of the biblical story I remembered so vividly from Jewish school, where God tells Abraham to sacrifice his son Isaac, only to reveal

at the last minute that it was only a test. Elia played Abraham and Dickie Stram played Izzy.

I made other movies like *Thumpalump*, starring an early girlfriend named Kitty Kao. (There was a running joke at school that if she married Elia, her name would be Kitty Katz.) A friend from school arranged with his father, the owner of a slum apartment building in now fashionable Union Square, to let us film in the apartment of a young man who had not paid his rent. There was a picture of Jesus over the bed and cereal boxes hung on the walls to cover holes.

There were great cultural events that were free in New York. Concerts in Central Park with entertainers like The Four Tops, The Supremes, The Temptations, Stevie Wonder, as well as Shakespeare at open-air Delacorte Theater in Central Park. I saw *King Lear, As You Like It, Macbeth, Hamlet, Henry the Fifth, Julius Caeser, A Midsummer's Night Dream, The Tempest* and *Othello* with great actors such as George C. Scott, Colleen Dewhurst, and James Earl Jones. I saw everything I could, taking the train from the Bronx and lining up for the seats. The Delacorte plays would begin an hour before nightfall and were subject to the vagaries of weather. You would sit through showers, but leave in a storm. Even when the weather was challenging, you were in a great location. If you were interested in culture in New York, you could inhale it seven days a week.

I remember going to the Ascot Theater on the Grand Concourse near Fordham Road to see foreign films directed by Antonioni, Fellini, Godard, Truffaut, and others. Those were weekend treats, as was going to Manhatten to MOMA to see Buster Keaton films and indie classics like Don Owen's *Nobody Waved Goodbye*. I also have great memories of the Museum of Modern Art, meditating

on the giant Jackson Pollocks, Picasso's "Guernica," and Monet's water lilies.

It wasn't all magical, however. NYC could be dangerous in the Sixties. I remember a Black woman, seeing me walking in her neighborhood towards Eventorium in Spanish Harlem late at night, advising me to head back to the subway because it was dangerous around there that night.

I had a teen-aged crush on Debbie Sherman who looked like a classic beatnik with long straight hair. In fact, she always looked out of it. I ran into her two decades later when my wife Elaine and I were in the Caribbean on vacation and asked her what was up with her and the other girls in school who looked stoned all the time. She told me that all of the dads took their daughters to see therapists who gave them downers to subdue their sexual urges.

This was the beginning of psychotropic drugs, uppers and downers that were used liberally to lose weight, moderate moods, and much else. Old therapies were on their way out the window and big pharma was storming in. This was part of the general social upheaval of the times. Ken Kesey documented it all in his famous novel, *One Flew Over the Cuckoo's Nest*, the movie version of which made Jack Nicholson famous. It encouraged new ideas about the treatment of mentally challenged patients, moving them out of institutions and out into the streets where their prescriptions were supposed to make them self-sufficient. It was not a policy that worked out well for many of the patients or our urban centers which have had to deal with the mental challenges of the homeless.

While going to school and pursuing my interest in film I also lived in my father's world, working summer jobs at the factory he ran for Certified Creations. His bosses wanted me to think about

going into their business after I graduated from college and they placed me in different departments every summer so I could learn all aspects of running a business: from stock boy to shipping and packing to accounting. They were terrific with me and I regret never having reached out to thank them, because the training they gave me helped me build my own business.

My father wanted to be the first person to arrive at work each day, so he and I would leave our apartment in the Bronx around 6:30 a.m. and drive across the Bronx and down the West Side Highway to the factory. He would open the doors for the rest of the staff. The employees were generally paid minimum wage and were typically Black or Puerto Rican. My first summer there, I stocked shelves alongside a sixteen-year-old Black worker who had just moved from the Deep South to live with his aunt and uncle in Harlem. When a riot broke out in his neighborhood, he was unable to come to work and had to sleep on the roof to avoid getting caught in the crossfire of snipers and street shooters. Listening to him made me appreciate my privilege for the first time in my life.

Before my father started at the factory, there had been turf wars between the different ethnic factions that worked there, a little bit like *West Side Story*. He successfully ended the tensions by making sure that each group was represented by a supervisor from its community, which made the staff see they were being treated with respect and that there was a way to get promoted and not always be a minimum wage worker.

This, again, was useful experience for me. Animation is an art form but it is also a factory-like process, one I could understand having worked in an actual factory. It was one of the many early experiences that contributed to my drive to create a studio.

## CHAPTER 4

# COLLEGE DAZE

*Antioch College opens my eyes to cinema, stimulants, and the major philosophers*

WHEN IT WAS TIME to go to college, I followed the advice of my father's boss, Robert Lehr, who had introduced me to Bronx Science. He was an alumnus of Antioch College in Yellow Springs, Ohio. I turned down an offer from City College of New York and went to Antioch. It was well known for its work/study program, where you spent three months on campus followed by three months of work, often in a distant city. My father liked the idea because it was a way to learn practical skills, but he didn't realize what a radical school it was until I came back to visit after four or five months, sporting a beard and dressed like a hippie pothead.

While I was majoring in philosophy, my first priority at Antioch was to seek out the experimental filmmakers on campus. I made friends with three seniors named Michael Houghton, Mike Mideke, and Rick Patton, who helped me to get back into the filmmaking

groove. I had a sense of urgency about the whole thing, because all three of them were graduating within a year and there were no filmmaking courses at Antioch. Without the year in their company, I might not have advanced my interest in film. The closest I could get to film studies was a spring break job in Antioch's audio/visual department, organizing slide shows for teachers and running movie projectors in classes.

For my first work semester, I went to Boston to work as an orderly at Peter Bent Brigham Hospital on Mass Avenue. I shared an apartment in the Polish section of Cambridge with a young medical student from St. Louis. It had four rooms and we were paying $50 between the two of us, a great deal except there was no hot water and no heat. We were there until mid-December, so it got chilly but we made the best of it.

At Peter Brent Brigham Hospital in Boston, my job was to move patients and specimens around the hospital corridors. When moving patients to the morgue, I was instructed to speak to them as if they were still alive, so as not to scare the living patients. I would talk to the dead about the weather, until I got to the morgue, attached a name tag to the body, and slid the corpse into one of the cooler drawers.

I wasn't as mischievous as Michael Burns, another Antioch student working at PBBH, who got sent home for switching uniforms with a young female patient and letting her wheel him around the hospital on a stretcher. Getting fired turned out well for him: his father was a TV executive who got him a work/study assignment assisting director Bob Rafelson on *The Monkees* and, later, on Rafelson's films like *Five Easy Pieces*.

I had to make my own opportunities to get into film, so while in Boston, I continued to seek out the filmmaking scene and found the

experimental film club at MIT. I don't know if this is still true, but back then, college kids felt connected to each other no matter what college we went to. We were part of what Canadian sociologist and generational guru Marshall McLuhan described as a "global village," a term he used to reference how the medium of television had shrunk the world and connected people. It seemed to fit the way film, music, and culture created a sense of connectivity within our generation globally.

Throughout the sixties and seventies, I was very influenced by McLuhan and his book, *The Medium is the Message*. McLuhan would work with graphic designers to rethink how text and images appeared on a page. Inspired by him, I wrote my first film manifesto, calling for a similar rethink of the film frame. With optical printing and what was known as "traveling mattes" allowing for a more sophisticated version of the old split screen, I argued that it was possible to maximize the full frame by splitting it in a sophisticated way. My old Bronx Science friend Elia Katz later arranged for me to speak on the topic at John Hopkins University. I published my theory as a manifesto in one of the film magazines of the time.

As with most theories, it was overstated and oversold, but it reflected how much of an inspiration McLuhan was to me and how he changed the way we all thought about media. His prose was thick as mud, so you weren't always sure what he meant by what he wrote and, in retrospect, I find it odd that I never visited him at the University of Toronto to ask him, but McLuhan's work was like the work of great philosophers; you had to penetrate its meaning. In fact, he was the great philosopher of media. His most famous quote was "the media is the message," something that made intuitive sense to me as a child of modern media. One of my favorite Wittgenstein quotes is "the meaning of a word is what

is intended by its meaning." I appreciate that kind of tautological thinking and McLuhanism is full of it.

During the COVID-19 pandemic, a friend, Anne Miles died and we attended her funeral via Zoom. I don't know what McLuhan would have said about this new development. But if the medium is the message, the Zoom conference was the new medium in that period. Somehow, we have all learned the rules of video conferencing: when to speak, how not to interrupt as we went along. There is a lot of talk about the metaverse today and I believe that the zoom call has prepared us to accept alternate virtual experiences in lieu of real-world living.

The 1960s were also the period when Harvard psychologist Timothy Leary and his colleagues were making the case for mind-altering drugs, flooding the streets of Boston with pure Sandoz laboratory LSD. People would put liquid LSD on a sugar cube or paper blotter and eat it. By the time I tried it, word was spreading about kids freaking out and having bad trips and the underground media was awash in advice on how to take acid safely. My friends and I would make sure that one person would stay sober to take care of the others, and to have a tranquilizer available to calm someone down after their trip. It worked out for us, as none freaked out.

Helluva hallucinatory experience, though. LSD, which came in a clear glass tube, gave you an experience that made you question the rational framework you took for granted. Up would seem down, black would seem white, social rules seemed silly. As a philosophy major, it appealed to me as a challenge to accepted reality. But people who took acid could sometimes get smug with themselves and think they were superior to those who had not tried it. We would urge our friends and lovers to follow this path to enlightenment. My father pointed out that we thought we

were highly individualistic, but we were actually very tribal—my generation even had a uniform of jeans, t-shirt, and sneakers. We all wore our hair long and many of us had beards. I didn't see it at the time but my father was right.

On my return to Antioch, I was having trouble finding a place to stay on campus until one autumn day I met a beautiful girl with a sleeping bag slung over her shoulder. Before I could try to pick her up, she told me she was there to live with a friend of mine named Rick Patton, but if he wouldn't let her crash at his house, she would go to the Glen, a national park at the edge of campus and live in a cave. She ended up staying with Rick, but I thought the cave sounded like a great idea, even though I was a very urban guy. So every night Rick and his friends would walk me to my cave and build a fire to scare away the bears and keep me warm. I slept in a hammock, covered by a sport jacket, a sweater, a winter coat, and a sleeping bag. It was only a five-minute walk to the campus bathrooms and showers, so it worked until winter came.

I encountered a different vibe at Antioch when I got back. It had become another epicenter of the counterculture and drug experimentation. Hippies would come to the campus bringing the latest innovative drug for us to try out. With Antioch kids working throughout the US and then bringing their experiences back to campus, there was this great feeling of a counterculture melting pot that was constantly being fed. Travel between campuses was common—it was how we connected before the Internet. A friend named John Hawkins and I hitchhiked to Ann Arbor, which made us nervous because John was Black and we were traveling through the Bible Belt, but we made it and crashed in the dorm of some University of Michigan students. I also hitchhiked to NYC with a friend who was bringing back birth control pills for the girls and

women at Antioch. Those pills, which were still new at the time, changed how our generation thought about sex.

With the money I saved living in a cave for six weeks, I made two short 16-mm films that semester: *The Greeks Had a Word for It*, starring my friend Michael Haughton and featured a soundtrack of Sidney Poitier reading Plato with jazz accompaniment, and *The Chinese Ballgame* with two other friends, Michael Mideke and Jay Birdsong. Placing friends in lead roles was an education in how to make something from nothing. The height of my experimentation was frying frames in coffee to get the reticulation pattern and coffee colouring on 8-mm film. Unfortunately, you could only fry film for so long before it lost shape and was unable to go through the film projector.

I also worked on light shows during this period to entertain my friends while high or tripping. Later on, after seeing a concert by the Velvet Underground with trippy visuals from Andy Warhol's Factory, I put together my own experimental light show that could be performed live with a rock band. I included film loops, slides made from rubber cement and colored inks which moved amoeba-like across the screen.

My favorite memory of Antioch was an acid trip I took before leaving the cave to return to civilization. On a walk through the Antioch Glenn, I was seeing prehistoric beasts alive and active in the national forest. No other LSD experience I had could match it.

All of this happened in just one year, but one year at Antioch in 1965-66 was like years in any other school environment. I was exhausted. My best friends were all graduating and they were talking a lot about how to prevent themselves from getting drafted. Their ideas ranged from trying to get disqualified by cross-dressing

or putting cigarettes out on their arms to have themselves declared unfit, or just running away to Canada.

A lightbulb went on over my head. To avoid the draft and the craziness I saw evolving in the US, I could just give back my green card and return to Canada. So I did. In fall of 1966 I was back in Toronto.

CHAPTER 5

# NORTHERN LIGHTS

*Returning to Toronto to attend university, study film, and avoid being drafted*

MY NEW SCHOOL WAS York University's Glendon College, a small bilingual school with a beautiful campus and interesting courses. Coming from the United States, I thought of myself as very hip and cool, while Toronto was still smaller than it is today, very provincial, and governed by blue laws that shut down most businesses on Sundays. There was less interest in recreational drugs than on US campuses. Another student in my dormitory experiencing this culture shock was Jack Christie, who as the son of a Canadian Air Force pilot had lived in France, Germany, and the States. As he later recalled, we were in the laundry area and he commented on being "turned on" by watching the laundry go around in the dryer. I told him I appreciated that reference and we found out we shared interests in American and European literature, as well as smoking grass and hash and experimenting with psychedelics.

Another student we bonded with over recreational drugs was Peter Dewdney. He was an incoming freshman with a red MG of which he was very proud, although he later sold it for money to buy pizza, a decision none of us could fathom but that was Peter. He took us home to meet his family in London, Ontario. His father, Selwyn, worked in art therapy and helped build the London art scene with artists such as Jack Chambers and Greg Curnoe. During the summers, he would take his sons canoeing and would document and sketch the rock paintings of Canada's Indigenous people hidden among the caves around lakes. Peter's brother, Keewatin, was a well-known mathematician at the University of Michigan. Their younger brother, Christopher, is one of Canada's leading poets and writers. Peter would later turn his love for the North and outdoor life into a successful career as a prospector.

In our second year at York, Jack, Peter, and I foolishly transferred from Glendon to the main York University campus because we felt Glendon didn't offer enough liberal arts courses. It turned out the catalogue made York's courses sound more exciting than they were. The main campus was a cold, barren, windswept wasteland populated with saplings. But one good thing that came of the transfer was that we made a new friend, another aspiring filmmaker named Patrick Loubert, a Canadian who had grown up in Europe. Like Jack, he was more cosmopolitan than most other students. The four of us decided to rent a suburban townhouse where we lived with our girlfriends, made films, and organized happenings.

Through a friend of Patrick's, we borrowed a stroboscope from a science lab at York and made some wild and crazy short films. I am not sure what our neighbors thought was going on when they saw the strobing light behind our home's sliding glass

doors. To buy film, Patrick sold a piano his parents had in storage, telling them that it had burned up in a fire. We had a blast there, although we sometimes took risks with our health. Jack once came down looking for his instant breakfast only to find that Patrick had enjoyed the whole package for his own breakfast. Jack was furious. Evidently his entire stash of hashish was stored in that Carnation Instant Breakfast package. Patrick was lucky and just slept it off.

Through an underground film festival event at York. I met David Cronenberg when we showed one of his films, as well as Robert Fothergill, who had directed a funny film called *Oddballs* and went on to become a professor at Massey College. A young filmmaker named Peter Rowe, part of the McMaster University filmmaking group that included Ivan Reitman, used my room to reshoot some scenes for a film called *Black Zero*. The original scenes had been confiscated by the local laboratory, which claimed they were pornographic. Another member of that McMaster group, John Hofsess, charged a camera and other expenses to the McMaster Film Board, which didn't exist; this inspired Jack and me to charge some rental bills to nonexistent groups like the York University Film Club. It was a time when young indie filmmakers thought of themselves as outlaws, summed up by New Wave director Jean-Luc Godard's saying that if you want to make a movie, you should rob a bank. It wasn't a sustainable view of filmmaking and we soon outgrew it.

## CHAPTER 6

# VOULEZ-VOUS COUCHER AVEC GOD?

*My first feature film, inspired by political turmoil, as movies take hold of my life*

J ACK CHRISTIE AND I began to work on an idea for a feature film called *Assassination Generation*, inspired by the political turmoil and social unrest unleashed by the wave of political assassinations in the US, starting with John Kennedy, followed by his brother, Robert, and Martin Luther King. The story was once again based on the Bible tale of Abraham and Isaac, with Abraham as a mysterious assassin and God as the mysterious Mister Big, a Bhudda-like underworld mob boss.

Jack Christie and I wanted to find a fluid storytelling mode for this story. We were heavily influenced by William Burroughs, famous for his cutup technique of writing, as well as Alain Robbe-Grillet, author of *The Eraser*. I was also inspired by the Danish philosopher Soren Kierkegaard, who wrote at length about the leap of faith Abraham had to make when God told him to sacrifice

his son, as well as the retelling of the Abraham story in Bob Dylan's song "Highway 61."

I'm not sure that we would have embarked on this film if we knew that it would take over six years to finish it.

Casting can be everything in filmmaking, so the key question was who to cast as Abraham. We decided to ask Tuli Kupferberg, the well-known Beatnik who appears in Allen Ginsberg's poem "Howl" as the man who jumped off the Brooklyn Bridge and survived. Tuli was one of the lead performers and songwriters in the musical group The Fugs, with hit songs like "Kill for Peace," "I like Boobs A Lot," and "Monday Nothing." He was also founder of the Revolting Theater Group, which did political satirical performances. Although already an underground star in the NYC scene, he was not only listed in the phone directory, much to my surprise, but he said yes after asking only a few questions. It turned out he and his wife, Sylvia Topp, an editor at *The Village Voice*, had a cottage north of Toronto, where Sylvia had grown up. They liked the idea of shooting near Toronto in the summer.

Next came the casting of Abraham's wife, Sarah, and their son, Isaac. While attending a party in Brooklyn with my friend Elia Katz, I met a young actress named Abigail Rosen (later Abigail McGrath), who, when I described the project, volunteered for it and volunteered her son Jason to play the part of Isaac. She later recalled that she agreed to do it because I had such total positivity about the project and because we had offered horseback riding lessons for Jason. That was enough.

The only bad thing about that party was that when it broke up, Elia, Abigail, and I accepted a drive back to the city with the host's cousin, Mary Kaplan, who was just back from Europe and stoned. She had a tiny sportscar. Elia and I didn't have seats, let

alone seat belts, and Mary ended up driving the wrong way on a highway until she was pulled over by police. That saved us from driving into oncoming traffic, but caused another problem: Elia and I had some pot on us, and Abigail was worried about the police because she was Black. It turned out Mary had a letter of introduction from Robert Kennedy, which she used as a kind of "get out of jail free" card. It worked. Not only did the cops take us to their own recreation room with ping pong table and coffee, they offered to drive us home. Elia and I said no thanks and took the subway, thankful to be alive and not in jail.

With the casting now complete, Jack found a farmhouse in Lakefield, Ontario for us to shoot in and a classic Woody car for Tuli to drive. I invited two of Elia's friends from Johns Hopkins to be our crew: Ken Locker, a terrific still photographer, was our cameraman; George Massenburg did the sound. Abigail invited a friend named William Pinkney to do the makeup. Since Sarah was 100 when she had Isaac, he went very old in his makeup approach.

We still needed more money, and Jack put us in touch with Howard Adelman at Rochdale College, the massive student-run co-op housing project that went up in 1968. Howard had been a leading member of Campus Co-Op, which had invested and operated a large housing pool on behalf of University of Toronto students. He had a philosophy of business he described as "Creative Capitalism." He helped us write a brochure to raise the money and referred us to Vince Kelly, a lawyer, who helped us incorporate under the name This Generation in Film. We were professional-like.

Our film's story was still evolving as we shot and edited. Tuli and Abigail were improvising and inspiring the other actors. Another cast member was George Ward, who stumbled upon us while we

were filming in the streets and told us he wanted to be in movies, so we wrote him in. George played a crazy presidential candidate with God's endorsement, who runs on contradictory slogans like "Kill For Peace." I never expected to see a real candidate so absurd in real life, but then Donald Trump came along.

At Howard's invitation, we moved into Rochdale and worked on the film there. Rochdale had attracted interesting creative people from the US and Canada, like Jim Gerrard, a theatrical director who launched the Theatre Passe Muraille and put on plays like *Futz*, about a farmer who falls in love with his pig, and Judy Merrill, a leading science fiction editor who agreed to take a part as God's wife in our movie in order to work with Tuli Kupferberg. And then there was Etheria, Rochdale's macrobiotic and organic restaurant where everything was made healthy but nearly tasteless. The chef was known as Wu and came from the former Yugoslavia, when it was still Yugoslavia. Jack and I contributed Fat Daddy's Cinema Permanente Narcotique, a revival cinema. For our bestselling screening, we rented the animated Disney feature *Alice in Wonderland* and ran it forwards and backwards all night.

Using Howard's "Creative Capitalism" schemes, the plan for Rochdale was to establish a free university in downtown Toronto. Its building would be constructed in collaboration with a developer, Revenue Partners. After finishing the building, Rochdale would collect a government-backed mortgage to pay off its loans. Revenue Partners would donate its earnings of $1 million to Rochdale, which would use the money as working capital. It was a great plan, except that construction was not finished on time. What had happened was that Rochdale's public-relations campaign had been too successful. It was featured on the cover of *Time* magazine and the article made it seem so appealing that thousands of kids hitchhiked

to Toronto and moved into the building before it was completed. They lived in the stairwells. They lived in the cubicles on each floor where you threw your waste down a chute. They lived in all the communal spaces. Their presence made it impossible for the construction crews to complete their work, which meant Revenue Properties could not get financing and thus could not advance Rochdale College its donation.

Tenants refused to pay their rent due to the hordes of young people crashing there. The administrators, paralyzed by their utopian values which drove the notion of a free university, didn't know how to evict them. One bright fellow had the idea of bringing in a motorcycle gang to prevent anyone without proof of residency from entering the building. The arrival of the gang caused many of the tenants to move out. Unfortunately, drug dealers replaced them with the blessing of the gang members, who charged the dealers for security. In the six months Jack and I had been living there, Rochdale had gone from a beacon of freedom to a police state and a drug haven. We moved out.

We found other filming locations. At one point, I got a job for about three months teaching film at Conestoga College near Kitchener, Ontario, an hour from Toronto. The regular course teacher had suffered a heart attack. I don't know why I got the call—I was an undergraduate and self-taught in film—but I made the self-serving decision to move shooting of our movie to Conestega College, with the students providing the tech. We used film stock and sound tape from the film program. Most of the equipment was pristine and brand new. For whatever reason, the teacher hadn't wanted his students to make films. I liberated the equipment and got the class filming, a very sixties thing to do. The teacher must have been in shock when he returned from his sick leave.

For another night of filming, David Britten, a Canadian actor and singer infamous as the man who introduced the Rolling Stones to LSD, helped us get a nightclub in Yorkville as our location. The club burned down after our lighting overloaded its wiring. David had told us that the club was mafia owned and operated, so we hightailed it out of there as the firetrucks were arriving. We were doing crazy things and getting away with them, almost as if we had a friendly spirit looking after us.

By the time we finished shooting, the improvisation had changed the focus of the movie. More of it had become about God, played by Tuli, so we changed the title to *Voulez-Vous Coucher Avec God?* based on a question Tuli asks Abigail as they are both sitting in a bathtub. The film emerged as an anarchic comedy, a satire about still-relevant issues like fundamentalist religion, politics, racism, and sexism.

Today's technology would make the editing process much easier than it was then. We had to edit with a moviola, an upright vertical editing machine that required a lot of dexterity and expertise. We had none, so the moviola would chew up our film, tearing up sprockets. We would spend many hours taping it all together again. Split-screen scenes and other process shots needed an optical printer to collage them together like a jigsaw puzzle. Making movies with no money in the pre-digital world was no picnic. And there were no backups, so when we left an entire edited reel of *Voulez-Vous Coucher Avec God?* at a pizzeria, we accepted their demand for $50 to have it returned to us.

Some people were quite helpful, however. Don Owen, the National Film Board of Canada director, helped get us a Canada Council for the Arts grant to shoot opening titles for *Voulez-Vous Coucher Avec God?* and I recall that he introduced me to a fantastic

editor, Don Haig, who offered us some weekends and midnight shifts to edit *Voulez-Vous*. An editor friend of Abigail's, Jerry Siegal, not only let us use his moviola, he let us sleep in his NYC penthouse apartment while we were editing. And being back in NYC, we could visit Tuli and Sylvia, who lived on the Lower East Side back when it was the murder capital of the US. There were outdoor fires in steel oil drums so the folks who lived on the street could keep warm. We were oblivious to all that, happy to be part of the local scene. Of course, today these areas have long been gentrified.

Well into the editing process, Jack and I decided to go to the marketplace and look for finishing money and distribution. We visited Bob Shaye, founder of New Line Cinema, who had distributed John Waters' movie, Pink Flamingos, and would later distribute the *Babar* feature film we made at Nelvana. He passed. We next went to a soft-core porn distributer, who said, "What is this jumble?" Frankly, no one was very encouraging, but we were driven to finish our movie regardless.

When the film was finally ready, it got few reviews or screenings, but had a second life after Tuli Kupferberg's death in 2010. Through the generosity of Deluxe Films and its CEO Cyril Drabinsky, I was able to digitally remaster the film, and forty years after it was completed, it got its NYC premiere as part of a Tuli Kupferberg Retrospective at New York's Anthology Film Archives. It was all the more meaningful to me because the AFA was started by Jonas Mekas, a leading figure in the New York experimental film scene, whose screenings I regularly attended when I was in high school.

What always amazes me about our film was that we got it made despite a lack of funding, inexperience, and many setbacks along the way. We had our detractors, but nothing stopped us from getting it done. It was Jack who took it through its final editing,

mix, and completion, working for at least two years on his own to get it done with the help of Crawley Films in Ottawa. Without his final big push, dedication, and the help of friends, we would not have finished the movie and it would be lost forever. Now it lives on in digital form.

There is nothing that can't get done if you set your mind to it and you put your heart and soul behind it. I am a firm believer in sticking with it and not giving up and I have seen this stubbornness pay off in the long run, time after time.

With our film made, the big question became what next? The problem I faced was that there was no private film industry in Toronto for me to join. There wasn't anything like that in all of Canada. There were only government institutions such as the CBC, TVO, and the National Film Board. Don Haig had organized a group of independent editors who cut documentaries for the CBC. He had grown up loving Hollywood movies and he would spend hours a week screening his personal collection of 35 mm prints of MGM musicals. He always wore dark glasses when he was editing or watching movies. It was one of his quirks. He would play a key role in mentoring us as we grew Nelvana.

CHAPTER 7

# THE CANADIAN WHITES

*A collective of creative mavericks
tackling diverse projects*

WITH THE CANADA COUNCIL grant money we received for *Voulez-Vous Coucher Avec God?* Jack and I built a rear screen projection set-up with stop-frame animation done in front, allowing us to produce our own optical effects. Marc Chinoy, a friend who was in Canada dodging the draft, came to us with an animation request. Marc had learned to do claymation with plasticene and had also worked on a Jim Henson production. The first season of *Sesame Street* was now in production. Henson had so much work to do for the series launch that he subcontracted Marc to create animation based on five letters of the alphabet. Marc asked me if I could put together a small crew that he could train to produce stop-motion animation. So Patrick, Jack Christie, Peter Dewdney, and myself got to make five animated shorts for *Sesame Street*, learning how to animate as we went along.

It was a lot of fun and when it was over, we asked Marc if he wanted to solicit some Canadian work. He wasn't interested, so my friends and I formed a partnership called Laff Arts to continue producing plasticene animation work, using our *Sesame Street* shorts as our sample reel. This really pissed off Marc, although I'm not sure I understood his reaction. He later moved back to the US when draft dodgers were offered amnesty and produced a plasticene animated film based on one of his favorite comic strips, *Pogo*. He then exited the animation and film production business, while I carried on.

I am not sure what gave us the belief that we could start an animation production company when Canada had so few film production companies of any kind. But that was our plan and our vision. Looking back, we were blind to reality.

When we were starting Laff Arts, Patrick and I met with Al Guest. Al had previously been very successful in commercials in Toronto, but he wanted to get into entertainment production. He took an order from Steve Krantz, a New York distributor to produce *Rocket Robin Hood*, one of the first animated series ever produced in Canada. He didn't have the local talent pool to do the work, so he recruited animators from all around the world. This made the studio a Tower of Babel where the talent couldn't communicate with one another and the production didn't go well. Eventually the distributor took over the show and brought in a young Ralph Bakshi, who became famous for the X-rated animated satire *Fritz the Cat* based on Robert Crumb's successful underground comic book, to finish it. Legend had it that Al was so distraught over losing the company that he walked around with a gun in a paper bag.

By the time we met Al, he no longer carried a weapon. He had a new backer/producer, Syd Banks, who had produced a folk-music

series called *Let's Sing Out*, a Canadian answer to *Hootenanny*. It featured young folk singers such as Peter, Paul and Mary, Bob Dylan, and Ian and Sylvia. Al and Syd were terrific to us and we benefited tremendously from their mentoring. Al taught us how to budget a show and other basics of how to run an animation business. After he moved to Los Angeles, I stayed in touch with him and always expressed my gratitude for his help.

Al and Syd also paid us to write a script for *Super Joe*, a cartoon short about football star Joe Namath. They were producing the short with the local animation company Cinera, run by Al's protégé Vladamir Goetzelman. Cinera, as it happened, was housed in a building that had been my father's factory where he manufactured slippers in the 1950s. Being there brought back memories of walking up the stairs and doing odd jobs my father made up to keep me and my sister Lily busy while he did his work.

Armed with the knowledge Al had given us, Patrick and I went out to make sales, wearing old suits we bought at the Salvation Army on Richmond Street. We didn't get any traction. We often would celebrate jobs that we thought we were going to get, but they didn't materialize. Were we too optimistic or too stoned to pick up on the reality of the meetings? Eventually we stopped using hash or opium beforehand and started pitching sober.

One of our weaknesses as a production company was that we didn't have a character designer. Carol Pope, who later became the lead singer and songwriter of the music group Rough Trade, recommended a friend of hers named Clive Smith, who had worked at Al's animation studio. He was also a rock'n'roller who had played keyboards in a popular British group, the Bonzo Dog Doo Dah Band. We engaged Clive to design characters and build 3D models for us. Trish Cullen, Clive's wife, was also a very talented

artist and worked freelance for us, building plasticene models for us to animate. She also worked on our music, as did Carol. Clive was heavily influenced by the Monty Python paper animation that Terry Gilliam produced, as well as the work of Spike Jones and other British comedians, not to mention British rock groups.

Patrick and I landed a contract from Bill Marshall, a successful local producer and communications expert, who hired us to doctor three films he was producing for the Toronto Stock Exchange. The films were meant to educate and inform visitors about the services that the exchange provided for the stock market. The production crew had travelled across Canada shooting a ton of film of business owners, farmers, and miners. But they hadn't followed Bill's scripts, so we needed to re-think the films, using as much of the existing footage as possible while designing new scenes that could be shot inexpensively in Toronto to fill in the blanks. After that, Bill hired us to produce an animated trailer for the Festival of Festivals, which eventually became TIFF, The Toronto International Film Festival, and a theatrical short promoting a Festival of Underground Theater, or FUT. Bill was a great person and a positive force in the creative community and TIFF would forever put Toronto on the map as a great film city.

During this period, Jack and I hadn't given up on thinking of ourselves as counterculture entertainers. *Voulez-Vous Couchez Avec God?* had featured animated green peppers called Bishop Daddy and his pal, the Reverend Ike, based on an article that claimed you could get high smoking a mouldy green pepper. We would sometimes paint our faces green and appear as the characters in live venues around town. We were friendly with an art group called General Idea, which would stage events and happenings like a Miss General Idea Beauty Pageant. General Idea stuck with it and

had a very successful career in the worldwide art scene, while we eventually settled on building an animation company.

As we built the company, I obtained another Canada Council grant to go to Japan and meet with stop-motion animators there. Judy Merrill had arrived ahead of me, translating Japanese science fiction for a new anthology. She gave me her ex-husband's egg nog recipe, which I've been using at New Year's parties ever since, and introduced me to a few of her friends, including the person who taught English on NHK, the national network of Japan. She cajoled me into scheduling a lunch with him, not warning me in advance that I would not understand a word he said. Fortunately, he talked through the entire meal. I couldn't have got a word in if I'd wanted to.

It was a great time to be in Japan. It was before Japan's industrial miracle. The modernization of Tokyo was just beginning. People still wore traditional Japanese robes and clogs. Sushi delivery boys would ride their bikes through the streets of Tokyo with clogs and kimono, steering with one hand and holding a large tray of sushi in the other. There weren't many western tourists so I always stood out. People would stare at my straight black hair and my eyes, which have a slight Asian cast, trying to figure out where I was from. In Japanese restaurants, business men would buy me sushi dishes if I engaged in conversation with them–they wanted to practice their English. One day when leaving a restaurant, the people I had been conversing with told me they thought I was very brave to try all these dishes. They said they would never eat sushi in a restaurant they weren't familiar with. I'm still not sure how I felt about that.

The density of Tokyo got to be overwhelming, so I went on a side trip to the less populated Japan Sea countryside and the setting

of a very popular art film, *Kwaidan,* based on the ghost stories of Lafcadio Hearn. After I checked into my room at the ryokan, a local-style hotel, I was surprised by a knock on the door. There were six Japanese schoolgirls offering to show me around and take me to the town's most famous tourist site, Ammano Hashidate. We walked up the hill and looked down at a lake reflecting one of the most beautiful mountains. You had to stand in one specific spot, because if you moved a foot to the left or right, you would see the open pit strip mining happening around that spot of natural beauty.

Later when back home in Toronto, I received photographs of the young students walking me through town. It turns out their young brothers had been keeping an eye on us, using their cameras. I also received some proposals of marriage and copies of the many photographs they took of our trip through the town.

On the journey back to Tokyo, I stopped in Osaka and spent a day wandering around. I stumbled on a protest and everyone started staring at me. I quickly realized that it was an anti-nuclear demonstration protesting the atomic bombs dropped by the Allies some twenty-five years earlier on Hiroshima and Nagasaki. I backed away, but a few people followed, yelling at me. I had heard about my father's experiences, but this was my first direct experience of what it was like to be part of a despised minority.

When I got back to Tokyo, I was dropped off at my ryokan by a friend I'd made on the trip, Hiko Kamei, an animator who had worked for Al Guest on commercials. Unfortunately, Hiko left me, without realizing that the ryokan had closed its doors and the lights were off. I was drunk and queasy from having tasted all sorts of foods and drinks that were new to me. I stumbled around and vomited on the doorstep. Pretty soon two policemen were shining

flashlights in my face and asking, "American?" They looked tense but immediately relaxed when I said, "Canadian." It turned out that Americans were deserting from Vietnam, showing up in Tokyo, committing robberies and causing mischief.

I had a great time in Japan, exploring another country on my own for the first time, but for the rest of my stay the staff at the ryokan would point and laugh at me whenever they saw me.

Back in Canada, our constant search for work seemingly paid off when we got a contract from TV Ontario for some labour management educational shorts, but the TVO producer went over budget and decided he didn't want to pay for the shorts, after all. We were earning a meagre $25 a week. After much complaining, they agreed to meet to discuss a settlement but still refused to throw us a bone. We were so upset that we stopped working for TVO. What surprised me is they didn't even care or notice that we were boycotting them. I brought it to their attention two decades later and they started buying shows from us.

We had better luck with another government organization, the CBC, which not only hired us to do the animated opening for a kids' show called *Drop In*, but commissioned me to write some scripts for the show, supplementing my meagre Laff Arts salary. One of the episodes was about the history of the Canadian Whites, Canada's black-and-white comic books that were published during the Second World War. Researching the episode led me to contact John Ezrin, who had financed Bell Features, the most successful of the Canadian Whites. Ezrin invited me and Patrick Loubert to his warehouse where he stored the original Bell Features archives, with the intent that if there was another war, he could republish the comics changing the names of the enemies and villains from Germany to Russia, or Emperor Tojo to Chairman Mao.

John reminded me of W. C. Fields, the famous comedian, both in voice and mannerism. He was funny but dry. He told us he was tired of keeping the archives, which took up a lot of storage space, and told us we could have them and the rights to the comics for $3,500. John also introduced me to his nephew Bob Ezrin who was then pursuing a career in music production. Bob and I later teamed up to create Wow Unlimited Media.

That seemed like a very reasonable price but we had no money or assets, so we financed our first acquisition the classic way, through presales. Our friend and patron Don Haig helped us pitch a documentary series to CBC Telescope about Canada's long-lost comics. I was only twenty-two and had never produced or directed a documentary before, so Don offered to backstop the production and do the post-production—he was our angel on this production. The CBC agreed to buy the documentary for $10,000.

We still needed to pre-sell more projects in order to buy out John Ezrin, so our next target was a book. I had written some freelance articles for *Toronto Star* editor Allan Walker, who introduced us to a book publisher friend of his, Peter Martin. Peter agreed to buy the book rights for $5,000. We would write the historical segments and curate the comic book stories for inclusion. Canadian artist Harold Towne, who had illustrated a comic book for a Bell Features competitor, wrote an afterword. Everything was lining up. We also interested the National Museum of Man (now Museum of Civilization) in buying the archives from us for $10,000, a deal negotiated by the Toronto art dealer Av Isaacs who served as our agent. And the National Gallery in Ottawa signed on to tour a show across Canada of the original comic book art. Of course, we had never curated a museum show in our lives. What amazes me today is how a book publisher, a TV network, and

Canada's most important art institution could take such a risk on us.

I'm not sure how we did it, but these projects sure kept us busy during 1970. We rarely slept those days. The release of the documentary was timed with the release of the book and a *Canadian Magazine* cover story. Despite all the deals we'd made, we were never able to fully pay off the bank loan we took out to buy the rights to the comics. Patrick's father had co-signed the loan and he paid the balance for us. We could never have gotten Nelvana off the ground without his generosity.

While we were working on this project, change was afoot in Canadian film and animation. Sheridan College was offering a degree course in Animation Production which would train young talent in Canada. There were increasing government financial incentives to help fund local production, including a federal Canadian tax shelter. The country was building the necessary ingredients to enjoy success—access to capital, local talent, and a large market next door—but it would take a long time to come together. Patrick and I were both passionate Canadian nationalists, proud of our young talent pool. I developed slogans like "World domination through animation" and calling Canada "the animation nation." The truth was that apart from some commercials and the failed television series *Rocket Robin Hood*, there was little to the Canadian animation industry.

Regardless, we chose to wind down Laff Arts and start a new company focused on animation. Laff Arts had seven partners. Patrick and I were the only ones to stay on, with Clive Smith joining as our third partner.

Patrick and I met with our mentor Don Haig and told him of our wildly optimistic vision. We were going to start a Canadian

studio. We wanted to make movies, television shows, art, books, and anything else we could think of. Don was taken aback. "Kids," he told us. "There is no Canadian show business to become part of. There's the CBC, the NFB, Allan King, and myself. That's it."

He was right. Fortunately, we didn't listen to him. To some degree, we were conditioned by what we had already accomplished by this early stage in our careers. We believed we were only a few steps away from creating a new Disney.

In the meantime, we needed to find money and make and sell shows, however modest.

CHAPTER 8

# NEW ENTITY, NEW IDENTITY

*The Nelvana team tries to make it in movies, TV shows, animation, art, and books*

MY FATHER WORKED VERY hard all his life. He saved his money and never bought himself or my mother a luxurious home, or expensive clothes, or an expensive car. His motive was to provide for his family, make sure his kids got a good education, and improve our lives.

My motive in starting Nelvana was quite different. I didn't have a family. I wanted to build a great company in the field of entertainment, especially animation.

What my father and I had in common was that neither of us were driven to make a lot of money. I did make a lot of money, more than my father or I would have imagined, but that was later. When I started the company, my father was concerned that I would be destitute for the rest of my life. In retrospect, I can see why.

In the early years of Nelvana, Patrick, Clive and I took $25 as a weekly draw and there were some weeks in which we had to forgo even that meagre sum. We were in business for seven years before we gave ourselves raises. Patrick's girlfriend and later wife, Judy-Anne Barkely, worked for the welfare department and told us that we could get welfare for a month or two during bad times. It turned out welfare paid more than our weekly draw. The hydro and gas companies would show up at my home door threatening to cut off service if they weren't paid.

I made ends meet by writing magazine articles for Allan Walker at *The Canadian*, the free weekend magazine of the *Toronto Star*, and doing radio work for the CBC. On *Back to the Future*, a hippie-oriented late-night show on the CBC, I performed under the name Active Mike and talked about countercultural subjects like the Whole Earth Catalogue and communes. Active Mike was popular enough that I was offered a chance to host *Sprockets*, a CBC TV series about underground films, but it turned out I didn't know how to look from one camera to another while reading a script so they found another host with TV training. I lost a gig that paid much better than Nelvana.

Our first Nelvana office was a third-floor walk-up in a ramshackle apartment building above a printer on King Street West. We found the place when a friend of ours from the local band Syrinx told us he was moving out of it to an apartment on the second floor. There was a bathtub in the middle of our space with nothing separating it from the rest of the room. We looked like we belonged there: we were still hippies in some ways, wearing clothes we bought at the Salvation Army and our hair was shoulder length. (I eventually cut it and wouldn't have shoulder-length hair again until the COVID-19 pandemic.)

## NEW ENTITY, NEW IDENTITY

The apartment did have a spare bathroom, which we used as an animation camera room, putting a light in the toilet bowl (after draining the water) and aiming it upward to create a backlight. We also had a Bolex camera that we could move up or down to create the illusion of movement to or from the camera. It was enough to get us started.

One of our chief weaknesses in our early years was our inability to find the right chief financial officer to help us build the business. We had a relationship with a bank, the CIBC branch at Rochdale College, which had given us our first co-signed loan. When Patrick ran up thousands of dollars on his CIBC Visa card on our behalf, the manager of the bank offered to give us a loan to pay down the card and finance the company. For our first year or so, he would meet with us regularly to get an update on the company and we would tell him about our revenue-generating deals. When he started asking us for financial statements, we ignored him at first, then asked him to recommend an accountant. He suggested the young man who did accounting for Rochdale's vegan restaurant, so we gave the accountant a shoebox full of receipts and copies of invoices. It didn't occur to us that we should review the statement before we let him take it to the bank.

A month later, the bank manager called us in for a meeting. He told us the story of how our accountant had come into his office dressed as Gandalf the Wizard from Tolkien's *Lord of the Rings* books, complete with a giant wooden staff. He plunked a two-dollar bill on the manager's desk and asked him what it was. He then proceeded to beat the manager over the head with his wooden staff. The accountant had to be removed forcibly and committed to the local hospital for several months. The manager was not amused. We found another accounting service to help us out but

it would take us two decades to get the level of professional help the business required.

The name for our new company, Nelvana, was the last thing we got out of the Canadian Whites. It was the name of the first Canadian female superhero, "Nelvana of the Northern Lights," an Inuit goddess who guarded her people to save them from "evil white men" based on the comic book created by Adrian Dingle based on a story that he heard from Frank Johnston a member of The Group of Seven. One reason we chose not to keep the name Laff Arts is that it sounded like "Laff Farts" and that wouldn't do for serious clients, or so we were told. Nelvana seemed perfect. It was neutral-sounding, had a hint of "nirvana," and was very Canadian. In fact, we had to give permission to the rock group Nirvana to secure their own trademark.

Over the years, working with our friends at the Coach House Press, we made our own art postage stamps with Nelvana and Johnny Canuck, another hero of the Canadian Whites. The Johnny Canuck stamps featured our favorite panel, where Johnny is tied up by the Germans and breaks free, with a caption that says, "They had better make stronger rope to hold Canadians captive." Eventually the Government of Canada produced a Canadian Heroes series of stamps, starting with Superman, co-created by a Canadian artist. They came to us at Nelvana to request a license to use Nelvana and Johnny Canuck.

After all the book and movie projects based on the Canadian Whites, the next few years were slower and more difficult. We made a series of ten thirteen-minute films for children called *Small Star Cinema*, mixing animation and live action; an episode called "Mr. Pencil Draw the Line" starred Clive in a shiny vinyl pencil costume. Patrick wrote and directed a Canadian Whites inspired

film, *125 Rooms of Comfort,* about Leo Bachle, who created the "Johnny Canuck" comics when he was only sixteen. Clive created a great opening sequence of photographs cross-dissolving, a technique he would later use for animating the cosmic spacemen in *A Cosmic Christmas.*

Don Haig continued to come to our aid. He would commission us to provide high contrast titles that television programs could use for their opening sequences. We shot them in the toilet. We had difficulties getting the high contrast black and white Don's clients required, and they often came out gray. But Don kept feeding us contracts and they kept us alive. He also commissioned us to create a Film Arts sign for his front window on Church Street. Clive hand painted it on plexiglass.

A selfless mentor, Don worked with both young and established filmmakers and introduced us to another helpful person, Rena Krawagna, who worked in acquisitions for the CBC for Merv Stone. Rena kept the local film scene going by buying short "fillers," three-to-five-minute films without narration that the network could run if a movie or sporting event ran short. This work helped to keep up-and-coming companies like Nelvana, Insight and Sunrise in business while we figured out how to build an industry.

One thing we both learned early on was that taking people out to dine was an essential part of the entertainment business. I learned to love it. Our favorite lunch spot was the New Orpheum Restaurant on Queen at Bathurst where you could get a three-course-meal for less than a dollar. Beside each booth was a sign written on lined paper begging patrons not to throw their napkins on the floor. Of course, the floor was full of napkins. I have never seen a floor with more napkins on it.

If we were doing serious entertaining, our restaurant of choice in the early days was Carlevale's, run by Joey Bersani and Michael Carlevale on Avenue Road, a short walk from our home on Huron Street. Michael, the chef, would regale our guests in his thick Boston accent with stories about the meat and fish he was offering, as well as his special pasta dishes. He and Joey served excellent meals, but more importantly made our guests feel privileged and important. I had many meals there with the likes of Sid Caesar and John Sebastian and it was always a success. The flip side was that it was expensive and would often create friction with my partners, who did not do much entertaining with our clients. But I kept at it and over the years developed a list of favorite restaurants in every city I visited.

Disagreements over dining habits were one of many things our partnership would have to figure out over the years. Patrick and I had very different outlooks, each based on a character in famous children's stories: The Little Engine that Could and Chicken Little. I was the optimist, Patrick the worrier, although the roles were not fully baked and evolved over time. We each had different strengths and learning how to work together and use the best of each other was a crucial component of our hard-won success.

CHAPTER 9

# LOVE AT FIRST SIGHT

*A serendipitous meeting in 1973 sparks an auspicious and enduring development*

IN FEBRUARY 1973, I met the most important person in my life, Elaine Waisglass, my wife, friend, and lover for the last fifty years. I was visiting The Filmmakers' Distribution Center at Rochdale College, which was based on New York's Filmmakers Co-Op and distributed some of my short films, including *The Greeks Had a Word for It* and *Chinese Ball Game*. Jerry McNabb ran the center at the time. In his office, I happened to look across the hall into another office and met the eyes of a beautiful woman. Jerry introduced me to Elaine, who was moving into a communal house with him and a couple of other friends. I immediately asked Elaine for her number and not long after that we had our first date, a cup of coffee and a muffin at the Harbord Bakery on Harbord Street. I realized I had left my wallet behind and Elaine had to pick up the tab. I can't remember if I was embarrassed or just going with the flow. But today I feel embarrassed and I remember I appreciated that Elaine didn't make a big deal of it.

Elaine worked making art etchings at the Open Studio, right across the street from our studio. I described our studio to her in glowing terms that might have been used to describe Disney. Then she visited our third-floor walk-up and saw the exposed bathtub and the animation camera mounted over a toilet. She was kind enough not to say anything. Many years later, when we were reminiscing, she told me that the disconnect between my description and the reality had made her believe I would eventually be successful. Like me, she believed the power of positive thinking was real, akin to "the force" in *Star Wars*.

After her visit to the studio, we went on a few more dates, but broke up shortly after. I began to realize that if I was serious about Elaine, I would have to make changes in my life to become more appealing to her. Over the next few months, for instance, I broke it off with the other women I was dating. Later, Jerry invited me to join him at the house he shared with Elaine to celebrate her birthday. He assured me that she had asked him to invite me. I later learned that Elaine had not asked. In fact, Jerry told her that I asked to be invited to the party. Jerry had played us both beautifully and it worked. When we met at the party, we realized we were on the same page at last. We made passionate love that night and began a beautiful love affair that has lasted to this day.

Elaine and her son, Jamie, moved into a fourteen-room semi-detached house that I owned with a friend, Jimmy Swanston, in an area of Toronto known as Cabbagetown. I had bought half the house with some cash earned by my freelance work in magazine writing and CBC radio appearances and houses at that time were still priced modestly and affordably. We had a sign outside, "Canuckville," referencing Johnny Canuck. The house had been built for returning soldiers from World War I and signs of hasty

construction were everywhere. The floors were uneven, perhaps because the foundation was built on orange crates. With the help of a loan from her dad, Elaine bought out Jimmy's equity in the house and we started to fix the place up so we could rent out rooms. We became hermits who rarely went out with friends, but we were madly in love and didn't want to go out. Work and childcare duties and hanging out together were enough for us.

We might have been home owners but we were living a bohemian lifestyle and we had trouble making ends meet, only paying our utility bills when someone was at the door threatening to cut off our power or our telephone. Fortunately, in addition to her art, Elaine began getting work in radio and TV as a researcher, producer, and editor, eventually joining one of Canada's top radio programmes, CBC's *As It Happens*. Being a sculpture major, she edited tape as if she was sculpting it and this new career kept the wolves from our door.

While working on a TVO documentary about coming technological changes, Elaine had visited a laboratory in Manitoba and returned to tell me that it was working on technology that would revolutionize the television business. It would soon be possible to have TV and film delivered directly to consumers at home without a local over-the-air TV signal. The signal would be transmitted by wire directly to the home. There would be fewer limits on the number of channels available and the demand for content would explode. This helped me to realize that Nelvana would need to build a library of shows that we owned. We might license them out to distributors, but it was important that the rights would always revert back to us so we would have content to meet the future demand.

Sure enough, over the next few decades we saw this direct-delivery revolution in home video, known as on-demand cable. It

was followed and expanded by DVD and streaming technologies. Every time a new technology came along, it added value to our library. It was Elaine's nugget of research that inspired me to focus on owning our own programs and creating the value that would eventually earn us enough money to live comfortably.

CHAPTER 10

# STARS ALIGN

*Cosmic Christmas leads to George Lucas and major Star Wars animation project*

AN IMPORTANT BREAKTHROUGH FOR us was *Energy Conservation for the Future*, a large educational project with the National Film Board, for which we recruited some of the first graduating students out of Sheridan College's animation program, including Dave Thrasher and Larry Jacobs. The project came about at the instigation of a non-theatrical educational film distributor, Marvin Melnyk Associates. We set up a company called Melvana Communications to handle it and we had a lot of fun with the local unions, signing up Melvana, but not Nelvana. That's the kooky way we operated in the 1970s. I would often compare us to the Three Stooges: Patrick resembled Curly, Clive was Larry, and I was Moe.

Patrick's idea for a Christmas special was literally built on a dream. He told us about a dream he'd had in which three wise aliens landed their spacecraft on Earth, having followed a star

at Christmastime to a town that had forgotten the meaning of Christmas. We turned that dream into our first fully animated special, *A Cosmic Christmas,* which became the underpinning of the Nelvana studio. To make it, we had to recruit more animation talent. In addition to the Sheridan grads, animators were becoming available from the United States after finishing a feature film called *Tubby the Tuba* in New York. One of these animators, John Celestri, in turn helped us find more US talent over the next few years, including such stalwarts as future Disney animator Tom Sito. By the time we were finished *A Cosmic Christmas*, Nelvana had built a great team of animators who would make us a powerhouse in the years to come.

Lenora Hume was working in retail managing when she saw a Nelvana ad for a camera person and decided to apply. Her studies at Waterloo University were computer science, photography, and dance, but she was looking for a way into an artistic profession. Peter Dewdney, in his capacity as our head cameraman, interviewed her and recommended we hire her. In addition to our original camera over the toilet bowl, we had installed a second camera designed by a boat builder who used a lot of nautical parts. Many of the design features on this nautical experiment failed to work, so we had to improvise. To do a zoom, for example, Lenora had to climb a ladder to change camera settings. Eventually, she would give up the step ladder and move up the corporate ladder, becoming our head of production; after fourteen years with us she was recruited by Disney to work in their television animation production department. Since Lenora, like the rest of us, had never worked for another animation studio, the production methodology she helped develop was not quite like that of any other studios. We invented our system as we went along.

For music, I approached Sylvia Tyson, the well-known folk singer/songwriter. She agreed to compose and sing songs for *A Cosmic Christmas* and recorded them at Daniel Lanois' studio in his family home in Hamilton. Lanois, who was just beginning his career at this time, eventually became famous as one of the top music producers in the world, producing albums for such artists as Peter Gabriel and Bob Dylan.

One reason we chose to make *A Cosmic Christmas* is that the *New York Times* entertainment section had declared 1977 would be the year of science fiction, with two of the most popular directors in America releasing movies in that genre: *Star Wars* from George Lucas and *Close Encounters of the Third Kind from Steven Spielberg*. That seemed to be a good wagon to hitch ourselves to. But we didn't have the budgets of Lucas and Spielberg and when we were about ninety percent completed, we realized we didn't have the time or money to animate the scenes with the wise men from space. Clive remembered a technique he had used in *125 Rooms of Comfort* and came up with the idea of dissolving between key animation drawings of the spacemen, which saved us the work of animation inbetweening and saved money on ink and paint as well. The dissolves not only allowed us to finish the special on budget and on schedule, they gave the spacemen an ethereal way of moving that added a nice arty touch to the film. Necessity is the mother of invention. We finished on budget and on schedule.

Early in production, I realized that the special would only make economic sense if we could sell it in the US. We engaged a freelance consultant who had done the advertising buy for the *Peanuts* holiday specials when he worked at the J. Walter Thompson advertising company. He helped me get meetings with the biggest children's and family advertisers in the US, and I showed some

of the film to the heads of specials for all three of the big US networks, but while I got some traction, we weren't getting the deals we needed.

Then our lawyer Jeffrey Kirsch, who aimed to become a partner in Nelvana, offered to introduce me to a family friend named Jamie Kellner, a young executive at Viacom. When I went in to pitch Jamie, he explained that he was heading up a new division at Viacom called Prime Access Syndication, aimed at getting first-run programming into the 7 p.m. hour just before the network prime-time lineup began. I thought Jamie looked exactly like Peter, the hero of *A Cosmic Christmas*. They both had ginger hair and the same face shape. I showed Jamie our sizzle reel of film from the special, which we cut like a movie trailer, and he immediately expressed an interest in the program. This spoiled me, because such a quick reaction turned out to be relatively rare in our business. When I told him we were hoping for a US network pickup, he encouraged me to tell the networks of his interest and try to leverage that into a pickup from them and assured me that his offer would still stand. None of the networks were ready to commit, so I went back to Jamie and we made the deal.

To air a show in first-run syndication, you had to make deals with independent stations, market by market. Sometimes you could clear a station group and get five or six stations with one deal and that's what Kellner did when he cleared the NBC O-&-O (owned and operated) channels. That gave us New York, LA, Chicago, Dallas, and Washington, and with that in their pocket, Kellner and his sales team got us around 200 stations representing 97 percent coverage of the USA.

One drawback of syndication is that the stations all agreed to carry the show on different days and time slots within the same

two-week period, so it was hard to sell advertising or do national promotion. Jamie generously let me sit on the sofa in his office while he made calls to stations and advertisers and I learned a lot about selling from him. Jamie is one of the smartest people in the industry and I rank him with George Lucas, Tim Burton, and Steven Spielberg among the top people I have worked with.

We sold the special but Elaine and I were still poor, although happy and not jealous of anyone who had more than us. We were both type-A personalities, headstrong and highly determined, so we had to learn how to get along. My mother had seemed passive to me in her relationship with my father, so early on, I encouraged Elaine to express what she was feeling and to be strong in affirming what she wanted and it did not take her long to do that. In hindsight, I recognize that my mother's personality was a product not only of her upbringing but also her experiences during the Holocaust, when she was hidden. I do regret not making more of an effort to get my mother talking and being more engaged, but kids aren't built to fix their parents.

For our first five happy years together, every phone call from my parents included a question about when we were going to get married. On one call I told them we would get married, but then we got caught up in our busy lives and did not actually plan anything. My parents didn't forget. They kept asking about the date. Finally, we said we would have a wedding party on September 1, 1978, so that anyone who had to travel could use the Labor Day weekend to fly to Toronto. My plan was to go to Toronto City Hall for a private wedding and then have friends and family over for the party. My dad sent us a check as a present to use for a honeymoon, and we immediately booked a trip to Portugal and had our honeymoon months before the wedding, touring Lisbon and the Algarve, the

Portuguese Riviera. One of the great pleasures we had was a boat trip with local fishermen at 4:30 a.m. as they went out on the Atlantic. We saw the sunrise, heard the fishermen sing a song of praise when their nets were full of sole, and curse when they caught calamari, responses reflecting the relative commercial value of the catches. Meanwhile, I had forgotten to go to city hall and book the date.

When we returned, I went to city hall and discovered that the earliest date we could get was September 28, so I booked it. That meant we had a wedding party about four weeks before the actual marriage. This didn't bother me, but Elaine's father, Harry, would later say he was convinced we had not gotten married and jokingly asked to see our marriage certificate.

The most embarrassing part came on the day of the wedding ceremony. I had forgotten about the city hall appointment. I was having lunch with my Nelvana partners when I remembered that I was supposed to be getting married. We asked the waiter to keep the meals warm, jumped into a cab and got to city hall just in time. Elaine was there waiting for us on the steps of this grand old building with our good friend, Marilou Stuerm. We lumbered up to the judge's chambers and enjoyed a short civil ceremony with, as I specifically told the judge, no rings. And, in a colossal error, I left Elaine and Marylou on the city hall steps, got back into a cab with Patrick and Clive and went back to the restaurant to finish the lunch we had abandoned. What was going through my addled brain, I don't know. I wasn't even aware it was a mistake at the time. But more than forty years later I am still paying for my failure to take Elaine and Marilou out to celebrate.

CHAPTER 11

# THE M FACTOR KICKS IN

*Movies, music, marketing, merchandising, and a few A-list celebrities*

A COSMIC CHRISTMAS HAD a great story and fun characters and it succeeded globally, but it didn't become the perennial classic we hoped it would be. Making a classic turned out to be much more difficult than we could foresee.

*The Devil and Daniel Mouse* was our second fully animated television special. Jamie Kellner asked us for another holiday special to follow *A Cosmic Christmas* and Halloween was highly desirable to advertisers. Patrick had the idea for the story and the protagonists, Jan and Dan are a folk singing duo who split up. Jan is seduced by the Devil into signing a contract with him. He takes her away from her folk roots and makes her a pop rock star. It was a funny parody of the music scene. My wife Elaine suggested singer/songwriter John Sebastian (founder of The Lovin' Spoonful) to write the music and I negotiated a deal with John's manager, Bob Cavallo, and his lawyer, Eric Eisner, to do the special, thus

beginning a long working history with John as well as Bob and Eric. The whole company loved making this cartoon. A version of the same story eventually inspired our feature, *Rock & Rule*.

We did several other holiday specials at Nelvana. One was *Intergalactic Thanksgiving*. I conceived the idea and persuaded Sid Caesar, the iconic comedy genius of the fifties, to do the voice of King Goochi of Laffalot, who prides himself on being the funniest man in his kingdom. It was an environmentally themed comedy and ahead of its time. Sid was fun to work with. He helped to structure some gags and was very actively involved in trying to make the show funnier. One particularly hilarious routine Sid created for us was built around a running line, "Why don't these things ever work?" which the king says every time he pulls a giant rope which is supposed to cause a giant cream pie to fall on one of his courtiers. Of course, it never worked. It also turned out that both Sid and I enjoyed making grilled cheese sandwiches, so Sid came to our house on Huron Street and we had a competitive grilled cheese bake-off. Not sure who won, but we had fun. Actually Elaine won because Sid loved her home made relish which we spooned on top of the grilled cheese. Sid gave Elaine his personal relish recipe that he reserved for grilled cheese making.

*Easter Fever* was an idea I had for a Hollywood style roast of the Easter Bunny, during which he recounts his favorite adventures. Once again, we had great original music from John Sebastian. We cast Garret Morris from *Saturday Night Live* as Jack Rabbit, who wants to quit his job as the Easter Bunny. On SNL, playing a Dominican baseball player, Garret had a signature line that had caught on, "Baseball been very good to me." In our show, we turned that into "Easter been very good to me." Garret was a great

Easter Bunny and Canadian voice specialist Maurice LaMarche (later the Brain on *Animaniacs*) contributed many voice impressions to the special.

One other holiday special was our Valentine's Day show, *Rome-O and Julie-8*, which Clive and I conceived of. It was a take-off on Shakespeare's *Romeo and Juliet* with competing robot manufacturers standing in for the Capulets and the Montagues. Of course, the robots from the feuding companies fall in love. I think the original idea was mine. Clive thinks it was his. We shared credit and we had fun with the show.

*Take Me up to the Ball Game* was the last of the holiday specials we made with our Viacom partners. It features the voice of Phil Silvers as an intergalactic promoter and original songs by Rick Danko of The Band. Rick sat in our kitchen at Huron Street and played Elaine and me some of his songbook. Then we headed to The Pilot, a Toronto tavern where Rick would be the headline performer that night playing with a Toronto backup band. We sat at a bar table drinking beer and listening to the opening act. Nobody paid any attention to Rick, until it was time to perform. Then magically he transformed from looking like an awesome Toronto guy into a charismatic music performer. All eyes in the room were riveted on Rick Danko, a star. Like other members of The Band, he died too young.

*Rocket Boy* was an interesting project initiated by Jamie Kellner, then running television at Orion, who wanted to do a syndicated kids show in live action and was working with a producer named Jerry Golod, who wanted to do a parody of old fifties-style shows such as "Captain Wonder." We decided it needed to be funny and worked with ex-SCTV writer/producer Dave Thomas to package in John Candy in the role of Rocket Boy. John was always

hard to nail down and while we thought he wanted to do it, he wouldn't close the deal and eventually passed, but not before we had a memorable meal with him in an Italian restaurant near the Second City Fire Hall Theater. John kept ordering more food for everyone at the table and when it was clear no one could eat anymore, John finished off all the food himself. Perhaps we should have abandoned the show when John was not available, but we decided to recast with Dave Thomas in the title role. Dave brought us in some talented guest stars and funny writers from the US, including the team of Tom Gammill and Max Pross, who went on to write for David Letterman, *Seinfeld*, and *The Simpsons*. The pilot was hilarious, but didn't get picked up.

As already recounted, *A Cosmic Christmas* led to our *Star Wars* animated short and our relationship with George Lucas. We stayed in touch after the short was completed, and I regularly visited George in idyllic Marin County, California at his property on Lucas Valley Ranch (named after a different Lucas). On my first visit, George walked me around showing me where he was going to build various parts of his campus, which he would call Skywalker Ranch. Every time I came to visit, another building was going up and George would tell me about his ideas: one was to house film geniuses like Akira Kurosawa on the campus to create a milieu for great creative exchanges.

George and I also had a number of conversations about animated movies. He had a theory that the best way to compete at the box office against Disney was to take a page from the Warner Bros. cartoons and make comedy features with a lot of slapstick humour. My partners and I spent large amounts of time brainstorming this idea, but we were never able to try it, although it still makes sense to me. People love to laugh and shows like *The Simpsons* and *South*

*Park* proved that you can make a successful animated comedy for much lower cost than the high-end pictures Disney and Pixar have focused on. "Funny is money" is how my Wow Unlimited Media partner Fred Seibert likes to put it.

For our first animated feature, we chose to do a rock opera, which we called *Drats* and eventually changed to *Rock & Rule*. We had trouble with the script from the beginning. As I recall it, we raised the $5.4 million production funding through a Canadian public offering structured as a tax shelter, based on a synopsis and a budget. We did not have a final script, nor did we have distribution, but when we got the funding, we had to make the movie.

The story started as a take-off on *The Pied Piper of Hamelin*, with characters that look like rats. The scripting was a team effort drawing on Peter Sauder, John Halfpenny, and Denise Fordham, with Patrick Loubert as the leader. Influenced by Disney, we started boarding and kept rewriting the movie as we went. This turned out to be an expensive exercise with a lot of wasted animation. While Disney had made some great movies this way, we lost our way in an intricate story that evolved over three years of fevered production and the script would be the weakness of the movie.

I wanted iconic rock artists to compose and sing the songs and our music lawyer, Eric Eisner, was a big help. He had a great rolodex and knew the managers and record label executives you had to work with to get to the artists. The most powerful executive of them all was CBS Records president Walter Yetnikoff. When I met with Walter, he was dressed in a black suit, wore dark sunglasses, and had the lights in his office dimmed. He was larger than life but a man of few words. He wanted to hear more about our project so I explained it to him as a unique musical vehicle. He considered coming onto the project as a co-producer but eventually declined.

Our big break came when we secured Debbie Harry to provide the singing voice of Angel, our heroine. She was a musical icon at the time as the lead singer of Blondie, which had evolved from Punk to New Wave and was on the leading edge of introducing rap and reggae into the mainstream. I took a liking to Harry and her partner Chris Stein, who were down-to-earth, outspoken, and incredibly creative, both in music and their interest in the visual arts.

One of our meetings at their West 58th Street apartment was just days after John Lennon was shot and killed in front of his home in New York. Debbie, hit very hard by his murder, was in tears. She and Chris were also afraid. Debbie's iconic look made her instantly-recognizable by star gawkers and Lennon's murder by a fan gave them good reason to be concerned. She had been painted by Warhol and featured on magazine covers and billboards. When we went out walking later that day, Debbie put on over-sized dark sunglasses and pulled her coat collar up and tied a big scarf around her head. In trying to look inconspicuous, she stood out even more, flanked on either side by me and Chris.

After Debbie came on board, we signed up Lou Reed as the villain, Mok, who brings a demon into the world. The demon was written and sung by Iggy Pop. We had Cheap Trick doing the music for the hero, Omar. Earth, Wind and Fire did a big dance song for a scene at a rave. All these artists liked being part of the team alongside Debbie Harry. And Debbie and Chris were excited about working with them. Debbie wrote great lyrics and was quick to rewrite in response to the notes we gave her; she was a great collaborator with these other artists in making the music of *Rock & Rule* work.

My meeting with Lou Reed and his manager, Eric Gardner, went equally well until I mentioned that Clive Smith, our director, would be at Lou's recording session for the film. Lou contorted his

face, muscle after muscle rippling in a way I never seen on anyone else's face, before or since. Lou started to tell me in a quivering voice that if our director came to the recording session, he would send him back in tiny pieces in a box. After pausing appropriately to consider the alternatives, I calmly told Lou that we would respect his wishes, as we preferred Clive alive and in one piece. I later told Lou that if he needed help during the recording, Clive would be available by phone to talk him through the storyboard sequences. They ended up spending so much time on the phone that Lou later told me that Clive should have been in the studio with him. I didn't realize until later that Lou had made a point of keeping record label executives out of his sessions throughout his career, and he mistook Clive and me for executives, when in reality we were working as collaborators on a creative project and he should have welcomed our participation.

All of the artists recorded their songs at different studios around the US, including Earth, Wind and Fire's Los Angeles studio, Arc, which my friend, George Massenburg, had designed and built. The most complicated number in the film was the final song, where the villain forces Angel (Debbie) to use her song to summon a demon; the demon manifests with Iggy Pop's voice and Rick Zander of Cheap Trick joins with Debbie to sing the demon back to his resting place in some sort of hell. Our score composer, Trisha Cullen, had to pull together all these different groups whose parts had all been recorded separately.

The film we ended up with has a great look, fantastic visual effects for the era, wonderful performances from a top-flight slate of artists and an amazing score by Trisha Cullins. Patrick and Clive poured their hearts and guts into the film. Now all we had to do was sell it.

## CHAPTER 12

# ROCK AND RULE

*Breaking the budget and dealing with failure
as our feature misses the mark*

I HAD BEEN SHOPPING *Rock & Rule* to all the studios and didn't have a deal until Charlie Lippincott picked it up. Charlie was a friend who had worked at Lucasfilm on the marketing and merchandising of *Star Wars*. While *Star Wars* was still in production, he built a fan cult for it by touring the comic conventions with slide shows of the movie's designs, pretty much inventing that kind of entertainment marketing. By the time of *Rock & Rule*, Charlie had become an executive at MGM/United Artists. As an aficionado of old comic books, the blues, jazz, and American pop culture, he understood what we were trying to do and convinced his colleagues to acquire it. He also suggested that we do a comic book to promote the film. I sold Jim Shooter, the editor-in-chief of Marvel, on a tie-in comic that came out just before *Rock & Rule* was ready for release.

By that time, however, Charlie had left MGM-UA, leaving the

movie with no internal champion at the company. The head of distribution didn't believe in the film and wanted it to go direct to video. After much argument he agreed to release it in a test market. Boston was selected because of its university audiences. There was no advertising budget, so it didn't have much of a chance. The reviews were brutal. Patrick, Clive, Elaine, and I went to theatres to see how it was playing. Some of our investors and board members, including Michael St. B. Harrison and Ted Kernaghan, came along. The audiences were more brutal than the reviewers. We played in big, near-empty cinemas and quickly got downsized to tiny theaters. All of our hopes and dreams for the film blew up on that first weekend. The reality sank in that we had produced a bomb.

We were stung by the failure of the movie. I feel a bit better about it today because the film has something of a cult following. If I am talking to an animator or an animation buff today, they know the film and respect it for its contribution to the art. But in the moment, we were despondent. Not that we had any time to mourn the production. We had run up two million dollars of debt finishing *Rock & Rule*, and kept the company afloat by raising a debenture from friends and family at twenty percent interest. I needed to line up some work-for-hire productions fast if we were to stay in business.

One person I reached out to was Seth Willenson, who had gone to Bronx Science at the same time as me, although we had never met (it was a school of 2,800 students). Seth was in charge of programming for RCA Selectavision in the then-new business of home video. They made laser discs that competed with a rival laser disc format from Universal. Both would soon lose the format war to VHS tapes, which would then give way to DVDs and

later online streaming. Home video revolutionized the world of children's entertainment as kids would watch their favorite shows and episodes over and over, which would drive their parents mad and create a tremendous demand for toys and merchandising with the same characters. The videos taught kids the play patterns for the new toys, forever changing their relationship to their toys. The major toy companies of the day—Kenner, Hasbro, Mattel—all invested heavily and thrived as kids watched the home video episodes of Care Bears, GI Joe, Strawberry Shortcake, Rainbow Bright, My Little Pony, Transformers, and many other titles over and over again while playing with their toy versions at the same time. One of my fondest memories of this phenomenon was watching *The Care Bears Movie* in a theatre and watching children hugging the Care Bears they brought along with them and at big moments in the story holding their Care Bears up to see the action on screen. Home entertainment also taught us to collect all of the episodes of our favorite shows in the same way we collected all the books in a popular series. Collectability builds fandom and market support for brands. For almost two decades, home video became the number two revenue source we enjoyed for our animated shows.

Seth introduced me to Marty Keltz, who was the founder of Scholastic Productions in NYC. Scholastic was producing its first animated special, *Herself the Elf,* in partnership with the title character's owner, American Greetings, the card company based in Cleveland, Ohio. Scholastic agreed to hire us as their animation supplier and I worked with Jane Startz, Scholastic's head of production, to get the audio tracks done. Jane had secured Judy Collins to write and perform the songs and Ellen Greene and Jerry Orbach to voice the principal characters.

Jane was one of the best producers in the kids' business and over the years it was always great to work with her and Marty on a series. In the early days of the home video market, we produced a low-budget series of direct-to-video specials based on *Clifford the Big Red Dog*, and would eventually work with them on *The Magic School Bus*.

One of the benefits of doing *Herself the Elf* was getting to meet the team at American Greetings that created the title character, an unusual group of card writers and illustrators who called themselves Those Characters From Cleveland (TCFC). We would later do other work for American Greetings brands including Get Along Gang, My Pet Monster and Madballs—rubber balls with sculpted wacky faces on their surface.

TCFC in turn introduced us to Bernie Loomis and Carole MacGilvray at MAD, a new division of Kenner Toys. Bernie, who had built the Hot Wheels franchise at Mattel before moving to Kenner, was one of the legends of the toy business. He was credited with coining the term "toyetic" to describe a movie or TV show with the necessary qualities to result in big toy sales. He took a chance on *Star Wars* toys but then refused Steven Spielberg's request for a similar deal for *Close Encounters of the Third Kind*, explaining to Spielberg that *Star Wars* was toyetic and *Close Encounters* was not. Bernie was a bigger-than-life character who was perfectly complemented by his number two, Carole, with her no-nonsense, get-the-job-done approach, and their gofer, Paul Pressler, who eventually went on to run Disney Parks and, eventually, Gap Clothing.

MAD had been tasked by Kenner with building new creative brands. They had already launched Strawberry Shortcake. To promote the character, there had been three animated specials

produced and written by Romeo Muller (of *Frosty the Snowman* fame). Bernie and Carole wanted to switch animation companies for the next special. My partners initially gagged at the idea of doing specials to promote a toy, as though we were above that. Eventually, they recognized that we could make a great Strawberry Shortcake production. And we really needed the income to service our debenture.

We were able to convince Bernie and Carole that Peter Sauder, our in-house writer who had co-written *Rock & Rule*, was capable of writing the show. Peter was a Sheridan graduate who started with us as an animator, but his animation was considered mediocre. Rather than let him go, Patrick decided to give him a shot at writing and he turned out to be an ace animation writer, working for many decades and winning an Emmy, among other awards. We flew Peter to New York to pitch Bernie and the rest of the MAD team. He was so nervous he started a panic attack, so I told him to close his eyes and imagine that during the pitch he made Bernie drop his pants and hit him on the butt with a wet fish. With that bizarre image in mind, Peter overcame his panic and survived the pitch. In fact, he did an outstanding job. Everybody loved the story he spun.

Throwing ourselves into work helped us keep going, but in one way, I dropped the ball. Charlie Lippincott, who had an almost professorial approach when discussing what he did, encouraged me to promote ourselves directly to fans the way he did with *Star Wars*. I tried to do that for *Rock & Rule*, but after that, I didn't promote Nelvana as a brand. In the decades to come, we produced a lot of kids' favorite shows, but they didn't recognize Nelvana as a brand like Disney. I realize now that that was our responsibility. To this day, Nelvana is underappreciated among fans of animation because we did not do that marketing job.

CHAPTER 13

# INSPECTOR GADGET SAVES THE DAY

*Our first TV series and first major hit leads to a Nelvana turnaround*

*I*NSPECTOR GADGET WAS THE first TV series that we produced. It came to us in our desperate years of working our way out of the debt that we had built up making *Rock & Rule*. I wanted to do a project about Jacques Cousteau and we discovered that the rights were controlled by DIC, a French animation company that had been very successful in France and the rest of Europe with shows like *Ulysses 31*. I contacted Andy Heyward, who was in Los Angeles running the US division of DIC, but it soon became clear that we had different visions for a Cousteau project and couldn't work on it together.

As I was leaving, Andy mentioned they needed help in closing the financing for a new series they had developed called *Inspector Gadget*, about a bumbling detective with gadgets built into his body. He showed me the pilot and told me that they had an order

for sixty-five half-hours for US syndication, but part of their US funding had disappeared and they had thirty days to come up with $40,000 per episode or they would be forced to abandon the series.

We had never worked on a series before. Patrick and Clive were uncertain they wanted to. I pushed hard for us to do it, mostly because it was an opportunity to make some money and pay our debts down and avoid bankruptcy. Fortunately, both Clive and Patrick liked the pilot and agreed that we should do the show. To get the money, I had to pre-sell the show at home. Canadian broadcasters at that time never paid more than $10,000 per episode for a cartoon series. However, pay TV had just started in Canada and these companies wanted to come out of the gate with Canadian shows that would create excitement. I was able to convince Joan Schaefer at First Choice, which was aiming to be the HBO of Canada, to buy the show in what now seems like a miraculously short period of time. So we had our financing for the series just under the wire.

Jean Chalopin, the CEO of DIC, flew from France to Toronto and on the day before Christmas, the two of us negotiated the contract. It had to be finished that day. I sat at the old manual typewriter and drafted and typed the contract, working with Jean directly. That could not have happened even a few years later. Contracts over time have become longer and more complex, requiring the services of lawyers and more lawyers.

To qualify the series as Canadian content, we took on producing the scripts, storyboards, voices, and post production—all the creative work that would make the show a hit. The animation was delivered by TMS, a Japanese animation company. Jean Chalopin worked closely with us and served as the showrunner, teaching us his methodology for series production, while our key

in-house talent, including Peter Sauder, Leonora Hume, and Ray Jaffelice, worked to get it made at the speed of a runaway train: all sixty-four episodes were produced and delivered within twelve months.

Once we had delivered the series and the industry had identified it as a hit, DIC became our fiercest competitor and would remain so over the next twenty years. Andy invited some of our writers, including Peter Sauder, to leave us and move to Los Angeles. This was war. I managed to convince Pete that he had better long-term career potential as Nelvana's star writer than working for DIC and we were incredibly fortunate that he decided to stay. Our key US clients liked Pete's work, and he became the nucleus of the writing team we needed to build to compete with US producers in that market.

Two other regular writers were Dan Smith and Dale Schott, both of whom, like Pete, started as animators and were picked by Patrick to try their hand at writing. In order to expand our writing staff, we started a training program run by my former assistant, Susan Snooks. Training Canadian writers allowed us to stay within Canadian content requirements, unlike a rival company, Cinar. It got in trouble for using American writers and having assistants in Montreal put their names on the scripts.

Another person who played an important role in building our animation studio was Frank Nissen. He was our lead character designer, lead animator, and storyboard artist. Frank mentored our young crew and was a great collaborator with Clive. Clive had a great sense of humor. Frank had a great sense of drama. Clive had a loose drawing line. Frank had a tight drawing line. Clive was over the top. Frank understated. They complemented each other perfectly. Frank eventually left Nelvana to go back to California

and worked for Disney for many years. His departure was a major loss and we missed him immensely.

We didn't limit ourselves to animation, however. In the early 1980s, the Disney company decided to start The Disney Channel on pay TV, their competitor to Nickelodeon. I decided we should try to develop a show for the new network and that it should be a live-action show, since Disney was unlikely to buy much animation from independents. I was interested in adapting the popular children's mystery book series *Encyclopedia Brown*, but it was unavailable and its competitor, *Einstein Anderson*, had too young a target audience. So Patrick and I developed an original story about a family of young geniuses named Edison who solved mysteries using science, with an animated clip at the end that would explain the science they used to crack the case.

In addition to interesting the Disney Channel in the show, I sold it to CBC Kids, but we were having trouble coming up with a good "bible," a document that explains the style and spirit of the show for potential writers. My wife, Elaine, volunteered and came up with a draft that got the show on the right track, even though she had never written a show bible before. Elaine, kindly did not ask to be paid for her contribution to the Edison Twins, since she knew that the company couldn't afford to pay her. Time and again Elaine helped out entertaining my clents at dinners and cocktail parties she arranged. When we took clients to restaurant dinners I would seat her next to a shy client she would engage in interesting conversation. Over the years she continued to be able to do anything she put her mind to.

We had to suspend production for a few months when the financing for the Disney Channel appeared to have fallen through and Disney suspended its launch. In the end, Disney went ahead

with the Channel and *The Edison Twins* became one of their first international co-productions. Licensing international rights to Viacom took care of the rest of our financing and the show went on for six years and seventy-eight half-hour episodes. It was a fresh and original show that taught what would later be called STEM (Science, Technology, Engineering and Mathematics) to young children in an entertaining way. The way the show used science to solve problems was similar enough to *MacGyver* that we weren't sure whether our series inspired that show or whether it was just serendipity.

When we were casting the show, Disney sent over the executive who had cast *The All-New Mickey Mouse Club* for the Disney Channel. That show later discovered Ryan Gosling, Justin Timberlake, Brittany Spears, and Christina Aguillera, so they weren't too shabby at casting. Our cast featured Marnie McPhail as Annie, the female Edison twin, and Sunny Besen-Thrasher as the twins' kid brother—the comic relief. Sunny's parents were Dave Thrasher, who had been one of our leading animators in the early days of Nelvana, and Joan Besen, a singer songwriter keyboard player with the country rock group Prairie Oyster. The part Disney had the most influence on was Tommy Edison, the male twin. The final choice came down to Andrew Sabiston and sixteen-year-old Kiefer Sutherland, Donald Sutherland's son. We were intrigued by Kiefer, who clearly had the acting chops, but Disney's pick was Andrew, who was cheerful and smiling while Kiefer was deeper and a little brooding. They thought Andrew was more of a Disney lead. Kiefer did okay. He went on to great success in movies like *The Lost Boys* and the TV series *24*. While we were disappointed we didn't get Kiefer, Andrew was indeed a cheerful performer and went on to have a good career as a writer and performer.

While initially limited in their programming hours, the Disney Channel and its competitor Nickelodeon soon grew to be twenty-four-hours-a-day channels dedicated to the kids' audience. It led other cable specialty channels to focus on children, which increased the demand for our programming. Before cable, children's viewing was ghettoized to a limited number of hours a day and week, but with cable, the "shelf space" for kids' TV grew to hundreds of hours a week. This allowed us to grow our business dynamically, so that by the time we sold Nelvana, we were producing over twenty series a year. When we started out, most animated shows had standardized designs and storytelling, but the increased demand for programming and the demand for fresh approaches made it possible to sell offbeat and unusual-looking shows.

We still needed more work to dig ourselves out of the multi-million-dollar hole we dug with *Rock & Rule*, so we took on every project we could get. I created an educational series about computers called *Mr. Microchips* as a vehicle for my computer expert neighbour, Skip Lumley, who was great at explaining computers in a simple and understandable way. Unfortunately, we provided him with no media training, so when we put him in front of a camera he froze. We replaced him with a young comedian, Steve Brinder, who was not a computer expert but could memorize and recite the material.

Another project came from Jamie Kellner, who wanted to take advantage of the lower Canadian dollar by producing a fitness series in Canada. *20 Minute Workout* was primarily programmed in the US as a workout show aimed at women, but in Canada, CITY TV head of production Ivan Fecan (who I knew from our days as freelancers for CBC Radio) bought the show for its male appeal and used it as a bar show for lunch and happy hour. A scene from the show can also be glimpsed in the movie *Ghostbusters*.

# INSPECTOR GADGET SAVES THE DAY

In 1984, we produced one hundred hours of television. Previously, we had never produced more than an hour in a year. We worked our butts off, but it got us on the road to recovery.

Throughout our financial predicament, there was one area where we insisted on spending extra money: we decided to deliver better animation than our clients were paying for. We felt that was our best bet to compete with US studios. While our competitors were delivering episodes with 8,000 animation cels, we were doing 15,000 to 20,000 cels per half hour. This cost much more but paid off in the long run. In the 1990s, Steven Spielberg entered the field with his Warner Bros. shows *Tiny Toon Adventures* and *Animaniacs*, which used a similar cel count to ours. Our work, unlike most of our competitors' work from the 1980s, did not suffer by comparison and our shows had longer shelf lives.

CHAPTER 14

# WINNING CAST OF CHARACTERS

*R2D2, C3P0, Care Bears, Babar, and Rupert pave the way for phenomenal growth*

Around this time, I got another surprise call from Lucasfilm telling me that they had sold two animated *Star Wars* spinoffs to the ABC network: *Droids*, about the adventures of R2D2 and C3PO, and *Ewoks*, about the fierce but lovable creatures who lived on the planet Endor. The shows were part of George Lucas's plan to maintain the merchandising business for *Star Wars* in the absence of new *Star Wars* movies. Each series was conceived so that every three or four episodes could be combined into made-for-video movies. I was surprised to find that George didn't want Darth Vader, Luke, Leia or Hans to appear in the shows, but we did get permission to use some of the *Star Wars* theme music.

Nelvana produced both shows, making the storyboards and layouts in Toronto and then animating overseas. We did *Droids* in

## WINNING CAST OF CHARACTERS

Korea with Steven Hahn and *Ewoks* in Taiwan with James Wang. A lot of blood, sweat and tears went into making the shows great, but neither series rated well. *Droids* only lasted one season and *Ewoks* two. I think one of the problems we ran into was that Saturday Morning network TV had too many restrictions on violence. We weren't allowed to show anything that kids might imitate so our weapons looked more like vacuum cleaners or channel changers than *Star Wars* weapons. While the Ewoks in the movie were cute, they were also warriors and that tension got in the way of making it into a successful kids' series. The plan to do multi-part episodes also became a challenge because ABC standards & practices forbade children's shows from ending episodes on cliff hangers. We had to design every episode to be complete in itself. Cable TV, which wasn't bound by FCC regulations, would be a better home for later *Star Wars* spinoffs like *The Clone Wars*.

One of the interesting aspects of both series, but especially *Droids*, was George's love of deep background and world-building. He introduced us to the works and theories of Joseph Campbell, whose analysis of mythical heroes and their journeys was a big influence on *Star Wars*. *Ewoks* was relatively simple as it was mostly inspired by the world of Endor in *Return of the Jedi*, but *Droids* was intended to have new leads every four episodes, with R2D2 and C3PO as the only continuing characters. George also kept changing his mind about whether he wanted it to be more comedic or more action-adventure. The two main droids were the Laurel and Hardy of the *Star Wars* saga, but sometimes George wanted them to be like Yosemite Sam or other Warner Bros. cartoon stars, and sometimes he wanted them to be Eddie Murphy in *Beverly Hills Cop*. We never found the right direction for the series.

While *Ewoks* ran more smoothly, it brought one of the most difficult production problems I've ever encountered. George had chosen the singer/songwriter Taj Mahal to write and sing the theme song for the series. The demo he delivered was quite rough. With only a week before air date, I went to Hawaii to attend his recording session for the final version and Taj was nowhere to be found. The engineer directed us to a local hotel lounge where we could recruit some singers who could sweeten the demo track with new vocals. We were recording them when Taj Mahal casually walked into the studio. Fortunately, he liked what we were doing and laid down another take of his lead vocal. Despite all this, ABC never liked the theme song and ordered a completely different song for season two.

While we were working on the *Star Wars* shows, George introduced me to John Lasseter, head of Lucasfilm's nascent CGI production arm that would be known as Pixar when it was later sold to Apple. George would have liked to use computer animation for *Droids* and *Ewoks*. The technology wasn't there yet, but John was on the critical path to building it, working on the animation side alongside Ed Catmull, who was more focused on the software and technology side. In those days, this type of computer processing needed big mainframe computers that filled a room. We didn't begin to take computer animation seriously for about another eight years, but then we started to computerize painting, inbetweening, animation and eventually the whole shebang. The reason we outsourced our inbetweening, painting and shooting to Asia starting with *Inspector Gadget* was that in North America and Europe, the cost of painting an episode was equal to the cost of animating that episode. By the nineties, computerized paint systems allowed us to repatriate that work and earn Canadian tax credits for doing it in-house. This

was also artistically desirable, because we could control the process more in our own studio.

While working on the Lucas shows, our clients at American Greetings offered us a chance to bid to produce *The Care Bears Movie*, based on characters created for a line of greeting cards in 1981. We were competing with DIC and Atkinson Film Arts in Ottawa, which had done the first Care Bears specials, written by Peter Sauder, whom we offered as the writer of the feature. DIC, our arch-rival after *Inspector Gadget*, was also young, hungry and independent, looking to displace the old industry leaders Hanna-Barbera and Filmation. During the last competitive meeting, Carole MacGilvray told us she was kiboshing DIC because their presenter had his trousers fly open during his presentation. We won the deal, and even though it was another work-for-hire production, I was relieved to get it. We were still working our way out of debt and in addition this was a chance to overcome the box-office failure of our first feature.

By the time we got the go-ahead, we only had nine months to make the movie. *Rock & Rule* had taken three years to make and animated features rarely took less than two years, but there was no changing the release date. Kenner Toys and their licensees were shipping product into stores near that time and the movie was a key part of their marketing. To get *The Care Bears Movie* done on time, we split production between Korea and Taiwan, our two main suppliers of overseas animation. Our director was Arna Selznick, who became the second woman to direct an animated feature. We were able to get Mickey Rooney to provide the voice of the narrator and John Sebastian once again wrote songs for us, as did Carole King. Carole worked remotely from her ranch in Montana and we had to communicate through her manager and

producer Lou Adler, a beret-wearing admirer of beatnik poetry, the co-owner of the Roxy Theatre and the producer of Carole King's Tapestry album, who had worked with everyone from The Mamas and the Papas to Cheech and Chong.

The Samuel Goldwyn Company signed on to distribute the movie, and their executives explained to us that we would need a cut of the movie to screen for exhibitors some four months before the scheduled release. This created quite the panic. We eventually screened a cut that was 10 percent finished color, 40 percent pencil test and 50 percent storyboard. We were on pins and needles, remembering how the original *Star Wars* initially opened with only seventeen screens because exhibitors hated seeing an unfinished cut. But this group of exhibitors loved the work-in-progress aspect of what they saw and we got the 1,000 screens we wanted.

Now our only problem was getting the whole picture done on time. We had a major setback when our Korean studio let us down. They were working on their own feature film simultaneously and the studio's owner, Steven Hahn, ran out of money and couldn't pay his animators for the work they did on *Care Bears*. We asked James Wang, who ran Cuckoo's Nest, the animation studio in Taiwan, to take over the rest of the movie. Patrick and Leonora, who were invaluable in getting the film done so quickly, went door-to-door in Korea with big suitcases of Korean Wan, meeting with the studio animators and buying back their drawings, which we then sent to Taiwan to complete. James Wang and his team of animators did a fantastic job, as did our editors and post production studios back home, and we delivered the movie on time. I don't believe anyone has made an animated theatrical film as fast as we made *The Care Bears Movie*.

A few months later, I got a call from Patrick telling me that he had just driven past a Toronto movie theatre, the University

## WINNING CAST OF CHARACTERS

Cinema on Bloor Street, which had a giant line going around the block. He asked me to guess what movie they were lining up to see. I would never have guessed it was *The Care Bears Movie*. It became the most successful non-Disney produced animated movie to that date. Our second animated theatrical film was a hit. Unfortunately, we didn't own any of it.

Still, I wanted to do more with the Care Bears. I optioned the rights to sell it as a network series and sold it to ABC, which was already in business with us through Lucasfilm. The show did well and got a second season order and then we had a great opportunity: American Greetings needed some cash to solve a short-term problem, so they offered to sell us the entertainment rights to the Care Bears for $1,000,000. We had no capital, but raised the money by turning the Care Bears show into a sixty-five-episode syndicated series, which turned out to be one of our biggest successes, a highlight of the Nelvana library for many years.

After I left the company, the new owners of Nelvana sold the Care Bears episodes and movies to American Greetings. I was saddened when I heard that. Care Bears was a cornerstone of the Nelvana success story and an important part of its heritage. The Care Bears were beloved by preschoolers and the programs we made with them were well regarded for the unique combination of humour, emotion and adventure.

Through Lucasfilm we were introduced to the Bee Gees, the bestselling musical group created by the brothers Barry, Maurice, and Robin Gibb. They were interested in doing an animated feature film adaptation of a self-published graphic novel about their early lives. After meeting with the Gibbs at their family compound in Florida, Patrick and I instead agreed to work with the Bee Gees to co-create a new original musical, not based in any way on their lives.

We came up with the idea for *Frank! The Musical*, about a Frankenstein monster searching for his identity in the many parts and pieces that the good Dr. Frankenstein had used to create him. In fifteen minutes, Barry Gibb captured the essence of the story by writing a song called "Be Who You Are," where all of Frank's different body parts are pulling him in different directions. It was great and made me believe the idea would work as a movie musical.

But every time we came back to meet with the Bee Gees, they would return to the idea of doing their life story. We knew that was a non-starter at that time. Disco was dead and the Brothers Gibb were closely identified with its demise, especially after their movie *Sergeant Pepper's Lonely Hearts Club Band* stiffed in the marketplace. In the end, the *Frank* project died a natural death, proving once again that timing is everything.

We continued to expand our business and opened a Nelvana office in Los Angeles, housing it in the Egg Company, a building George Lucas had bought at the corner of Lankershilm and Ventura Blvd. Our US entertainment attorney, Stan Coleman, was very helpful in teaching me some of the ways of Hollywood. He recommended Kevin McCormick as our US executive. Kevin, who had got his start with producer Robert Stigwood and signed the original *New York* magazine story that became the movie *Saturday Night Fever*, was a delight to work with. He brought us some excellent opportunities. I was sorry when Kevin left us to go on to a great career as an executive in charge of production for Warner Bros.

One of the big Hollywood players George introduced me to was Alan Ladd Jr., the executive who greenlit *Star Wars* at Fox and who was now running his own business, The Ladd Company. Laddie, as everyone called him, had some similarities to George

Lucas. He did not speak much in meetings. There would typically be long pauses. A Lucasfilm executive described it to me as sitting with a lox [a smoked salmon] at the table, but I had the same style so it didn't bother me. I was happy to sit there quietly while we each thought about what we wanted to say. My favorite memory is sitting in the office while he took a call from the CFO of Warner Bros., the Ladd Company's distributor at the time. He motioned to me to stay in the room and talked for about forty-five minutes, more than I had ever heard him. His recent movies had bombed, but he talked up his current slate and particularly a small movie that he claimed would be a major hit. The film was directed by *WKRP in Cincinnati* creator Hugh Wilson and was called *Police Academy*, which indeed became a major hit and spawned a series of seven films and two television series.

Hugh Wilson would later be brought in to rewrite and direct a movie I was producing for Nelvana called *Burglar*, based on a series of books by Lawrence Block about a gentleman burglar. The title role had been written for Bruce Willis, with Whoopi Goldberg as his comedic sidekick. But after Warner Bros. bought the package, they started to worry about greenlighting the movie with a TV star in the lead role, even as *Moonlighting* took off and other movie studios started bidding for him. Warner Bros. hadn't committed to Bruce when his *Moonlighting* hiatus was coming up, so he jumped ship to *Blind Date*, a comedy directed by Blake Edwards. We sold the studio on the idea of rewriting the movie with Whoopi as the lead. Hugh Wilson did a brilliant job of quickly rewriting the script and Whoopi was a delight to work with, generously giving money to every needy person she passed. But Whoopi was miscast in the part. It needed a cooler, Cary Grant-ish performer like Bruce. Also, she had just finished starring in another film, *Jumpin' Jack*

*Flash*, which had many plot similarities to our movie. While the movie tested well, it stiffed on release.

Lisa Lieberman, who worked with us while Stan Blum ran the LA office, had a movie background and we thought we could stay in the movie business with the right executive. We optioned the rights to an original story for a thriller and made a deal with Castle Rock. After many years of development, it was produced by that studio as the movie *Malice*, starring Nicole Kidman and Alec Baldwin, but while we were attached as executive producers, we did not do anything beyond identify the story and assign our option to the studio. While a modest box-office performer, the movie is noted for some of the great dialogue Aaron Sorkin wrote. Alec Baldwin, playing a doctor, proclaims "I am God!" in a fantastic moment in the film.

Another live-action project came through Elia Katz, my friend since the age of fourteen. Elia became a television writer on shows like *Hill Street Blues* and we worked together on a few scripts, but the one project we produced, from a pilot script by Elia, was the series *T & T*. It started with a call from our US agent Triad, informing us that *The A-Team* was about to be canceled and that if we came up with an idea for Mr. T to star in a syndicated series, Triad would package us all together. The only precondition was that Mr. T had to make $1 million per production season. I thought it would be fun to go against Mr. T's stereotypical image and put him in fashionable suits so Elia wrote a script where a young blonde lawyer works with Mr. T as a private detective, helping the young and needy defend themselves against false accusations. When he was in action, Mr. T would shed his suit and change into his fighting clothes, just like Superman. It was high concept and Triad liked it, Mr. T liked, it and 200 US station owners liked it, too.

I sold it to the Global TV Network in Canada who co-financed the series with us.

When the show was picked up, Mr. T suggested that the writers and producers meet him in Chicago. He wanted to show us the housing projects where he grew up so we would better understand who he was. I had to go to the Chicago Tribune building to meet the representatives of our primary station group, so I was not able to join the visit to Mr. T's childhood home, but evidently when Patrick, Elia, and others arrived with Mr. T in his white limousine, local kids surrounded our group and asked Mr. T why he was working for these white guys. Mr. T explained that they were working for him on his new show and the kids asked him to fire the white guys and hire them. When one of the gang members took out a knife and threatened to kill Elia and Patrick, Mr. T talked the gang down, telling them they were shaming themselves, him, and the whole neighborhood. After a few tense moments, the knife disappeared and Mr. T and our group made their escape back into the limo. When I caught up with Patrick and Elia, they accused me of setting them up to be killed.

Soon after we started shooting, Elaine and I invited Mr. T to our home to have a home-cooked meal. In a phone call with Elaine setting up the dinner, Mr. T made it clear that he liked to start his dinner by eating his desert of vanilla ice cream first, followed by a big thick steak with baked potato. A neighbor who was about ten years old at the time recently told me that all the kids were excited to see Mr. T drive up to our house in his white limo. When Mr. T arrived in his white stretch limo I was not yet home. Elaine had prepared for the dinner by buying a big container of Hagan Daz ice cream and served Mr. T a big bowl of it. He loved it so much that he asked for a second bowl. I arrived in time to barbeque

Mr. T's giant steak. But he was so full of ice cream he couldn't eat more than half of the steak.

Elaine showed Mr. T the trees on our property. He said they looked sickly and jokingly offered to cut them down. He had just been involved in a dispute with a neighbour in Chicago that involved some retributive tree felling and did some harm to his image.

Our show might have been a bigger hit if Mr. T had kept his reputation for doing good deeds, but he did an amazing job of selling the show at the National Association of Television Program Executives (NATPE) convention in New Orleans, going from table to table shaking hands and posing for pictures with the general managers and programmers of stations and their wives. He would say: "I pity the poor fool that don't buy *T & T*." He was a trouper and he never stopped working, until the incident with Don King.

The famous fight promoter and Mr. T were friends and shared the same agent. When we were beginning season three, Don told his agent he wanted to be made a producer on the show for more money than either Patrick or I were making. We passed. Shortly thereafter, Mr. T and Don King started holding prayer meetings on set in his Winnebago, sending back word that he couldn't make the call time because he was busy praying. Through their agency, we learned that Don would stop calling T for prayer meetings if we made him an executive producer with a large fee. Again, we passed. Patrick went to Mr. T and told him what Don was doing and Mr. T said he would stop the prayer sessions with Don if we gave him a new jeep. Mr. T went back to work after he got the new car. In hindsight, we should have hired Don King. He would have used his resources to promote the show.

My favourite Mr. T line was that his first name was Mister, his middle name period, and last name T.

## WINNING CAST OF CHARACTERS

In the third season of production, I found myself in London with Elaine and Jonathan returning from the MIP tv market when I was awakened by a call from Patrick. Patrick was all doom and gloom and advised me that he had just received a call from lawyers at Quintex, our US distributor for T & T telling us that their company was going into bankruptcy as a result of the insolvency of their parent company in Australia. Patrick told me this would bankrupt us in turn. We were in the middle of production and without Quintex's cash investments in the production we would have to cease production and we would be responsible for the repayment of our production loans with our Bank. I hung up from the call not fully grasping what he had told me. Elaine woke me up and encouraged me to call Patrick back and discuss what we could do to mitigate the oncoming train wreck. She pointed out that I sold the series to a client and that I would likely sell it again to another client. She said I should get on a plane and travel everywhere to get the series sold ASAP. While on the phone with Patrick, I brainstormed that we would contact our French partner Canal Plus because this would negatively effect the co-productions we had together. We would ask Canal Plus to help us with a bridge loan while we sorted things out. Pierre Lescure the CEO of Canal Plus told me that while he couldn't do that he would ask his friends at the French Bank Credit Lyonnais to help us out. I returned to Canada quickly but then turned around in forty-eight hours for a meeting with the head of entertainment lending at Credit Lyonnais in Rotterdam. Patrick and I met with him and he agreed to advance us cash immediately with the loan paperwork to follow. It pays to have good friends and relationships in business. This loan was an important part of the solution to save our business.

Next we had to save the production season for T & T and find a new US buyer for the show who could fund the deficit. I flew to Virginia City to meet with The Family Channel and they decided to buy the series from Quintex and agreed to advance the balance of what was needed to fund the show. The timing for the production save was critical. At some point you lose cast members to other series. The Quintex bankruptcy was going through the courts and we had to navigate our series out of the proceedings. We were successful in that endeavor by pointing out that the asset would have more value to the debtholders if we could finish this third season that got us to sixty-five, the syndicatible number of episodes. Fortunately everyone cooperated and now we were truly saved from going under.

## CHAPTER 15

# THE ELEPHANT ON THE MEZZANINE LEVEL

*Legal battles, barbeques in the backyard, and global expansion.*

**K**EVIN MCCORMICK, NELVANA'S first Los Angeles-based studio head, called me one day and mentioned he had met Clifford Ross, a New York-based artist who had optioned a number of properties to develop including *Babar*, Tom Swift, and the work of Edward Gorey. Kevin asked me if we had an interest in *Babar*. I had been a huge fan of the character since childhood, but I had to think about it since *Babar* was not typical of what was working on US network television at the time. It struck me that we could use the Canadian co-production treaty with France to arrange financing as an alternative to using US network presales to finance the show. I conferred with Patrick, and we decided to go for it. Kevin made the introduction to Clifford and, after much discussion, we optioned *Babar*.

We all got along well in the beginning. We even grilled vegetables on our barbecue in the backyard at Wychwood Park. It seemed we

were on the same wavelength and we entered into a short form deal memorandum and started developing the property. A significant part of Clifford's role was to fulfill his promise to the de Brunhoff family to be sure that the *Babar* property was developed in keeping with the spirit of the original seven *Babar* books written and illustrated by Jean de Brunhoff, as well as the almost thirty books created by his son, Laurent, from whom Clifford had optioned the property. While in her nineties, Jean's wife, Cecile, had asked to meet Clifford during her last trip to New York to firmly establish her family's wishes.

We tried a number of different approaches including modernizing the look, but settled on a classic *Babar* close to the illustration style of the original books with the addition of humor based on the court life around the king and his family, inspired by the British bureaucracy depicted in the successful *Yes Minister* television program. This approach appealed to CBC, which decided to program *Babar* early on Sundays at 7 p.m. CBC had historically programmed *The Wonderful World of Disney* at that time.

Because I had sold the show to CBC for prime time, we had to make it work for co-viewing, so each episode had bookends, set pieces off the top and end of the show, in which Babar's children would have an issue with something, prompting *Babar* to gather them around and tell a story about his youth and help them sort out their issue.

Even with CBC onside, we needed to secure more financing. We took *Babar* to Cannes, looking for potential partners from around the world. We produced a sizzle reel featuring the character—it later became the series opening—and were fortunate to strike a pre-sales agreement with Canal Plus, the pay-TV network, helping to finance the show. Canal Plus's subsidiary, Ellipse, became our co-production partner. Ellipse had not yet produced animation and its executives, Stephan Sperry and Pierre Bertrand Jaume,

saw *Babar* as a great entry point into the field. Stephan and Pierre were a great team with a fine sense of humour. Stephan had worked as a film producer and distributor with Island Records and Pictures founder Chris Blackwell. Pierre had been a broadcast executive at a French channel Antenne 2. Ellipse was able to bring in France 3 into the deal; it paid higher license fees. I nicknamed Mireille Chalvent, who ran France 3 Kids, Babarella because she took a highly possessive and defensive posture with the character. We shared her passion and the nickname was intended as a compliment. Mireille was a terrific partner for *Babar*.

A secondary benefit of going to Cannes and handling the distribution of *Babar* ourselves was that we talked to a lot of other buyers and producers. We were able to do more deals, which amortized the costs of being in Cannes across a range of shows and partnerships while also growing our business.

Later, I secured a US sale for *Babar* with Sheila Nevins and Carole Rosen at HBO. Sheila and Carole appreciated what I called the "charmth" of *Babar*. They were also great partners and kept buying the series year after year. It was the perfect animated show for their network, and HBO was the perfect US home for the character.

Now we were in business with our first proprietary show, jointly controlling the merchandising rights with Clifford, who also had an active producing role with all our audio-visual productions. Since we hadn't successfully licensed any other character, we were initially happy to work with the French licensing agent Guillaume de Bouvier, who had been appointed by Laurent de Brunhoff, son of *Babar* creator Jean de Brunhoff. Once we had Canal Plus and HBO involved, we decided to change and expand the team representing the character. In France and the EU, we appointed Ellipse as our representative. Ellipse hired Anne Gastou to run

the French program. In the US, we hired Jerry Houle and his company, Bliss House.

One of the first deals Jerry made was for a plush *Babar* by Gund. Anne, meanwhile, arranged for Dauphitex to handle apparel and Villac to continue producing wooden figurines. Before we came into the picture, *Babar* had never earned more than $75,000 a year from its licensing program. We were soon able to make him a hit character, with seven-figure licensing deals to follow. It happened to be a great moment for pre-school licensing. There were no hit pre-school properties at the time. The market needed something new. We had it.

We launched *Babar* with a big party in New York at FAO Schwartz during Toy Fair that year. It was a sensation. We managed to get an elephant up to the mezzanine level of the store's Fifth Avenue showcase location. For years, I joked that I helped push that elephant up the escalator. Laurent de Brunhoff was in attendance, along with Clifford and Stan Blum, the merry band leader for the event.

Now Stan brought real excitement and an expectation of big deals to the *Babar* property. But Stan was a bit like the Cat in the Hat. He ran roughshod over people, and he and Clifford did not mesh well. It added to friction between Clifford and myself. Clifford wanted me to pull Stan off Babar, but I was impressed with the types of deals that Stan was negotiating, worth many millions of dollars a year to us. In retrospect, Stan should have been fired and replaced by someone just as good, but polite and not abusive. Sticking with Stan was a mistake. It was an element of the disagreements with Clifford that led to a legal confrontation. That we managed to continue our work together in spite of this struggle is a testament to the strength and legacy of *Babar* and our shared desire to bring *Babar* to new generations.

*Babar* was successful, but instead of becoming a home run it was

a baseball double in terms of success. We produced sixty-five half hours of television and two movies and won numerous awards. Our merchandizing program itself won awards and continued to be successful, generating a wide range of beautiful products which kids and parents loved. Among the hundred plus characters that I have brought to life through animation, *Babar* remains one of my favorites. I am proud of what we produced and I am grateful that after I left Nelvana, a new series was created. *Babar* is a classic that continues to entertain young and old to this day.

Raising the financing for *Babar* and distributing it ourselves turned out to be a good decision. We had formerly used Viacom to distribute our programs abroad while our Canadian competitors, Atlantis and Alliance, distributed their own content. We founded Nelvana Enterprises to put ourselves on a level playing field and hired Neil Court, who had worked with a local producer and distributor named Peter Simpson, to run the division. Neil was a born salesman with boundless energy and an agile mind in deal making.

When Neil came aboard, we had three series that we were looking to launch in the international market: *The Care Bears*, *T & T*, and *My Pet Monster*, based on a toy created by American Greetings' toy division, Amtoy. Our first market was Mipcom, the trade show in Cannes, France, and as we got in too late to organize our own booth, Neil asked Ted Riley, his opposite number at Atlantis, if we could share their booth. It turned out Atlantis did not have new offerings for the upcoming market and they were happy to share the cost of the booth with us. To our surprise, *T & T* and *The Care Bears* were such huge attendance draws in Cannes that the Atlantis team had no space to use the booth and gave up on it. They recommended we get our own booth next time. It was the first market test of Nelvana Enterprises and we got some great sales.

Over the next few years, Neil Court and I visited markets across Europe, pre-selling shows and looking for deals that might help projects get greenlit or supplement other license fees that perhaps weren't big enough to cover the cost of a show. One of my favorite stories from the markets with Neil was our effort to sell *Babar* to Italy. At the Annecy market, we pitched *Babar* to the head of RAI Uno Kids and he said he would buy it. Time went on and he never sent a contract, no matter how often we asked for one. Eventually Neil decided to sell the show to another RAI buyer, RAI Due. The buyer at RAI Uno was so furious that he stormed out of a meeting with Neil and said we would never sell another show to him. Neil had booked dinner with the buyer that night and expected it to be canceled, but the buyer insisted on having dinner and picked Neil up that night in a small sports car. Neil, who is very tall, squeezed into the tiny Italian sports car with difficulty. The buyer drove them furiously through Rome to get to the restaurant and sat there through dinner fuming. The gentleman in question wouldn't say a word. He basically ate a multicourse meal and drank lots of wine and then sped off in his car, leaving Neil in his trail. The moral of the story was that while you couldn't count on this guy to sign a contract, you could count on him to finish his dinner.

The other moral was that the only thing worse than a show that no one wanted to buy was a show that everyone wanted, since someone was bound to be disappointed.

Another popular project was *Jim Henson's Dog City*, based on an old Muppet special of Jim's. Our version told animated detective stories in Dog City, framed by live-action sequences with a Muppet animator. It was a lot of fun to work with the Henson folks, but the show was incredibly expensive. Looking to get the balance of the funding, Neil went to Canal Plus Spain and negotiated one

(Top) Jack Christie and Michael Hirsh (right) at Kitchener city hall shooting without a permit for *Voulez-Vouz Coucher Avec God?* in 1969; (middle) Tuli Kupferberg as Abraham in the 1967 proof-of-concept shoot of the film; (bottom) Michael Hirsh (middle) and a group of artists protesting in front of Isaac's Gallery and paying homage to Johnny Canuck's classic line—"they had better start making stronger rope to hold Canadians captive."

(top) Images courtesy of the Media Commons Archives, University of Toronto Libraries. (middle) Courtesy of Ken Locker (bottom) Courtesy of Coach House Press.

Patrick Loubert woke up from a dream and *A Cosmic Christmas* was born. It was Nelvana's first worldwide hit show and led to an important call from George Lucas's studio.

©Nelvana Limited. All rights reserved.

The *Star Wars Holiday Special* cartoon introduced the character Boba Fett in 1978. Courtesy of Lucasfilm Ltd., LLC.

*Inspector Gadget* was Nelvana's first television series in 1984, followed by a CGI version (top) at Wildbrain in 2015.

Images courtesy of Wildbrain. All rights reserved.

The *Care Bears Movie* was the turnaround Nelvana needed after *Rock & Rule*. Alamy.

*Babar: The Movie* was distributed by New Line Cinema.
Jointly Licensed by Nelvana/The Clifford Ross Company Ltd. TM and ©Nelvana.

Hirsh (third from left) launching the Babar merchandising program in Paris with Le Studio Ellipse represented by Pierre Lescure (to Hirsh's left), then CEO of Canal Plus, and Pierre Bertrand Jaume (to Hirsh's right); Babar plush toy from US licensee Gund.

(top) Image courtesy of the Media Commons Archives, University of Toronto Libraries. (bottom) Photo by Paul Armstrong, courtesy of the Media Commons Archives, University of Toronto Libraries.

Tintin and Snowy made a great team solving mysteries in Nelvana's 1991 co-production with Le Studio Ellipse, *The Adventures of Tintin*; Nelvana's 1983 feature *Rock & Rule* is a cult classic for animation buffs, featuring original music by Cheap Trick, Debby Harry, Earth Wind & Fire, Iggy Pop, and Lou Reed.

(top) Courtesy of Mediatoon and Tintinimagination. (bottom) ©Nelvana Limited. All rights reserved.

Debby Harry composed and sang songs for Angel, *Rock & Rule*'s heroine; Lou Reed composed and sang songs for Mok, the show's villain.

(top) Alamy. (bottom) Alamy.

One of the first Star Wars animated series, *Ewoks*, featured the lovable creatures from the Planet Endor, in 1985; (bottom) *Droids*, the second Star Wars series, premiered with *Ewoks* as a Star Wars hour on the ABC Network in the US.

(top) Courtesy of Lucasfilm Ltd., LLC. (bottom) Courtesy of Lucasfilm Ltd., LLC.

Steven Spielberg (top left) produced *American Tail*, the animated movie that knocked out Nelvana's Care Bears movie as the most successful non-Disney release (fortunately, Nelvana won the opportunity to animate the series version); George Lucas (top right) gave Nelvana its big break with Star Wars cartoons and later became a mentor to a young Michael Hirsh (below).

(top) Alamy. (bottom) Image courtesy of the Media Commons Archives, University of Toronto Libraries.

*The Magic School Bus* featured Miss Frizzle, who was voiced by Lily Tomlin.
Courtesy of Scholastic Entertainment Inc.

*Beetlejuice* won Nelvana's first Emmy award; another highlight for the company was working with Tim Burton, who directed Beetlejuice the movie; *Tales from the Cryptkeeper* was based on EC comics from the 1950s and the eighties HBO series *Tales from the Crypt*—its executive producers included Dick Donner, Joel Silver, Robert Zemeckis, Walter Hill, and David Giler.

(top) Licensed by Warner Bros. Discovery. All rights reserved. (bottom) ©Nelvana Limited. All rights reserved.

Toper Taylor tried to option a book by author Bill Joyce but all Bill had available was a poem on his studio wall, which led to *Rolie Polie Olie*, Nelvana's first CGI hit and another Emmy winner; Hirsh liked *Franklin*, based on Paulette Bourgeois and Brenda Clark's beloved books, so much that he bought the publisher Kids Can Press to consolidate Nelvana's interest in the character.

©Nelvana Limited. All rights reserved. (bottom) With permission of Nelvana and Kids Can Press ©P. Bourgeois & B. Clark. All rights reserved.

(Top) Hirsh (left) and Taylor (second right) at a London brand show with Anne (centre) and Ian Miles (second left), our partners in *Rupert*; (below) Hirsh and Taylor with the Bernstain Bears, characters in a production that was part of the Bookworm Bunch on PBS.

Images courtesy of the Media Commons Archives, University of Toronto Libraries.

*Braceface*, featuring the voice of Alicia Silverstone (also an executive producer), dealt with a young teen who discovers special powers in her braces; *Maggie and the Ferocious Beast*, produced by Nelvana, was a Nickelodeon hit created by Mickey and Betty Paraskevas.

(top) ©Nelvana Limited. All rights reserved. (bottom) ©Nelvana Limited. All rights reserved.

*W.I.L.D.C.A.T.S*, which ran on CBS, was based on an Image comic book, which in turn was based on Jim Lee's opus; *Pelswick*, the first animated series featuring a kid in a wheelchair, was based on an original idea by the great cartoonist John Callahan, himself a quadriplegic.

(top) ©Nelvana Limited. All rights reserved. (bottom) ©Nelvana Limited. All rights reserved.

Alamy.

Alamy.

Alamy.

After producing *Beetlejuice*, Nelvana developed an animated movie with Tim Burton (top), who also brought the company in to doctor *Family Dog*, a series he had executive produced with Steven Spielberg and Brad Bird; (centre) looking for a series after *The A-Team* was cancelled, Mr. T signed on to Hirsh's idea for *T & T*; (bottom) Roseanne Barr picked Nelvana to produce her animated series *Little Rosey* for ABC Network.

(Clockwise from top) Toper Taylor with Vince Commisso, a protégé and the founder of Nine Story Entertainment; (from left) Clifford Ross, Hirsh, and Laurent de Brunhoff celebrate Nelvana's success with *Babar*; John Vandervelde, senior financial executive at Nelvana and Cookie Jar, and CFO of Wow! Unlimited Media; Peter Dewdney, Hirsh's college buddy and Laff Arts partner.

Images courtesy of the Media Commons Archives, University of Toronto Libraries.

*Gerald McBoing Boing*, based on the Academy Award-winning short film and featuring a character who spoke in sounds and noises but no words, was one of Cookie Jar's first shows; *Johnny Test*, was Cookie Jar's first hit, playing as often as eight times a day on Cartoon Network and Teletoon.

(top) Courtesy of WildBrain. All rights reserved. (bottom) Courtesy of Wildbrain. All rights reserved.

Hirsh with Rooney, Dee Dee, and Moe Doodle of *The Doodle Bops*, another big hit for Cookie Jar; (bottom) at his desk at Nelvana, surrounded by the Care Bears, Babar, and other friends.

Images courtesy of the Media Commons Archives, University of Toronto Libraries.

Arthur and friends watching the first episode of *Postcards from Buster* for PBS; (bottom) *Caillou* was another hit Cookie Jar property.

(top) Courtesy of WildBrain. All rights reserved. (bottom) Courtesy of WildBrain. All rights reserved.

(Top) *Bravest Warriors* was a Frederator hit at Wow! Unlimited Media (a season was co-produced with Nelvana); *Bee and Puppycat* was a Frederator hit for Netflix.

(top) Courtesy of Frederator. All rights reserved. (bottom) Courtesy of Frederator. All rights reserved.

*Castlevania* was a co-production led by Frederator's head of production, Kevin Kolde, based on the Konami video game; *Ukulele U*, produced by Bob Ezrin, featured Melanie Doane, a ukulele guru.

(top) Courtesy of Frederator. All rights reserved. (bottom) Courtesy of Mainframe. All rights reserved.

A cartoon from a Nelvana artist presented to Elaine and Michael Hirsh at his first (but not last) retirement party.

Image courtesy of the Media Commons Archives, University of Toronto Libraries.

of the highest license fees that we had ever heard of for the Spanish territory. Neil then proposed that he should move to Europe to start a Nelvana office overseas, eventually establishing himself in the UK.

At this time, I was seeing a Chinese acupuncturist, who Elaine introduced me to. After he took my readings, he looked me straight in the eye and told me to go see my family doctor on an urgent basis. He said the last person exhibiting these readings had dropped dead of a stroke while crossing a nearby street. I heeded his ominous warning and was soon diagnosed with atrial fibrillation, an irregular heartbeat, which meant my heart wasn't processing my blood well, leaving me at high risk for clots and strokes. I was forty and my father had developed the same condition around the same age.

My cardiologist wanted me to do regular cardio exercises, so I started on a program to learn to jog, run, and sprint. Elaine found Joe Ross, a sprinter, who would drop by my house and work out with me several times a week. The program evolved with the help of Cheryl Thibedeau, another sprinter introduced to me by Joe. Cheryl had trained under Charlie Francis, Ben Johnson's trainer, who had been taken down by Ben's positive test for steroid use after winning a gold medal at the Seoul Olympics. I worked with Joe and Cheryl for many decades and even when our sessions were canceled during the early days of the COVID pandemic, I managed to maintain a consistent workout regime alone.

I found that with all the business traveling I was doing for Nelvana, maintaining my exercise program helped me adjust to different time zones and kept me mentally alert and physically fit. Whether running on the Croissette in Cannes along the Mediterranean, or in Green Park in London, or in Paris, or up the Hollywood Hills in LA or Central Park in New York City, working

out gives an hour of mental relaxation and physical stimulation. Later when I developed diabetes, the exercise helped me manage the disease better than I otherwise might have. I had come a long way since I was a kid doing everything I could to avoid exercise, whether in gym class or afterschool activities.

With things going better for Nelvana from a business point of view, Elaine and I decided to have a baby and she wanted a new home for us. Elaine had always liked Wychwood Park, which features sixty-plus homes in the middle of a large park inspired by Utopian concepts imported from the Oxford region of England and inspired by the Arts and Crafts movement headed by British artist, writer and publisher William Morris. Marmaduke Matthews, the artist who designed the community in 1876, intended it as an artists' enclave and over the century and a quarter many artists have lived in the park including George Reid and his two wives, Mary Hestor Reid and Mary Wrinch; Marmaduke Matthews; sculptor York Wilson; composer Phil Balsam, painter Mary Anne Bailey, and writer Marc Giacomelli and most recently the artist T. M. Glass (my wife Elaine's psuedonym).

When we first walked through the neighbourhood, it struck us as a magical oasis with beautiful homes, pond, ravine, tennis court, and 400-year-old oak trees, and it was all ten minutes from the center of town. When she was pregnant with our son, Jonathan, Elaine called me while I was in Los Angeles to tell me that a Wychwood Park house had come up there and she wanted to bid on it. We agreed we could afford it, but the night the listing came out, there were multiple offers. Elaine ended up bidding ten percent more than the offer price. We won, although once again we were house poor. We were living in paradise, however, and Jonathan was born and raised in Wychwood Park.

## THE ELEPHANT ON THE MEZZANINE LEVEL

When we moved into the house, the garden had all turned to weed and the grass was overrun, so Elaine not only supervised the renovation of the house, she designed the garden studying traditional English arts and crafts. Inspired by the writings of William Robinson and Gertrude Jekel, she made one of the best gardens in the city of Toronto. This has been attested to by the Toronto Botanical Gardens, who have often included us in their garden tours.

A few years later, a second Wychwood Park house became available, built by Eden Smith, Canada's leading Arts and Crafts architects.

We learned a lot about lifestyle and keeping a home from Anne and Ian Miles, who distributed our shows in the UK through their company, Abbey Road. They had worked in the music business and really enjoyed it, but they pivoted to video and became the UK's leaders in children's TV and video. They had a country home at Marston Meysey. Elaine and I visited them and their daughter, Francesca, on quite a few occasions. It was a historic property, dating back to the Domesday book of 1086. Many of the buildings on the property have thatched roofs. Anne and Ian kept miniature animals—goats, horses, and other creatures and our son, Jonathan, loved visiting. They took me into the fields to shoot clay pigeons. It was my first time shooting a rifle and I didn't take instruction carefully enough. The recoil of the rifle left my side sore and black-and-blue for days.

Anne and Ian were gracious hosts and loved entertaining. They decorated their home in a warm and inviting way that made it feel comfortable even though it was the town manor house. Elaine used the same principles in decorating our home in Wychwood Park. When people entered the house, they would always comment on how comfortable they felt.

We've had incredible house concerts in our music room, some of which were curated by our then-neighbor, Tony Rappaport. One highlight was a performance by Aradia, a local Baroque chamber group that performed Bach's "Coffee Cantata". It featured a Baroque dance group in period costumes. The Coffee Cantata is a lot of fun—it showed how the generation gap existed in the 1700s, when coffee was first introduced into Europe and parents thought of it as a gateway drug that led to loose moral activity.

We've lived in Wychwood Park for three and a half decades. It has been a treat. We have the sort of neighbours you'd expect would be attracted to a Utopian English village. One of my intellectual heroes, Marshall McLuhan, had lived with his family in Wychwood Park for many years. His widow was still there during our time and Elaine and I became friendly with her. She confided to Elaine that Marshall's spirit would speak to her from the top of the stairs every day and she offered to ask him any questions we had. But I could never get comfortable with the idea of posing questions to the spirit of the great man.

While working together with Canal Plus, we decided to partner with a French animation company, Le Studio Ellipse Anime, which did the French production of *Babar* and our other coproductions. Canal Plus, seeing the success we had with *Babar*, worked at licensing another hit Francophone property, *Tintin*. They asked us to coproduce a *TinTin* show with them. This was a great opportunity to build on the networks we had established with *Babar*. *Tintin* was a worldwide hit comic book property created by Herge in Brussels, my home town.

HBO came into *Tintin* enthusiastically. Canada's Family Channel was our Canadian partner. Broadcasters all over the world jumped on the band wagon. However, there was an early issue in

# THE ELEPHANT ON THE MEZZANINE LEVEL

the rights deal with Le Fondation Moulinsart, Herge's estate, run by his widow Fanny Remi. Together with Ellipse, we had produced a sizzle reel which later became the opening title sequence. Everyone loved it, but the new management for Le Fondation didn't want to sign off and finalize the rights deal. I flew over to Paris and met with Stephan and Pierre from Ellipse and then took a train with them to Bruxelles to meet with Nick Rodwell, manager of the *TinTin* empire. Fortunately, we were able to resolve the differences and walk away with the project greenlit. We adapted all of the *Tintin* books that we could and had another successful classic series.

After our successes with *Babar* and *TinTin*, I looked for another classic property we could revitalize. Anne and Ian Miles suggested Rupert Bear, created by cartoonist Mary Tourtel. Rupert had enjoyed a long life as a character, starting after World War I with his own comic strips in the *Daily Express* newspaper. Paul McCartney had produced an award-winning short called *Rupert and the Frog Song* and had been developing a feature film for some time. His option ran out, however, and McCartney upset the *Express* with his demand for a free renewal. I made John Pay at the *Express* a formal proposal to option Rupert for a series and movies and when McCartney still wouldn't pay to renew his option, the *Express* went ahead with us. I organized a co-production with Ellipse and we pre-sold it to the YTV channel in Canada and ITV in the UK. Francesca Miles led the UK licensing program and organized a fantastic range of product from Plush to tuxedo shirts and from toys to silver pins.

The show premiered in 1991. The night after the first episode ran in the UK, I received a call from a reporter in London who had gotten a complaint about it. We screened the show and couldn't spot anything that would give offense. Finally, the reporter called the complainant, a grandfather in the Midlands, who told us to

freeze frame one scene early in the episode when Rupert walks by a bookstore. If you turned your head sideways, you could read the titles on the spines of the books for a couple of film frames and there were naughty titles such as *S&M in the Middle Ages*, *Maidens in Uniform*, and *Bondage in Medieval Times*.

I told the reporter that we were recalling and reshooting the episode and that the offensive shot would never be shown again, but the story ran on the front page of all UK newspapers with the exception of the *Express*, where it was buried at the back of the book. UK newspaper publishers are all very competitive and relished the embarrassment of the *Express* and its long-running comic strip hero. The story took a month to fade away. In the meantime, there was consternation at Nelvana as we searched for the culprit. It turned out he was one of our best layout artists. He was from England and had got a call from his fundamentalist Christian parents who asked him how he could work for a company like Nelvana that would do such a thing to England's beloved bear!

*Rupert* was a good show in our library, with animation up to our usual standard and beautiful backgrounds that preserved the look of the color Rupert Annuals. Abbey's licensing program in the UK was fantastic, but the property didn't hit as big or as globally as *Babar*. I learned that not every property has it in its DNA to break out and succeed beyond expectation.

Roseanne Barr and Tom Arnold came into our lives at Nelvana courtesy of the William Morris agency who represented both of us. Roseanne had sold ABC Networks on a show based on her and Tom as children. Though they met as adults that was the conceit of Little Rosie, the Saturday Morning show we were hired to produce. At this point in time, Roseanne was the biggest comic star in America with a global following. She was a major star. But she had a big

reputation for being difficult on producers and writers. So we took the show on with trepidation. Stan Blum who was running our LA office at the time thought we could sell a lot of merchandise based on her character and he delivered millions of dollars of advances and minimum guarantees. Working with Roseanne, despite our fears, was among the best experiences we enjoyed with a celebrity. She got along well with our crew and was fun to be around.

While working with Tom and Roseanne was a positive creative experience, we had a few testy moments along the way. One of those moments when our key creative team accompanied by Stan and I took them to dinner at a local Italian restaurant of their choice. After sitting quietly for a few moments they began what started as a fun steak knife fight at the table. The other guests in the restaurant stopped eating to watch their duelling. While no one drew blood, all of us at the table were quite concerned.

When we launched the series at Mipcom in Cannes, Tom and Roseanne were honeymooning in nearby Nice. They kindly agreed to take a few hours and come to Cannes, a forty-five-minute drive and hold a press conference to introduce the series to the global marketplace. I met them in Nice in a car provided by the Mipcom conference and was assured the driver knew how to get us to the room for the press conference. The car that was sent was a little bit on the small size considering both Tom and Roseanne were big people, but they tolerated that. Then when we got to the conference no one with us knew how to get the room for the press. So we tried a few doors unsuccessfully. Roseanne told me that if the next room we tried was another miss she wanted to leave immediately. I was facing several doors to open and randomly picked one which fortunately turned out to be the one. All's well that ended well. They gave good interviews and we got the press and sales we were hoping for.

Then Roseanne hit the wall after opening a Dodgers baseball game by throwing out the first pitch and singing the US national anthem. The Dodgers were owned by her series producer Tom Werner. Now Roseanne, while a fantastic comedienne, was not known for her singing. She did her best, but it was off-key and the stadium audience misinterpreted her performance as un-patriotic and booed her, which was very unfair. When she threw the opening pitch, she imitated a pitcher spitting on the ground and threw the pitch wildly, and they booed louder. The crowd did not get that she was being funny. Reporters reported her performance as disgraceful. And to top it all off George H. Bush, the president of the US, who earlier that week had decided to invade Iraq to drive them out of Kuwait, denounced her performance as unpatriotic from his seat in Air Force One. The next day our licensees for apparel and toys received cancellations of their orders for Little Rosie merchandise and they tossed the product on its way to the US into the Pacific Ocean. Thus ended our dreams of a merchandising hit.

The resulting fiasco meant that the network no longer wanted the second season it had ordered. But Roseanne and Tom wanted something from the network in exchange. They asked for two prime-time specials. We all met with Bob Iger, then head of the ABC network, a division of the Walt Disney Company. Bob was smooth at handling Tom and Roseanne and making them feel good about the resulting exchange. Roseanne was not easy to manage. I was impressed with his managerial skills and not surprised when he eventually became the CEO of the Walt Disney Company.

One of my favorite shows was *The Magic School Bus*, based on bestselling educational entertainment books by Scholastic. At that time, it was very hard to place educational shows on the air outside the US. European broadcasters told us they doubted that their kids

## THE ELEPHANT ON THE MEZZANINE LEVEL

had anything to learn from American producers and that their audiences wanted pure entertainment, not education. We went ahead and invested in the show ourselves to help Scholastic to greenlight it. Once we had finished episodes to show them, the major European broadcasters caved and bought the show. While it was designed with Fourth Grade science curriculum, it was mostly viewed, over and over again, by preschoolers who could recite the science lessons perfectly. It was a great experience making the show and making science fun to kids of all ages.

I liked producing shows that reminded me of my early interest in math and science. Another was Cyberchase, a series developed by WNET, the PBS station in New York City. It taught kids about mathematics and there was a great comic relief character, a parrot voiced by Gilbert Gottfried.

Some properties didn't make it due to bad luck. We had acquired the rights to two classic Simon and Schuster young-adult mystery book series I had loved as a kid, *The Hardy Boys* and *Nancy Drew*. We sold the USA cable network on a show called *Nancy Drew and Daughter,* with the Canadian actress Margot Kidder (who played Superman's girl friend Lois Lane in the first *Superman movie*) as a grown-up Nancy Drew. Margot had issues during shooting which came from her abuse of prescription drugs and led to a famous car accident on the set. It was covered in the tabloids and so was Margot's eventual lawsuit against us. Fortunately, we had footage of the accident from all sides, including footage from a camera operator sitting in the car's back seat, which made it clear that Margot stepped on the brakes for no reason while driving on a deserted road at fifteen-kilometres-per-hour.

Margot, in a wheelchair, let us know that if we wanted her to go back to work, we would need to promote her boyfriend to

the position of producer. After we passed, she asked to take her wardrobe, which was in a large trailer. She was wheeled to the trailer and then with great alacrity jumped out of the wheelchair and chose the clothes she wanted to take. We filmed this whole scene and it was part of the evidence that resulted in her case being thrown out in the early stages. We couldn't recast the part to USA Network's satisfaction, so the show was abandoned. We subsequently co-produced a *Hardy Boys* and *Nancy Drew* series, but it only lasted one season. It frustrated me that these beloved properties were so hard to sell.

We also had the rights to *Jake and the Kid*, the series of radio plays and short stories by W.O. Mitchell, a great Canadian writer who died in 1998. We produced the show, about the friendship between a boy and the hired hand on his mother's farm, in live action for Global TV. But a show about growing up in the great Canadian west did not catch on anywhere in the US and had low viewership as a result.

Some shows were hits, others not, but we ate well regardless. It's a fact of the entertainment business that food is important and that clients expect to be entertained at excellent restaurants. The more successful you get, the better the restaurants.

My first experience of the big leagues was at Le Cagnard, a restaurant forty minutes from Cannes in Hautes de Cagnes above Cagnes Sur Mer. It is an ancient medieval town, dating from the eleventh century and featuring narrow cobblestone streets and fortress walls. The restaurant and hotel, Chateau le Cagnard, are built into the walls of the city. I first went there as a guest of Viacom when its executives were in Cannes at MIP selling *A Cosmic Christmas* and *The Devil and Daniel Mouse*. Ron Hastings, a friend and Viacom sales representative for Canada, invited me along.

# THE ELEPHANT ON THE MEZZANINE LEVEL

We drove in a bus full of MIP attendees on the autoroute then a short distance along the Mediterranean Sea to the small parking lot outside the town. We walked up to the restaurant. One of the fun features of le Cagnard is a roof that retracts and opens so that after dinner guests can smoke cigars without disturbing other diners. Over the years, I would return with Elaine, clients, and friends to enjoy meals in this wonderful ambience. They make a wonderful breakfast of scrambled eggs with black truffles which Elaine made for me back home, having bought black truffles in the Cannes market before flying home to Toronto.

My mentor, Don Haig, still at the National Film Board, started to attend the Cannes TV and film festivals and brought along his partner, Bill. Bill and Elaine took a cooking class together at Moulin de Mougins, which had three Michelin stars and was recognized as the top restaurant on the Cote D'Azure, fifteen minutes outside of Cannes in the picturesque mountain village of Mougins. The restaurant is among the best I have frequented for decades under the leadership of legendary chef Roger Vergé. To this day, Elaine cooks recipes from Vergé's books. He was one of France's great chefs, reinventing French cuisine in the 1960s along with Michel Gerard and other young rebels. The cooking school would let student chefs invite guests to lunches that they had helped to prepare. Elaine invited Neil Court and I up, and we would drag along clients whenever we could. Shep Gordon, the agent for Alice Cooper and Blondie, represented Vergé and created the label "Celebrity Chefs." Interestingly, recipes are one of the few creative works that are not protected by copyright, so when you cook a chef's favorite dish, it doesn't generate any royalty income stream for them. The invention of the "Celebrity Chefs" concept helped create an ancillary market for some of the great chefs of the world.

## CHAPTER 16

# WEATHERING THE STORM

*Lessons from my father and others help
me to face down adversity*

I NEEDED A NEW head of our LA office to replace Kevin McCormick, who had decided to leave us to go back to his career producing feature films. Jennie Treas at ABC Kids recommended Harriet Beck, who had previously worked for the animation company Ruby-Spears. Harriet flew to Toronto for an interview with me. During our interview, I got a call that Elaine who was pregnant was having contractions. I told Harriet I had to leave and she started crying, saying she had flown all this way to meet me and she really wanted and needed the job. I called Elaine back and asked if we could invite Harriet over for dinner. This was a terrible thing to do to Elaine. I don't know what I could have been thinking. Obviously, I was not thinking. But we did have Harriet over and Elaine cooked us dinner while listening to the job interview. When Elaine's contractions got worse Harriet offered to

give her a back massage. Elaine quietly asked me to call a taxi for Harriet and and afterward I drove her to the hospital where she gave birth to our son, Jonathan. And I hired Harriet.

With hindsight, hiring Harriet was a mistake, just like bringing her home, but I was desperate. The LA part of our business was critical. We generated our best sales there, and living in Toronto with a newborn son, I did not want to be flying out to California every week. I needed an accomplished executive who could handle the meetings and get shows sold. But as I learned more about Harriet's practices, I became more and more doubtful about my decision to hire her. She would sneak into our buyer's offices and leaf through their pile of scripts, seeking to learn what the network was developing. This gave us competitive information, but I worried about the damage that would be done to our reputation if she were caught. Harriet worked for me for about two years before she quit in the middle of a contract renewal negotiation and sued us for constructive dismissal, costing us a huge amount of time and money. All in all, she was among the most disappointing employees I ever had.

That lawsuit taught me a lot about litigation. After four years, we found ourselves in court in downtown LA with a jury. Elaine had been asked to be a witness to the original interview which she had heard while serving us dinner in between contractions. The judge asked Elaine why she had such a detailed memory of the interview and when Elaine explained why the occasion was so memorable the judge raised an eyebrow as if he did not believe the story to be plausible. We were fortunate that there was at least one juror who could read contracts—he was an auditor for the US post office. The jurors finally gave us the victory but thanks to one holdout, they awarded Harriet some limited damages. The

holdout believed we did not treat Harriet fairly. We talked to our lawyers about appealing the award, but they talked us out of it. The cost of the appeal was greater than the financial award. We walked away, having skirted greater disaster and realizing that winning can be more expensive than settling. That is why so much litigation in the US results in settlement.

Neil Court claimed that another person who was having a negative effect on the Nelvana business was our general counsel, Eleanor Olmstead. When I talked to Patrick about this, he was her biggest defender and wouldn't hear of letting her go. Neil decided to leave the company. He gave up stock options that could have made him a lot of money a few years later, but he could not stand working with Eleanor and felt she would be the ruin of the company. Neil went on to great success on his own, consulting for the Jim Henson Company and starting a company called Decode which, after several mergers, was part of DHX when I became executive chairman. Neil was long gone by then, however. He could not work well with Michael Donovan, the CEO, who felt the same way about Neil.

What should have been one of our big breaks at the US networks happened when Paul Levitz and Jenette Kahn at DC Comics gave us the rights to make a cartoon based on Batman. We were out pitching the series without great success when Warner Bros. announced that after years of different filmmakers trying to adapt the property, they were finally making a Batman movie to be directed by Tim Burton, with Michael Keaton playing the lead role and Jack Nicholson playing the Joker. I thought that would make our rights a sure thing, but the Saturday morning buyers still didn't believe in the property. We struck out. In the process, however, we got a development deal with ABC, which had bought a series

based on another Tim Burton/Warner Bros. movie, *Beetlejuice*. ABC needed an animation company to produce it. The decision as to which company got the series would be made by Burton and Dan Romanelli, the head of licensing and merchandising for Warner Bros. Dan was open to doing it with us, but he was also considering DIC, our *Inspector Gadget* partner and rival.

Our meeting with Tim Burton was in Dan's office in the merchandising building. Tim came into the room and instead of sitting down in an ordinary way, he immediately perched on a chair as if he were a bird. He spoke about what he was hoping for from the animation. Tim had gone to Cal Arts, the top animation school for character animation in the US—indeed, in the world. He had started his career as an animator and made his name with a short stop-motion film he directed at Disney called *Frankenweenie*. As evidenced by his movies, Tim leaned towards the artistic side of filmmaking. I identified with him as a studio executive with the mind and heart of an indie filmmaker. I told him about my humble beginnings making films in high school and showing my early works at the Filmmakers Cinematheque in NYC.

One of our lead animators, Robin Budd did some early designs for the show and we sent them to Tim, who immediately favored them. I then flew with Robin, Stan, and our story editors, Ted and Patsy Annesty, to London, where Tim was working on *Batman*. All of that was a big investment on our part, but we loved *Beetlejuice* and I believed the series could be a breakthrough for us—a comedic show that would help break us into the funny animation business. (Yes, we had *Inspector Gadget*, but DIC got the credit for that.)

When we arrived at Tim's apartment in Knightsbridge, I sat on the floor, which connected with Tim. It seems like a small detail in the re-telling, but I know it appealed to him more than me standing

or sitting on a chair. It let him know that while I was an executive, I was an executive of an indie company. Tim liked us for all the right reasons. He loved how much of the work we did in our own studio in Toronto, which gave us more artistic control of the look of his show. He also really liked the development that Ted and Patsy had done, especially the idea of having Beetlejuice metamorphose into objects that would be identifiable by his black and white stripe costuming. Tim also liked that we were going to produce some sequences for each episode using computer animation, still in its early experimental days, to give a multimedia look to the show.

There remained one hurdle. Warner's Dan Romanelli wouldn't give us *Beetlejuice* unless we relinquished our rights to Batman, which was scheduled to return to DC Comics in a month. Before doing so, I called all of the network heads telling them that this was the last opportunity to buy Batman before we lost our rights. Again, no one saw this movie becoming a blockbuster hit, so they all passed, including Jamie Kellner, then head of the Fox Network and a long-time friend and supporter. We gave the rights back to Warners and made the deal to produce *Beetlejuice*, which became a critical success and won us our first Emmy.

What I most enjoyed about working with Tim was his artistic eccentricity and his encouragement to experiment and make the show as unique as possible. His support with the network helped us get permission to push the boundaries of an ordinary Saturday Morning cartoon. The show succeeded with both the funny and the supernatural elements and Beetlejuice's constant morphing prefigured what Disney would later do with the genie in its *Aladdin* movie.

We eventually produced sixty-five half-hours of *Beetlejuice* for ABC Saturday morning and later WB syndication. It led to us

doing other comedy shows. *Eek the Cat* was a comedy that Fox Network had developed with Savage Steve Holland and Bill Kopp. It was about a loveable, reluctant hero with a great philosophy of "it never hurts to help." Together with *Inspector Gadget* and *Beetlejuice*, *Eek the Cat* is in the pantheon of great comedies that we produced at Nelvana.

Another show that established our chops in comedy was *Ned's Newt*, based on an original idea by Andy Knight and starring the voice of comedian Harland Williams as the manic talking newt from another world. It played on Fox Kids and was a multi-season hit.

Yet another comedy show we developed in the 1990s was *Blazing Dragons*, created by Terry Jones of Monty Python, set in a medieval world where knights and dragons have traded places. Toper and I had dinner with Terry in London at the St. James Club, where we discussed his children's books and what else we could adapt. We had a lot of laughs and the show was funny, but it didn't break out and only went two seasons.

We later went on to develop a movie with Tim Burton based on drawings from his notebooks, which Robin Budd developed into a great look for the movie. The project was part of a series of films we developed with Frank Marshall and Kathleen Kennedy, who at the time had an overall deal with Paramount which funded their development costs. When Kennedy and Marshall exited their deal with the studio, all the movies we had developed with them, including *Puff the Magic Dragon*, *The Trumpet of the Swan* and *The Thief of Always*, and this film, died.

Years later, when Tim ran into trouble on *Family Dog*, a series he was producing with Steven Spielberg based on a cartoon by Brad Bird, he recommended us as the company to come in and doctor

the show to make it airable on the CBS network. The show was a co-production between Warners and Universal and they had gone with a talented, young first-time director who approved all the first drafts the showrunner had submitted, resulting in many script and story issues. The title character didn't speak and they didn't have a feature-film budget to bring a silent character to life. As it turned out, there was only sufficient budget to fix about four episodes, and the show was cancelled shortly after airing them. I talked to a few executives about buying the show from Warners and Universal so we could revive it at Nelvana, but there wasn't much prospect of doing so. It is difficult to get one studio to sell a property; convincing two studios is all but impossible. And when Spielberg and Burton are involved, definitely impossible. I always felt we could have made a great series based on *Family Dog*.

We had long ago abandoned the original Nelvana as our logo and replaced her with a polar bear. The bear was the subject of one of the strangest phone calls I've ever received. John Cooke, then head of the Disney Channel and a senior corporate executive from Disney, wanted us to give him the rights to our polar bear logo for free. It turned out that Disney was launching Hollywood pictures, a new studio that would focus on an adult audience and it had designed a logo with a polar bear that looked a lot like ours. When John told me he didn't want to pay, I explained to him that we were a comparatively small company and it would cost us hundreds of thousands of dollars to replace and re-animate our own logo on stationary, films, and TV shows, among other signage. But there was no moving John. When I asked him if they would give us a production commitment for a new series, he said that there would be no contractual commitment but we would

be looked upon favorably if we gave them our logo. If we didn't co-operate, Disney wouldn't buy another show from us.

We didn't give them the logo and Disney didn't buy anything from us until the executive suite changed over and John was replaced by Nickleoldeon's Geraldine Leybourne. I have never understood how those who have so much can take pleasure in trying to push around the little guys who depend on them. What was Disney trying to prove?

We kept the polar bear but the late 1980s brought another big change to Nelvana: we left our agents at the Triad Agency and went to the William Morris Agency. Our old ally Jamie Kellner had convinced Bob Crestani, the head of television at William Morris, to sign us as clients. I had to overcome my memories of our bad experiences with his agency in the late seventies. Even though the *Star Wars Holiday Special* was being packaged by a William Morris agent, our own agent at the firm never thought to recommend us and we got the assignment with no help from him.

Fortunately, our new agent, a young man named Toper Taylor, was the most aggressive agent I had ever worked with. He was relentless in looking for opportunities for Nelvana. He loved children's books and kept promoting properties and opportunities to me. He also loved comedians and was always looking for a way for us to work with them.

When I needed to find another new head of our L.A. office, I asked Toper if he could recommend someone and he told me he was interested. It turned out Toper was an even tougher negotiator when making his own deal. He wanted a senior executive title and a piece of the company. He was only twenty-four at the time. It was a hard sell to Patrick who couldn't fathom how this young agent was worth this kind of money, but somehow we all

got on the same page and made the deal to bring Toper into the company.

Toper made some incredible deals for us. I was on a flight to LA where Micheline Charest, who ran our competitor, Cinar, told me she was bidding on *Fievel's American Tails*, a CBS animated series based on Steven Spielberg's animated film about an Eastern European Jewish mouse who immigrates to America. I mentioned this to Toper and he worked his magic and we won the bid. Micheline's mistake shows why I have always preferred being tight-lipped about discussing pending business. Unfortunately, despite the show's great theatrical movie pedigree, it didn't rate well enough to get renewed.

Life in show business is never boring, but after Toper came on, it made the old days seem dull by comparison. Toper was a whirling dervish, pushing all sorts of projects our way and inventively working to build the business. His dynamism started to chafe on Patrick, who felt we were chasing too many opportunities and that we would do better focusing on fewer projects. I supported Toper because I believed in the "at bats" theory of television and movies: the more frequently we stepped up to the plate, the more often we'd hit home runs. Toper, like me, was determined to build the company into the dominant independent animation company, which we did by the late nineties.

One step I felt we needed to take on our path to dominance was an IPO, or initial public offering. Toper, of course, was in favor of us evolving from a private to a public company with our shares available on stock exchanges. Not only would it trigger the grant of shares that we had agreed to in his contract, he felt it would break down the control that Patrick was able to exert over our decision making. Patrick and Clive were uncertain whether they wanted

to be part of a public company, not only because their decision-making power would decrease but because we would have to grow aggressively at 20 percent a year. But our competitors had gone public one by one, first Paragon, then Alliance, Atlantis, and Cinar. Public companies could outbid us for talent and properties. I was able to convince Patrick and Clive that our leadership in animation would be threatened if all our rivals were public and we remained a capital-constrained private company.

One of those rivals, Cinar, made news in 1993 while it was in the process of going public. The artist Claude Robinson claimed in a lawsuit that Cinar's show, *Robinson Sucroe*, was based on an adaptation of Robinson Crusoe that he had developed years earlier. He had hired Cinar to help him make pre-sales and paid the company to take him to Cannes so he could pitch his show at the MIP market. When he saw Cinar's show on television, he tried calling the company but no one would take his calls. Executives claimed not to know him. This made Claude very angry. He approached the RCMP, who hold jurisdiction over copyright theft in Canada. They raided the Cinar offices, a move that made the front pages of the national newspapers of Canada—right in the middle of Cinar's IPO.

As it turned out, the RCMP did not file criminal charges against the company. Claude found a law firm in Quebec to file a claim against Cinar on a contingency basis. This suit resulted in the exposure and publicizing of Cinar's many sins. Claude and his lawyers were masters at leaking scandals uncovered during the lawsuit's discovery process and the Quebecois press made a feast of them. The suit dragged on for seven years, with ugly revelation following ugly revelation, all making headlines and eventually leading to the company's unravelling.

As a result of our decision to take Nelvana public, we needed to appoint a chief financial officer. Our first choice was not interested so we promoted Sheila Murray Tateishi, who had previously been CFO of the Republic Bank. Eleanor Olmstead added the position of chief operating officer to her duties as general counsel.

I would come to regret the decision to expand Eleanor's role and it would take three long years to remove her as chief operating officer. There were several major problems, starting with Eleanor's bullying and insulting behavior. Eleanor led the prospectus writing stage for our IPO and made it far more difficult than it needed to be. I heard from our lawyers that they had never experienced anything like it before. And when we invited potential underwriters to come to our offices to hear a presentation on the Nelvana story, Eleanor froze with stage fright. I had to jump in. From that point, she did not address large groups of people.

It didn't help that Patrick and I had agreed to be co-chief executives. It reflected how we had been running the company informally: I was Mr. Outside, going across the country to pitch investors on the Nelvana story and worldwide to manage the sales efforts, while Patrick was Mr. Inside, overseeing operations. Again, I did not foresee the problems that would result. Running the company as co-CEOs had worked while Patrick was fully engaged and involved, but he was suffering from what would later be diagnosed as Lyme disease and starting to burn out. As he became more withdrawn, he started to passively-aggressively use Eleanor to argue over things he would not confront me on directly.

Royal Bank's George Dembroski and his young protégé, Bruce Rothney, led the syndicate to start the IPO process. I went on a road trip with Bruce across the country, introducing the Nelvana story. As part of the process, we had a secondary offering for

management to sell some of our shares and get immediate cash. The cash one earns from an IPO is often referred to as "IPO Dust," because it goes quickly.

Elaine and I went to visit her old friend Ira Gluskin, who ran Gluskin Scheff, one of the most successful investment firms on Bay Street. We were planning to invest our IPO dust with his firm, where they had been enjoying spectacular annual gains. Ira advised us to buy something that would give us pleasure and focus on making more money later. We used the money to buy our second Wychwood Park home. Ira was right in advising us to focus on quality of life.

Nine years after moving into Wychwood Park, a few of our neighbors came around encouraging us to buy a large house that had been up for sale for three years. They were afraid it would be bought and torn down by developers as had happened to other old houses in the neighbourhood. Elaine and I went to see it and found a Halloween house, empty except for cats and dogs and the occasional human who visited for maintenance purposes. Elaine is an asthmatic and allergic to cats and dogs. We had to rush through, but we were both impressed with the architecture and the fantastic entertainment space the place could provide. It had been designed by Eden Smith, the pre-eminent Arts-and-Crafts architect in Toronto. We went from being dubious to buying it and we have lived there for twenty-eight years, a special house that has enriched our lives.

One memorable visit to the house involved singer/songwriter Peter Yarrow, who became a friend after Nelvana optioned the rights to make an animated feature film based on "Puff the Magic Dragon," the song Peter co-wrote and performed with his trio Peter, Paul and Mary. Peter was always working on socially

sensitive issues and I was able to help him with something related to his Operation Respect/Don't Laugh at Me project, which provided schools with a curriculum against bullying. Peter needed many duplicate copies of a video he made for his project and I collaborated with Cyril Drabinsky of Deluxe Laboratories to donate them to the organization Peter had co-founded. When Peter was visiting our home, we got a phone call from our rabbi and friend, Eli Rubenstein, who wanted to drop by with seven young students who were refugees and survivors of the Rwanda genocide. They had just come back from Auschwitz and the March of Remembrance. While we were all chatting, Peter immediately grabbed his guitar and taught us all to sing "Where Have all the Flowers Gone". It was very moving for Eli and our visitors and everyone joined in the singing—an unforgettable evening.

Now that we were public and needed to show steady growth, it was critical to become a partner in a cable channel. Teletoon was licensed in 1997 as Canada's only all-animation network. We thought about competing for our own license but decided instead to form the consortium, with a 20 percent share. The rest of the consortium included Cinar, Family Channel, and YTV. It turned out to be a great deal. TD Bank loaned Teletoon the funding it needed to start up and the cashflow was managed conservatively. We never had to put a dollar of equity into running the service. Teletoon was a high-margin, low-overhead network that kicked up a lot of cash. Within five years, our share of Teletoon would represent about fifty million dollars of the eventual Nelvana sale price.

## CHAPTER 17

# GROWING PAINS

*Nelvana gets bigger and more complicated
and we think about selling the company*

Going public meant we were finally able to buy our executives computers. We started to discover email and began to look into the idea of computerizing production. Software for 2D animation was developing slowly but steadily, and it eventually allowed us to bring the work we were outsourcing to Asia back to Canada while keeping our production schedules and budgets in line with industry norms.

One of our first productions with Adobe Flash animation was *Jacob Two-Two*, based on the bestselling kids' book series by Canadian author Mordecai Richler. Michael Levine, a friend and agent for the Richler estate, came to us with the project and we made the show for YTV, working with their head of programming Peter Moss, who had directed a theatrical adaptation for Young People's Theatre. The Adobe Flash animation had a stylish look and successfully captured the feel of the book and the plays.

Patrick was facing an ugly divorce from his wife Judy Ann, whose lawyer was claiming that Patrick's share of Nelvana was worth more than the whole company's public market capitalization. While that didn't make any sense, it put Patrick in a tizzy. He was breaking down, crying in his office. I agreed to look at the sale of our company.

It made sense because the leadership partnership with Patrick was becoming untenable. I entered into negotiations with Dick Snyder from the Little Golden Books company. Unfortunately, Patrick kept changing his mind about selling and I called the deal off. Soon after, Patrick, Clive, and Eleanor decided to see if they could get the deal back on. During this process, Nelvana kept changing its forecast for the year and eventually Golden Books dropped its bid. The whole process infuriated me, so I started working with TD Bank to see if I could find a strategic partner to buy Patrick and Clive out and change control of the company.

Potential partners I met with included Michael Kuhn of Polygram, the music company which had recently added an entertainment wing, and J. R. Shaw, founder of Shaw Communications, who ran the second largest cable company in Canada, focused on Western Canada. J. R. also owned YTV, Canada's top kids' channel, and we went a long way in our discussions, but he eventually decided he didn't want to buy the company if the founders were feuding.

Michael Harrison, the chairman of our board of directors, was meanwhile trying to get management to patch things back together. He asked me to drop my attempt to acquire the company. I explained that I would need the board to fire our chief operating officer and chief financial officer in order to make things work. Michael couldn't deliver that, as Clive and Patrick would not agree. I then suggested engaging an independent consultant to evaluate

the COO and CFO and recommend what to do about them. Patrick and Clive agreed and I called in Stuart Sucherman, who over the years had done great work consulting with such Viacom companies as Nickelodeon and MTV, as well as for NBC, owned by General Electric.

Stuart flew into Toronto and met with all the principals: Patrick, Clive, Eleanor, and our CFO, Sheila Murray-Tateishi. The process took a few months and at the end of it, Stuart recommended terminating both the COO and CFO and, much to my surprise, Patrick agreed with him. The best part was that Patrick took ownership of the decision. I have stayed in touch with Stuart over the years and appreciate what he did for us. He saved our company and I have often told Stuart that while he provided some good mentoring to me, I prefer to think of him as a saviour, rather than a mentor.

It was important to get this disagreement behind us and start rebuilding the company, because if management did fall apart, the company we had spent our lives building would be worth very little. So we took our time and searched carefully for the right people to fill the vacant positions. Eventually, we hired Sally Moyer Kent as our CFO. Sally had worked at Rogers as head of Investor Relations for a number of years. Hattie Reisman, who had been Atlantis' general counsel, took that role at Nelvana. Working together for three years, the new team was able to grow the company at a steady 20 percent compounded annual growth rate, which positioned us well for the eventual sale.

We also adapted the work of another Canadian artist *Santa Claus Brothers,* by author and illustrator Michael Bedard. It was computer-generated imagery, or CGI, and a co-production with Disney Channel and YTV. We won an Emmy for it.

## ANIMATION NATION

Not every new technology paid off immediately. Canal Plus, our French animation partner invited us to co-produce *Donkey Kong Country*, based on the Nintendo game. Their subsidiary Media Lab was an early player in the 3D CGI field. The show used its motion capture system, where actors act out the scene while wearing suits with magnets tracked by computers; their performances are captured digitally and cleaned up in the animation process. As it turned out, the captured data required a lot of remedial work from animators, so it wasn't faster, cheaper, or better to produce a show. We switched to conventional CGI animation for the second season. Over the last twenty years, motion capture has been useful to produce animated characters in live-action films like *Lord of the Rings*, but generally it has not been useful in making animated TV series.

We gained useful experience with CGI during the same period that we produced the animation for a primetime pilot about an animated sheep who interacted with humans. We worked with an animation group from Minneapolis called Windlight, led by Scott Dyer. They also worked for Alias behind the scenes on writing the Maya software that became the go-to software for CGI in movies and television. Windlight's intimate knowledge of the Maya code gave us a head start in building our own CGI studio.

Another Canadian company, Toon Boom, would later take over as the industry's animation software leader for 2D. Before leaving Nelvana in 2002, I started conversations with Toon Boom executives about buying their company which was then in financial difficulty. After I left, Scott Dyer made the acquisition and Nelvana became a great home for Toon Boom, which won the 2D digital animation wars and is the dominant software in the industry. Nelvana recently sold the company for $147.5 M.

In the field of traditional animation, one of our successes of the early 2000s was *Berenstain Bears* for PBS. This was a property we had wanted for some time, but our conversations with the creators, Stan and Jan Berenstain, went nowhere because they wanted to do a movie that they would write themselves. Finally, they allowed us to make the series and we produced sixty-five episodes as part of the PBS Bookworm Bunch.

In response to the adult animation boom that started in the late 1990s, we had *Bob and Margaret*, a great show developed by David Fine and Alison Snowden based on their Academy Award winning short *Bob's Birthday*. They had sold the series to Channel Four in England, which agreed to pay only a quarter of its cost. We came on board to complete the financing and sold it to Global TV in Canada and Comedy Central in the US, where it played after the breakout hit *South Park*.

In the first season, David and Alison wrote many of the scripts themselves. It was a big hit on Global, less so on Channel Four, and it performed better as a companion to *South Park* than any other show to that time. But David and Alison were exhausted and wanted a break before starting a second season. The show started to repeat too many times on Comedy Central. Ratings fell and Comedy Central withdrew its offer to renew. Once that happened, we convinced David and Alison to bring on other writers to make a second season. It was one of the most successful Canadian prime time shows on Global, delivering top ratings. Global's orders kept it in production for four seasons, but it was a hit that got away from us. By not accelerating production for Comedy Central, we lost that all-important US sale for the show.

Another animated series for adults was *Committed*, based on a comic strip about a suburban family by Michael Fry. It had a great

production team, including writers Anne Beatts (*Square Pegs*) and Valerie Bromfield, and a great voice cast with Catherine O'Hara, Eugene Levy, Andrea Martin, and Dave Foley. Unfortunately, it didn't break out and was a one-season wonder.

*Pecola* was based on a series of books by Naomi Iwata. We co-produced it with a Japanese company called Milky Way Cartoons, but the partnership ran into ego issues. When we placed an advertisement in *Variety* to help promote sales for the series, we angered Milky Way by leaving it out of the ad. We offered to remedy our mistake by running an additional ad thanking them and providing the correct credits, but they would not accept our apology unless I flew to Japan to apologize in person. By this time, we were in the last stages of selling the company. Nevertheless, I flew to Tokyo with the idea of returning to Toronto within forty-eight hours. While we were descending into Tokyo, I discovered that I had mistakenly brought my son Jonathan's passport and not my own. After telling my story to multiple customs agents, all of whom were threatening to send me home to Canada on the next flight, I finally found one who decided to help me by giving me documentation to enter the country, but to leave I had to get a temporary passport from the Canadian Embassy. Fortunately the next day Elaine was able to find my own passport and fax a copy to me in Tokyo. When I went to meet the director of Pecola, he refused to accept my apology, much to the shock and dismay of his financial partners at Yomiko, one of Japan's largest advertising agencies. They all felt bad for me, took me out to dinner, and accompanied me to the airport to bid me goodbye. They felt their partner was making too much of this matter.

And, after all that, the show did not make its mark. The production, while beautiful, just didn't work.

## GROWING PAINS

Sally's arrival as the new CFO also helped us make an important deal. Toper and I had wanted to buy Windlight to help us move more swiftly into computerized 2D animation but our former COO at the time didn't have a notion of how to get the deal done and, more importantly, Patrick didn't fully support the idea. As co-CEOs, we had to be unanimously in support of a measure to implement it. We spent about nine months not doing much about Windlight. It wasn't until Sally joined that we were able to complete the purchase. Scott Dyer and his team moved from Minneapolis to join us.

The decision to buy Windlight turned out well for us. While we weren't the first to produce CGI for television, we developed an early lead in using digital production in both traditional 2D animation and 3D CGI. Scott built one of the first CGI pipelines, allowing us to share the production work smoothly between Toronto, Paris, and Vietnam. And our first series with the Windlight team, *Rolie Polie Olie*, won an Emmy, making it the first CGI series to win the award. Scott went on to run Nelvana twice after I left the company.

*Rolie Polie Olie* was based on an unpublished poem by Bill Joyce. Toper had been visiting Bill, looking to get one of his book properties which it turned out were all unavailable, when he spotted the poem on a wall and inquired about it. We ended up optioning it for a show. Through Emmanuele Petry, who ran our European operation, we partnered with a French publisher Metal Hurlant who owned a small animation studio in Paris and Vietnam. The designs of *Rolie Polie Olie* were perfect for what we could execute in CG at the time. We produced a one-minute promo which helped us presell the show in all key territories, including CBC and the Disney Channel. Our broadcasters and partners were all enthusiastic.

Maurice Sendak was one of the best children's author in America, his work beloved by all, but he had avoided licensing his books for TV series productions, allowing only adaptations of individual stories for self-contained films and specials. Two pieces of information gave us hope that we might nevertheless be able to get into the Maurice Sendak business. Toper had learned that Brown Johnson, who ran Nickelodeon's Nick Junior, was a big fan of the children's book series, *Little Bear*, which was illustrated and controlled by Maurice. And through our talent agency at the time, CAA, we were aware that Maurice had a deal with a Hollywood producer named John Carl. Toper approached John and offered to make a deal for a *Little Bear* show. While Maurice had not written *Little Bear*, he had illustrated it and he controlled the ancillary rights on behalf of himself and the estate of author Else Minarik. It turned out that Maurice was open to working with us because he had liked our production of *Babar*. He felt we had enhanced *Babar*, which was great praise from him.

We had a great artist named Ray Jaffelice working in our studio who was capable of working in Maurice's graphic style. He did a great job directing the *Little Bear* series and supervising the design. Young Canadian playwright Betty Quan was the story editor. The show made for gently-paced, comfortable viewing. I am proud to have produced one of the most serene animation shows ever, one that made kids, parents, and grandparents alike happy to watch it. At the time, most preschool cartoons didn't show either parents or grandparents, and we had both. It was a great family program and it remains one of my favorite shows. After the series ended production, Ray continued to illustrate the *Little Bear* books that spun off from the show

We made a deal with the Gund toy company, with whom we had successfully worked on *Babar*, to develop and sell a line of *Little Bear* plush toys. I remember a toy fair where Gund design director Rita Raiffe was proudly showing Maurice her Little Bear prototype. Maurice was not happy and asked if he could take it apart. She handed him an exacto knife and he went into a back office and took the bear apart, put it back together himself, and pronounced it ready to go. Rita, whose family owned and operated the Gund business, took pride in her work and really wanted to please Maurice and went with his re-design. Everyone involved wanted Maurice to be happy with what we made of *Little Bear*.

We held a *Little Bear* book signing at F.A.O. Schwartz, which was selling the Gund plush line as well as *Little Bear* books. It was a stormy winter day in NYC, but despite the terrible weather, families were lined up around the block. Maurice was insistent that he would not sign anything but *Little Bear* books. Even when someone came in with their old original copy of *Where the Wild Things Are*, Maurice turned down their requests, holding true and fast to the advertised fact that he was only signing *Little Bear* books. He would look these poor begging people in the eye and point to the ad on the table that spelled out what he would and wouldn't sign. One family pleaded that they had driven from Massachusetts through stormy weather to get Maurice to sign a book that wasn't Little Bear and still he stuck to his guns. I could see his point, but I felt for the fans.

We went on to produce several other shows with Maurice. He was the executor of the estate of James Marshall, author of the *George and Martha* book series about two hippos. We sold an adaptation to HBO in the US and YTV in Canada, starring Andrea Martin and Nathan Lane as the voices of the title characters. Maurice's

first book, *Seven Little Monsters*, which looked like the inspiration for his better-known *Where the Wild Things Are*, became a show that appeared on PBS as part of the Bookworm Bunch, with the Barenaked Ladies performing the theme song. I had a lot of hope for both shows, but they got lost in the shuffle. Bookworm Bunch was Toper's innovative deal with PBS to supply them with their first ever Saturday morning programming block. It included Berenstain Bears, Seven Little Monsters, Timothy Goes to School, George Shrinks, Marvin the Tap Dancing Horse, Redwall and Corduroy Bear. It took Toper a couple of years to close the deal to launch the PBS Bookworm Bunch and it speaks to his creativity in dealmaking as well as his tenacity, which was second to none.

I was also interested in doing an animated special based on Maurice and Tony Kushner's book, *Brundibar*, based on an opera children would perform at the Theresienstadt concentration camp in Nazi-occupied Czechoslovakia, but I couldn't pull it together. Over the years, I had considered other animated projects about the Holocaust, including an adaptation of Art Spiegelman's *Maus*, but ultimately never pursued them. I am not sure if that was because of my own sensitivities or because of the difficulty of successfully mounting these projects in animation. I have a fear of making the camps look "better" than they were or of not capturing the horror of the Holocaust. Filmmaking can make dark subjects seem lighter and I did not want to be guilty of that.

## CHAPTER 18

# RIDING HIGH

*Nelvana leads the independent animation world and Cinar is in trouble*

WE FOUND OURSELVES AT the pinnacle of success for Nelvana. We controlled more programming slots on US television than any other competitor. We were especially strong on PBS, for whom we produced such shows as *Timothy Goes to School*, based on the Rosemary Wells book series, *Marvin the Tap Dancing Horse*, an original idea by Mickey Parskevas, and *George Shrinks*, created by Bill Joyce, about a little boy who is tiny in comparison to the rest of his family and lives in his own microworld. Like all of Bill's creations, *George Shrinks* had great designs and stories and characters.

We also had a strong relationship with CBS Saturday Morning, but the other US broadcast networks as well as cable channels like Nickelodeon, Disney, and Cartoon Network all came to us for their children's programming. US studios also knocked: *Gargoyles* was a hit Disney series and we agreed to produce a season of it for them.

We were in demand, but our stock price was not reflecting that. The darling of Wall and Bay Streets was Cinar, which reported steady results that outperformed market expectations. Investors were constantly asking us why we couldn't produce great consistent results like our competitor.

The Cinar results made no sense to us. Each quarter, I would sit at the board table with John Vandervelde and our other top finance people and analyze the Cinar public reporting to understand how people there were doing it. Our conclusion was that they were cheating. We thought that because they were never taking an unusual write-down of their film assets.

True, Cinar had some hits, like *Arthur*, the PBS educational show. Nelvana missed the opportunity to produce it when we negotiated too hard with WGBH, the PBS station that owned the character. After our success with *Babar*, I wanted the licensing, merchandising and distribution rights, but Cinar took the series on the terms that WGBH offered and it was such a success that they used the program in an ad on the cover of *Variety* the week they launched their IPO. Still, we knew that we had the better properties and that we generally struck better deals with partners, but we would have to write down underperforming assets. Somehow Cinar never did. It also never suffered any consequences if the Peso or the Euro or the British Pound declined relative to the Canadian dollar. Our guess was that they were buying shows from themselves through a dummy company. Years later, when doing due diligence on Cinar, we found evidence of that, among other shenanigans. In fact, the number of misdeeds we found was beyond belief and we had to check their contracts during due diligence very carefully, because there was fraud buried in many deals.

Claude Robinson's protracted litigation over *Robinson Sucroe* kept Cinar constantly in the news. Cinar founders Micheline Charest and Ron Weinberg had managed to make this personal for Claude, and he and his lawyers retaliated by leaking as much damaging information as they could. One of the biggest stories was the one I mentioned earlier, about Cinar cheating in regard to the rules requiring Canadian scriptwriters. Canadian subsidies rewarded productions that had key creative positions filled by Canadians and a young assistant, Thomas La Pierre, the son of Telefilm Canada Chairman Laurier La Pierre, testified that he had not written scripts for *Robinson Sucroe*, although he was credited and paid for it. He described a process by which Cinar engaged him to write the scripts but also gave him a US author's name with contact information for their agent. He was to employ that US writer to write the script without screen credit, paying the US writer out of his fee and keeping the balance to offset the Canadian taxes that would have to be paid on his "writing income." When asked if this arrangement was unique to that series, the young La Pierre explained that it was common on Cinar series. This disclosure eventually led to many funding and regulatory Canadian agencies investigating Cinar for fraud and the public markets reacting negatively to the Cinar stock.

The rapid decline of Cinar's stock led to a devaluation of all Canadian entertainment public companies. Rather than denying these accusations, Ron and Micheline acknowledged them but claimed all other Canadian producers did the same. Of course, that wasn't true. Our independent review reassured our investors by proving that we were complying with government regulations in hiring writers, but Cinar had sowed doubts and undermined trust in the industry in general.

Cinar mounted a major PR campaign to win back investor support for the company and did so successfully. It then launched a US equity offering led by Bear Stearns, who raised $134 million dollars for the company. Unfortunately, the next big scandal hit Cinar a few months later. As a result of the Canadian authorship scandal, the company's auditors were instructed by the board to do a more thorough corporate audit and they learned that the money which had just been raised publicly had been sent offshore to the Bahamas by a Quebec investment group. The board ordered Ron, Micheline, and the chief financial officer, Hasanain Panju to repatriate the cash, but they couldn't get it back. When it had landed in the Bahamas, the money had gone out in Roman Candle fashion to numerous other accounts in other jurisdictions. When this scandal was made public, Ron, Micheline, and Hasananain were suspended and forced to leave the company by its board of directors.

Not long after their departure, we were in the market, trying to launch a US IPO on NASDAQ, having just bought a US book publishing company, Klutz. Stocks were slumping generally and it was a terrible environment for raising money in the US. We raised very little. I sat in an office in Boston, trying to convince an executive from the State Street Fund who had invested in Cinar and befriended Ron and Micheline to invest in Nelvana. He noted that both Cinar and Nelvana were Canadian animation companies and partners in Teletoon. While he had no reason to doubt our story, we were just too similar to Cinar for him to touch. He broke down in tears when recalling how much he had trusted Ron and Micheline. They were close enough to have vacationed together.

We were fortunate that it was a cross-border deal, because Bruce Rothney, our faithful and friendly RBC banker, rallied

his troops and helped us sell the deal into Canada. Bruce also suggested selling a part of the deal to Corus as a first step towards building a strategic relationship. After meeting with Corus CEO John Cassaday and chair Heather Shaw, we entered into the strategic relationship, which eventually led to the Corus buyout of the company a year later.

# CHAPTER 19

# THE BIG SALE

*After a complex process, Corus purchases
Nelvana and my new era begins*

WORKING WITH TOPER TAYLOR was a lot of fun. Whenever we travelled together to markets, we had great dinners and took long ponderous walks and talked about how to build the business. We joked and laughed and worked really hard to make the company successful.

Our strategy was based on controlling the limited shelf space on the four main US broadcast networks: ABC, CBS, NBC, and Fox. In those days, there were still few enough hours available on TV that any slot you filled was one less available to your competitor. We concentrated on building programming blocks, occupying as much as three hours on each network's schedule. While this wasn't foolproof, it was usually the case that if a slot opened at a particular network, it preferred to fill it with a show from the same supplier. That strategy made us the leading supplier of animation to all the US networks by the end of the nineties, and that extended to the international marketplace.

# THE BIG SALE

*Cadillacs and Dinosaurs* was a great one-season production for CBS, based on a fantastic comic book published by Kitchen Sink Press. Kitchen Sink was the top publisher of nostalgic comic art books and strips such as the complete *Li'l Abner* by Al Capp. *Cadillacs and Dinosaurs* came to us through the producer Sasha Harari with screenwriter Steven E. de Souza (*Die Hard*) adapting the comic and running the series. While the show was fun and innovative, it didn't rate well, so it goes down as a one-season wonder. Other comic book adaptations we did for CBS were *Savage Dragon*, based on a successful Image Comics book by Eric Larson, which ran two seasons, and *Wild C.A.T.S.*, based on a comic book by Jim Lee, co-produced with Lee's Wildstorm Productions.

At CBS we produced a lot of content for their educational blocks. *Blaster's Universe*, part of our CBS educational content based on a popular math educational video game, lasted only one season. So did *Dumb Bunnies*, based on Dav Pilkey's books. We co-produced it with Yoram Gross' company in Australia, which later evolved into Flying Bark Studio. *Flying Rhino Junior High*, based on a series of books about a boy genius who transforms his school into different realities and time periods, lasted two seasons. *Mythic Heroes: Guardians of the Legend* was a CBS educational series we co-produced with France, where the broadcasters were not happy with the liberties we took with Greek mythology to make a great action-packed series.

For ABC Saturday morning, we produced *Tales from the Cryptkeeper*, based on the EC comic books *Tales from the Crypt* which inspired the HBO series, with the title character introducing scary stories. I remembered these comic books from my youth, when they were highly controversial and drew the scorn of child psychologists. The producers of the HBO show were Joel Silver, Richard Donner,

Robert Zemeckis, David Giler, and Walter Hill. We licensed our rights through them. The show ran two seasons on ABC and was later revived by CBS and Teletoon. For YTV, we went on to do *Moville Mysteries*, a show with scary supernatural mysteries, starring the voice of Frankie Muniz, the kid star of *Malcolm in the Middle*.

*Stickin' Around* was a Fox Kids Morning series created by Robin Steele, who had produced stick-figure shorts. We worked together to make it into a half-hour series, but the show fell between the cracks in demographics. The writing was for six-to-eleven-year-old kids and the design style appealed to preschoolers. *Will and Dewitt* was another Fox series on Saturday mornings that we produced with Procter and Gamble. Dewitt the Frog was the mascot associated with their Kandoo personal care products. The show was an experiment to bring consumer products money into a kids' TV business that needed an injection of cash.

We produced a show for Fox Kids called *Sam & Max*, a comedy based on a popular comic book series that evolved into a video game series from Lucasarts. During production, Fox Kids executive Sydney Iwanter demanded changes that contributed to our going significantly over budget on the show and so there was only one season. While this was going on, I had an interesting meeting with Fox Kids head honcho Haim Saban. I told him that his executive was costing us a fortune and, in my opinion, his notes weren't improving the show. Haim commiserated and told me during the meeting that he wanted to eliminate all the program executives and just tell producers if they made a hit, they'd get more orders, and vice versa if they delivered a failure. But his Fox partner, Rupert Murdoch, wouldn't let him.

When I saw how many shows we had running, I thought back to the early days of Nelvana and how difficult it was to crack the US

networks. It made me appreciate how far we had come. Toper was a major part of that success. The two of us made a great combination and dominated the animation world for a decade. When John Cassaday, Corus's CEO, promoted his company's acquisition of Nelvana, he called our company "beachfront property" because of the dominant position we enjoyed. No single person contributed more to establishing that beachhead than Toper. He is one of the great rainmakers in the history of our industry and he has been a great friend to me during our careers together.

We not only had a lot of shows running, but an astonishing range of shows from many different creators, made with all kinds of business partners and all kinds of business arrangements.

Toper initiated ideas for some of the shows, such as *Braceface*, about a tween-age girl with braces. He also came up with the idea of bringing in Alicia Silverstone as the voice of the title character. Alicia also executive produced and gave us her creative input. With her as part of the package, we sold the show to Fox and it enjoyed four seasons. The show was funny and it made kids with braces feel better about their self-image.

One of Toper's favorite books was Don Freeman's classic 1968 book *Corduroy Bear*. We adapted it as a series for the PBS Bookworm Bunch. Our show reflected the Caribbean Black culture that is such a vibrant part of Toronto. I recently spoke to a class at Ryerson University and one of the students told me that as a Jamaican Canadian, she had identified with our show.

*Miss Spider's Sunny Patch Kids* was a book series by David Kirk, published by Nick Calloway. Toper has maintained a relationship with Nick Calloway and has worked on some bestselling books with him. Another creator we have stayed in touch with is Mickey Paraskevas, who with Betty Paraskevas created the book *Maggie and*

*the Ferocious Beast*. Our animated adaptation, developed with Brown Johnson of Nick Jr., was enchanting—a very fun monster and a great color palette. It was a top-rated show on Nick Jr. Mickey was like a grown-up version of his beast.

*Franklin* was a preschool book series written by Paulette Bourgeois and illustrated by Brenda Clark. I first considered it when I read it to my son Jonathan, who loved it as a preschooler. But the sales weren't sufficient at the time to drive television interest. When I learned that sales had reached 14 million books, I thought we could get it sold. We made it a memorable series built around the friendship of Franklin and his buddies, with a great theme song written by Bruce Coburn about Franklin's friends coming over to his house to play. We bought the publisher, Kids Can Press, and we sold the US broadcast to Nick Jr, where it was a major hit. It also became a major hit in France on TF1. We organized a promotion with *The Rosie O'Donnell Show*, giving away a ton of Franklin merchandise. After another seven years, we had sold thirty million more Franklin books. We hoped that we would succeed again by adapting another Kids Can Press property, *Elliot Moose*, but while cute and multimedia, it didn't have enough of a well-developed character at the heart of it to work and only lasted two seasons.

*Redwall* was based on a series of best-selling children's books by author Brian Jacques, about a medieval battle between mice and rats. It was a beautiful show directed by Ray Jaffelice and ran on PBS. Brian came to our studio to help get the show off the ground. That he came was a major concession: he was so addicted to smoking that he could not stand flying, which by that time was all non-smoking.

We did some groundbreaking work for Teletoon with original ideas from parapalegic independent cartoonist John Callahan.

## THE BIG SALE

*Pelswick* was about a boy in a wheelchair and his day-to-day life, the first animated series I am aware of that was centred on a kid in a wheelchair. Callahan's *Quads*, co-produced with an Australian partner, was way out there and we couldn't get any traction with it.

The first Japanese anime show we picked up at Nelvana was *Cardcapturer Katsura*. We organized the voice dubbing and rewriting of scripts, distributed the show outside of Asia, and got a toy deal in the US for the property. Jim Wetherford, a talented executive who ran our Asian business out of Tokyo, brought the opportunity to us from Kodansha, a major Japanese publisher.

While it was not a big hit, it got our toes in the anime water and eventually led to our participation in *Beyblade*. Jim, with an American dad and Japanese mom, understood both the US and Japan well and was able to guide us through the complexities of doing business in Japan.

With Svensk Film in Sweden and Beta Taurus in Germany we produced twenty-six animated half-hours and a movie based on *Pippi Longstocking*, Astrid Lundgren's classic books about a young girl in pigtails and multicolored stockings. Astrid was in her nineties when we made the show and I am told she would review our artwork by holding a telescope up to the art and moving the telescope around to compensate for her poor vision.

*Neverending Story*, based on the book series by Michael Ende which had inspired successful live-action movies in the 1980s, was another German/Canadian coproduction and fraught with partnership issues, although they were resolved enough for the show to be produced. Co-productions were difficult to manage because of the cultural differences between the partners which needed to be resolved.

*Rescue Heroes* was a series based on a Fisher Price toy line. We produced the show working with Mattel's Rob Hudnut. The show was well liked by kids and the toy line sold a lot of product. We had a share of the toy and licensing royalties and sold the show around the world. As for *Medabots*, it was a project that we co-produced with a Korean studio based on their creative concept.

All of these shows combined were what made Nelvana "beachfront." The sale of the company began to take shape about six months after we agreed on a strategic relationship with Corus. We decided to approach them about buying the whole of Nelvana and they were very receptive. We were part of John Cassaday's larger plan, which he shared with us. He wanted to leverage our content library and worldwide media contacts to export his channel Treehouse TV, into the US and then expand it globally. It would have been the first preschool channel in the US. Following that, he could potentially do the same for another of his channels, YTV. John had already met with Liberty, a key cable distributor in the US, and it was a viable plan. This was before the launch of Noggin, a joint venture between Nickelodeon and Sesame Street.

I thought John's strategy made a lot of sense. A content library was invaluable as a way to start a TV network. Ted Turner had proven that when starting his movie channels with the MGM/Warner Bros. library and the Cartoon Network with the Hanna-Barbera, Looney Tunes, and Tom & Jerry libraries. We were now benefiting from his model.

Patrick and I had dinner with John and we all decided to make the combination work. I set a price of $50 a share, which was an incredible premium over our actual stock price, then trading for approximately $19 a share. Our share price did not reflect the value of the company; it was depressed by the Cinar blowup.

We shared a sum-of-the-parts analysis that valued each business segment separately and John agreed to pay $49 a share. We called a board meeting.

The Nelvana board expressed exhuberant surprise at the offer and suggested we get it in writing as soon as possible. But the board then asked us to appoint an investment banker to represent the company in a sale process. They wanted the banker to quickly shop the deal to see if anyone would be interested in topping it. Bruce and his team at RBC shopped it and found that it was generously priced and unlikely to be topped.

The deal hit a snag in due diligence when the Corus tax lawyers in Calgary expressed some concerns about our Irish distribution office. This delayed the deal for a few months, until we resolved the matter by taking another dollar a share reduction in price and closing at $48 per share. The deal was announced and there was a lot of excitement in the studio and outside. The sale price was $554 million and Corus took on our debt of $75 million. At the time Corus already owned 6 percent of Nelvana.

John Cassady had previously invested in a minority interest in Decode, founded by Neil Court and Steven De Nure. He had an opportunity to buy the rest of that company. Neil and Steven called me to congratulate us on the deal and confessed their hope that if Corus ever bought an animation company, it would have been Decode. Still, they benefitted from our deal. It set a high benchmark for the valuation of Canadian animation production and distribution companies.

The timing of the deal, consummated with cash and shares, turned out quite well for Nelvana investors. The stock market collapsed about one month after the closing of the deal. We went through the Internet and tech meltdown of 2000. Markets all

over the world were decimated. This eventually had a negative impact on our business. Broadcasters had a harder time selling advertising and consequently bought fewer shows for less money. Our library lost a lot of its value overnight. Prior to the market collapse, the German territory was worth up to $75,000 for an animated television half-hour. After the collapse, you were lucky to see $5,000 an episode.

We were forced to reduce production and let people go. Facing this economic meltdown would have been far harder on Nelvana as an independent company, but it was nonetheless brutal at Corus. The bursting of the tech bubble was followed shortly thereafter by 9/11, which compounded the downturn. We saw a sharp decline in the value of all foreign sales. While our business had previously been focused on growth in EBITDA (earnings before interest, taxes, depreciation and amortization), it now switched to focus on cash flow. "Cash is King" became the slogan of the day. Cash is always king, but in periods of high growth such as the one we'd just been through, growing EBITDA exponentially was more attractive to investors.

Our biggest hit of the Corus era, in fact our greatest hit of all, was *Beyblade*, a Japanese cartoon series based on a line of spinning-top toys. Jim Wetherford brought the property to Toper Taylor and we decided to produce an English-language version. It was among the most blatant toy commercials I had ever seen, so we had initial difficulty getting Cartoon Network or YTV, our sister company at Corus, to agree to air the series and pay for it. We also had initial difficulty closing a deal for the world toy distribution (excluding Asia) with Hasbro, because it required the show to be broadcast in the US. After YTV turned it down, we managed to get John Cassaday's assistance in turning that decision around and the

# THE BIG SALE

viewing statistics on YTV convinced Cartoon Network to pick up the series. Once it was being broadcast in the US, Hasbro jumped aboard and there was no looking back for *Beyblade*. It generated billions of dollars of toy sales. *Beyblade* was the biggest hit Nelvana had ever been part of enjoying the TV sales as well as the licensing and merchandising sales.

It was a period with a lot of tumult both in tech and the independent media business. Several times, we saw tech-dependent business plans fail because the world wasn't ready for it. For instance, we all thought that television streaming would explode in the early 2000s, but there wasn't bandwidth, computer power, and streaming software to make it happen. It wasn't until some ten years later when there had been enough technological improvement to support Netflix and Amazon as they built their streaming offerings. When we sold to Corus at the end of 2000, that streaming value was priced into the company transaction, but the win did not come until fifteen years later.

Shortly after our sale of the company, our mentor and good friend Don Haig died. Don meant so much, for so many years, to young filmmakers that we thought it would be great to keep his memory and spirit alive. Patrick, Clive, and I, along with others, made major donations to help jumpstart the Don Haig Fund. It has continued for many years, recognizing the work of young directors and giving them money to help finish their films. The prize is recognized and awarded at the Hot Docs Festival. I attended the award ceremony a few times and on the last occasion wore dark sunglasses in honor of Don's custom.

I had a two-year contract with Corus and when the two years were up, I decided it was time to leave Nelvana. One of the last shows that went into production as I was leaving was *Max and Ruby*,

based on a preschool book series by Rosemary Wells (*Timothy Goes to School*). The show continued on for many years.

    The choice to leave was both mentally and emotionally difficult. So much of my persona was tied up in the founding and building of the company. But the sale had been in the wind for three years. It was the only way to bring my partnership with Patrick and Clive, which had reached its "best use by date," to an end. We had become dysfunctional. I had tried other approaches to wind us up, including buying one of both of them out, and failed. The sale to Corus ultimately led to a breakup that needed to happen.

CHAPTER 20

# LIFE IN A COOKIE JAR

*Cleaning up a scandal-riddled Cinar
and transforming it into Cookie Jar*

ADJUSTING TO LIFE WITHOUT Nelvana was hard on me. I was used to getting phone calls from around the world from early morning to late evening. I'd be busy talking about everything from financial performance to production/development issues to distribution, merchandising, and licensing. Now the phone calls stopped dead in their tracks, except for a few friends who checked in with me. Elaine had warned me that would happen and she was right. It is very difficult to adjust to leaving the high activity of a growing company, but somehow we all eventually make the adjustment.

Before I left Nelvana, I had encouraged John Cassaday to buy the now scandal-ridden Cinar. The Cinar board had pushed out Micheline Charest and Ron Weinberg and was looking to either sell the company or rebuild it. I thought acquiring Cinar was a good way to average down Corus' acquisition costs for Nelvana. Corus

had bought Nelvana at the height of the market and now Cinar could be acquired at the bottom of the market. But John decided against pursuing the acquisition due to the messy reputation of the company. There was a lot of hair on Cinar and Corus didn't want to wear it.

I eventually benefitted from this when I was able to acquire Cinar in 2004 by prevailing in an auction process run by Merrill Lynch and approved by the Superior Court in Quebec.

The process began with Toper, John Vandervelde, and myself. Toper and I went on a search for private equity money to back our bid. We met with numerous investors in the US and Canada before settling on Toronto Dominion Capital Private Equity Partners who subsequently rebranded as Birch Hill Private Equity Partners. I had dealt with Natalie Townsend, a partner in the firm, when mounting my bid for Nelvana. We moved early to lock up Ron Weinberg and Micheline Charest's support for our bid. That gave us an advantage in the process of having the founders' votes locked up, unless, of course, our bid was trumped.

Because of Cinar's past misdeeds, we undertook a tremendous amount of due diligence before arriving at our bid. We evaluated the assets of the company as well as the existing and potential litigation. The process was made more dramatic by news about characters like Lino Mateo and John Xanthoudakis ("Johnny X"), two financial-firm executives who were eventually convicted along with Ron Weinberg on criminal charges associated with the Cinar fraud. The acquisition took fifteen months. It was drawn out in part because Cinar had just hired Stu Snyder as a new CEO and the board was hopeful he could rebuild shareholder value without a sale. I knew Stu from his days at Turner Video. He is a terrific executive and Cinar was lucky to bring him on board.

One of the decisions we took which I later grew to question was that we agreed to buy the whole company rather than just its assets. That meant we inherited its lawsuits. We did debate putting the company through bankruptcy to wash away the litigation so that we could buy it clean, but that would have been a problem in part because Cinar had too much cash on hand to go bankrupt. I don't think we went far enough in evaluating that option, however. The lawsuits ended up being a long distraction.

The Quebec courts had to approve our transaction and they wanted to see an independent committee established to manage the litigation. We formed one led by Wes Voorheis, a Toronto lawyer who specialized in distressed litigious situations. We set aside $5 million to fund the litigation. Unfortunately, litigation is difficult to end midstream, so we had to keep funding it. Before it all was wound up, we had spent twenty million dollars on various suits. Wes's committee chased the money trail in the Caribbean through courts in Britain, the Caribbean, Canada, the United States and Panama. By the time we had collected the settlements we earned, we recovered approximately $15 million, leaving us $5 million in the hole, which was equal to the amount we had originally budgeted, but it took us close to eight years to get there. We would have been better off without any of it.

The biggest loss in that pool of litigation was Claude Robinson and his *Robinson Sucroe* lawsuit. We did not expect to lose the case because the underlying property, Daniel Defoe's novel *Robinson Crusoe*, was in the public domain. Nevertheless, we encouraged the insurance company to settle. We were worried about the very successful media campaign that Claude had run against Cinar and the impact it would have on the court case. Sometimes you have to cut your losses to move on in life.

CHAPTER 21

# TALES FROM THE COOKIE JAR

*Seducing buyers and partners with freshly baked cookies*

After the Cinar acquisition was completed, Toper and I both felt strongly that we should change the name. I wanted to take the "sin" out of Cinar and separate us from the company's problems and its ongoing litigation. We went through many possible names—thousands, in fact. We asked everyone we knew if they had any ideas. Around this time, we were having lunch in New York with Huck Scarry, son of the children's book author Richard Scarry. Cinar had enjoyed some success with a series called *The Busytown of Richard Scarry* on the Showtime network in the US and we wanted to renew Cinar's rights to Richard's books. Huck said he would think about a potential name and when he got home to Switzerland he sent us a drawing of a kid on a stool reaching for a cookie in a cookie jar on a shelf with the words "Cookie Jar" written on the side of the

drawing. Toper and I loved the name. Cinar encompassed 3,000 half hours, over fifty brands, and multiple companies including Carson Delosa and High Reach, so it really was like a cookie jar.

The name was not received well by our new partners at Birch Hill. They felt it was too close to Cinar. Given the financial improprieties that had been perpetrated, Birch Hill wanted something from the other end of the alphabet and it also felt that the double meaning of "Cookie Jar" was problematic—the headlines wrote themselves. I focused on the positive aspects of the name. At trade shows, including the Mipcom Screenings and Toy Fair, we baked cookies on location and the fragrance of burning sugar and melting chocolate wafted across the large convention halls, drawing everyone to sample the cookies. I suspect many of our colleagues gained several pounds as we reinforced our brand. At Christmas, we shipped chocolate chip cookies to our partners and clients around the world in custom-made cookie jars with our characters on them.

During due diligence we kept finding crazy stuff about the previous management, like the money-back-guarantee on the *Caillou* Christmas special to Warners. In order to book revenue on the special, based on one of their biggest hit shows, Cinar had guaranteed that it would refund 100 percent of the shortfall in Warners' minimum guarantee. But it booked the revenue misleadingly, defrauding Cinar investors. When Warners approached us about making good on the guarantee, I noted to them that they could be seen as participating in Cinar misleading public shareholders and the studio dropped its request.

The first series we produced at Cookie Jar were *Busytown Mysteries*, based on the Richard Scarry books, and *Doodlebops*. *Busytown Mysteries* turned out well. The most controversial part of the show

was the series name. Toper and the marketing team liked *Hurray for Huckle!* and I liked *Busytown Mysteries*. We ended up using both titles, which still causes confusion today. There is a cute and innovative segment in the show where the main character is reviewing the evidence he has gathered and trying to solve the mystery. We play a thirty-second song called: "Who, What, Where and Why?" It repeats in every episode and gives the audience a chance to solve the mystery. While the show worked well in Canada and most of the world, it never found the right home in the US.

I began developing *Doodlebops* while I was working on the Cinar acquisition, after Cheryl Hassan, who ran CBC Kids at the time, agreed to do a music show with me. Cheryl was a great partner on the project and we couldn't have asked for better support from the CBC during the whole development process. It let us do a wild and wacky show, rolling the dice that it would click with kids. And did it!

I started with the premise of a funny music show, reminiscent of the Beatles movie *A Hard Day's Night* and the TV show *The Monkees*. I decided early on to work with a musician. Merle Anne Ridley, a former colleague at Nelvana, recommended a few artists, including Carl Lennox, who had co-written music for *Rolie Polie Olie*. Merle Anne and I met with Carl on a frequent basis and together the three of us created the characters. Then I brought in my stepson, Jamie Waese, who had just left CBC Kids to join us and direct and write the show. My son, Jonathan, also worked on the show, starting as an assistant and eventually worked on lighting and special effects.

We were able to finance the show totally out of Canada as we couldn't get a pre-buy from any broadcaster outside of the country. Before the show aired, Toper pitched it to a Disney

Channel executive named Nancy Kanter. Nancy liked the episodes we showed her and convinced her group to test the show. It tested positively, so we were able to bring in the Disney Channel early on. With it on board, we were able to convince the Feld Organization, best known for Ringling Brothers Barnum and Bailey Circus and the Ice Capades (including Disney on Ice), to organize a US tour for the musical group from the show. We already had the Feldman Agency on board to handle a Canadian tour under the auspices of Richard Mills, who embraced the opportunity.

The show took off. Preschool kids across the continent fell in love with the Doodlebops. The first season was produced inexpensively but it had passion and the cast had great chemistry on screen and on stage. One of my fondest memories is that the Doodlebops were able to ride elephants on Seventh Avenue as part of the Ringling Brothers Circus elephant parade into Madison Square Gardens for the circus. It made for a great photo opportunity. The Doodlebops became celebrities and appeared on *The Today Show* in New York. When they went backstage, Billy Bob Thornton, who was appearing on the same episode, asked them for their autographs for his child. They played across the United States for three years, including successful appearances at Disney World.

*Caillou*, based on a book created by Christine L'Heureux and illustrated by Helene Desputeaux, was among the properties we inherited at Cinar. One of my contributions was facilitating the settling of the lawsuits between Cinar, Desputeaux, L'Heureux, and their publisher. Caillou was a hit in merchandising and publishing in Turkey, Spain, and Brazil. The series also did well on PBS, so we did our best to keep it going, which meant steadily finding ways to produce it for less money. The big payoff came later when *Caillou*'s presence on YouTube made it a French hit

and drove French publishing and YouTube advertising. We also inherited Arthur and kept the series going for a number of years. Arthur was a major hit on PBS, CBC and the BBC. Based on Marc Brown's books it appeals to children four-to-eight years of age. And we won some Emmies with Arthur. We also produced an Arthur spinoff *Postcards from Buster* for PBS.

Toper continued to generate new ideas for us. *Kung Fu Dino Posse* was a wacky show he developed. It went one season, albeit with forty episodes. *Gotta Catch Santa* was a Christmas special written by Toper's son, Trevor, based on the amusing idea that a kid who believes in Santa tries to prove to all the non-believers that Santa is real by setting a trap and catching him. Santa is voiced by William Shatner.

As we had at Nelvana, we developed a huge range of shows at Cookie Jar, again with all kinds of partners and source material from around the world. Again, not all of them worked. *Magi-Nation* was a kids' card game like *Dungeons and Dragons* which we optioned and adapted into a television series. We had high hopes for it but it never broke out. *Noonbory & the Super 7* was a Korean project that we co-produced to help out our Korean partner on *Magi Nation*. All in all, we would have been better off not to make either series.

*Gerald McBoing Boing* was an Oscar-winning short by UPA, a great independent animation studio in the fifties. Gerald was a boy who spoke in sound effects and not words. We did a couple of seasons for Cartoon Network and Teletoon, but programmers around the world didn't know what to do with it. The premise was good enough for the Oscars, but by the time we adapted it, it was out of step with expectations for preschool programming.

One of our biggest mistakes at Cookie Jar was greenlighting too many large series orders without US prebuys. Shows like

*Spider Riders, Mega Force,* and *Kung Fu Dinosaur Posse* were disasters that damaged us by burning too much cash. They were all toy-driven shows but none of them ever made it to the consumer shelf. *Spider Riders,* for example, was an original idea of Toper's that we presold to Mattel. We had high hopes for the toy prospects, but Mattel never made the toy line while we went ahead and made the television series.

Fortunately, we hit a turning point when Warner Bros. was looking to abandon *Johnny Test,* a series they had developed for the WB network. The company had made a decision not to invest in producing animated shows that didn't promote classic Warner brands. They were now auctioning off the rights to produce the series. Toper identified the opportunity and skillfully outbid our competitors to take over the show.

*Johnny Test* was a comedy created by Scott Fellows. It's about a young boy with two genius older twin sisters. Scott knew how to run a comedy show, and he proved once again that "funny is money." In our hands the show lasted seven seasons and became a ratings juggernaut around the world, particularly on Cartoon Network and on Teletoon where it ran six to eight times a day. It also became our first "locomotive" with Netflix when it started to buy streaming rights. Johnny Test gave us fresh leverage in the global marketplace.

Around this time, mobile smartphones and iPads changed the way we consumed cartoons and other video content. The number of screens in a home dramatically increased. Co-viewing diminished as a result, because everyone in the family had his or her own screen. You could take your favorite shows with you and watch them in the car, on a plane, on the train, at work, at school, on the bus, in the waiting room of the dentist or the doctor. You

might start and stop the show you were watching many times before you finished watching it. So storytelling changed. You could have more complicated stories, as the ease of rewinding and watching a scene or a show gave you the opportunity to go back and look for story moments you might have missed. Companies started to produce shorter content that fit how we consumed content on mobile phones. Once again McLuhan's motto, "the medium is the message," was relevant. The technology we employed and the way people consumed content changed storytelling. Cliffhangers, catchy sayings or gestures, signature moves and the like all have great demand in the short-form universe.

New platforms are developed and grow overnight by fulfilling previously unrecognized needs of an audience. A platform like Tik Tok becomes a sensation for teenage girls who identify with their ability to post do-it-yourself content sharing their favorite characters sayings or dance moves or gestures. We had the great experience of getting a phone call from a colleague whose niece had just informed him that we had 80 million views on Tik Tok for DIY content highlighting Catbug, a minor character in our *Bravest Warrior* series. As a result of that new audience support, we began developing a new series starring Catbug. There does not seem to be an end in sight; there will always be a new cool platform for a niche audience to connect and communicate through.

CHAPTER 22

# A VISIT TO THE WORKOUT ROOM

*Financial crises lead to restructuring
and a sale to DHX Media*

WHILE THE CINAR LIBRARY was attractive, we were adding additional series we wanted to add to it by buying another company. My old competitor, DIC, became available. This was an interesting revisit to the past, as DIC owned the rights to *Inspector Gadget* which we had co-produced at Nelvana. It had also successfully relaunched both *Care Bears* and *Strawberry Shortcake*, two properties Nelvana had produced before. DIC had a library that consisted of recognizable popular brands like Archie, Sabrina, Sonic the Hedgehog, and Super Mario Brothers—not always the best productions but great characters and great market appeal.

After a lengthy process, negotiating with company CEO Andy Heyward, we were the winners of the DIC auction and we set out to buy the company, but American Greetings, co-owner of

the Care Bears and Strawberry Shortcake, sent us legal letters threatening to stop the deal. It secured a temporary injunction in an Ohio court preventing us from acquiring DIC. Working with my longtime litigation advisor Robert Abrahams, we were successful in overturning the injunction at a higher court.

American Greetings told us that the reason they wanted to stop the deal was that they had an offer from Hit Entertainment, one of the companies we beat out in the DIC auction, to buy the American Greetings 50 percent share in Care Bears and Strawberry Shortcake for a lot of money, about $195 million US. They didn't want to lose that deal. I convinced my equity partners that we should match the offer—the opportunity to buy two multi-billion-dollar brands was hard to come by.

After the deal was announced, I went to visit Hasbro, the other 50 percent co-owner of Care Bears and Strawberry Shortcake, and learned from their CEO, Brian Goldner, how angry Hasbro was at American Greetings for committing to selling their stake in these properties without working it out together with him.

Hasbro had not realized that the properties had that kind of value. Interestingly, the future of both properties was still in Hasbro's hands because it had taken back the toy rights previously licensed to smaller toy companies. Before launching new toys, Hasbro wanted to make sure that all of the toys that were in the market from the previous licensee were sold through, so that delayed our relaunch for over a year. This resulted in declining revenues for both Strawberry Shortcake and Care Bears, which led to more and more problems with American Greetings.

Our problems grew as Kidsco, an international children's network partnered by DIC, NBC/Universal, and Corus, continued to be a sinkhole for capital. As the new owner of DIC, we were

on the hook, continuously writing cheques to fund the deficit in Kidsco. When the economy melted down in 2008 and 2009, our CFO, Scott McCaw, didn't bring the critical focus to liquidity that we required. We were busy supporting failing business units that we should have shut down. Then, when we had to make our first big payment to the banks to start reducing our debt, Scott convinced us not to pay, believing that the bank had agreed to defer payment. This decision led us into the bank's workout room in a very bad way. The bankers were furious and their financial penalties added to our crippled state.

Failing to pay turned out to be a massive mistake that cost us well over ten million dollars in fees and increased interest charges. In fairness to the bankers, they were in the middle of a financial meltdown where banks were being reviewed by their regulators every day. RBC was not as upset as Bank of America, which brought in FTI Consulting to review our financial position. That, too, cost us a ton of money. Scott then told us that not only was he quitting our company to return to the construction industry, but he was moving to Africa. At first, I felt abandoned, but quickly realized that we needed a different kind of CFO to work our way out of trouble. Through a search firm, we found Aaron Ames, who specialized in helping troubled companies work their way back to liquidity. I recognized that Aaron was our guy and John Loh, one of our Birch Hill partners, quickly agreed with me.

We still had the problem that we had bought DIC with Canadian denominated debt, but DIC earned US dollars, British pounds, and Euros. With the economic meltdown, everything went helter-skelter and the Canadian dollar went from eighty cents to the US dollar to $1.10. The same thing happened with the pound and the Euro. This was a modern equivalent of the Diefendollar

which had sent my father into financial restructuring at the end of the fifties.

On top of all this, the broadcasters bought fewer new series and less library content as advertising shrank with the recession—they were worried about their survival. A number of our business units were now losing money. We had bitten off more than we could chew when we bought DIC and also agreed to take on Care Bears and Strawberry Shortcake, neither of which were producing the income we expected because of the launch delays at Hasbro. There was no way we could meet our financial covenants, especially with the banks worried about their own liquidity and giving us no leeway.

Philosophy helped me go through the great financial meltdown of 2008 and the similarly trying meltdown of Cookie Jar one and a half years later.

The crash was caused by sophisticated investment bankers who had developed a financial model that showed you could not lose money on mortgages if you had a big enough pool of investments. That led to banks and other financial institutions providing mortgages to people with no income. The underlying thesis was that property values were rising higher and higher all the time, so if there were defaults on mortgage loans, the properties could be sold and more than cover the downside of the mortgages. So said the model. Reality proved otherwise.

At first those who were committed to the model defended their actions, quoting the quants at the investment banks and insisting that there was no problem. When a massive number of people defaulted on their mortgages, the real estate market collapsed and a depression began. The model had fundamentally misunderstood reality.

## A VISIT TO THE WORKOUT ROOM

In Plato's story of the cave, the people who live in the cave are afraid to go out in the light. They experience the world by the shadows cast by the sun on the cave wall. Their whole experience is illusory because they choose to view a reflection of reality rather than reality itself.

And so it is with financial modeling. If you choose to ignore what is happening in the real world but live in the shadow world—a world of models—you'll fail. A model needs to be tested constantly against reality and adjusted to conform with the real world. Success can never be found exclusively in the model.

We had our own shadows on the cave wall of the film and television business. When we were suffering financially at Cookie Jar, our CFO looked at our model and predicted that our financial outlook would improve. He showed us how that played out on the model and we agreed. We all believed that the world and our business were on the verge of an upswing. But the model was flawed: it did not reflect the possibility or the consequences of a larger financial collapse.

Our biggest mistake was not making that first scheduled payment to the banks. It would have been better for us to withhold payments to others in order to make that payment. The banks and the consultants they assigned to us took a lot of management's time and a lot of the company's money. Often in these situations, if a company isn't out of business when the banks and the consultants move in, they are when the process is finished. Banks pile on you when you mess up. Those extra fees and higher interest rates and the demands they make on management only compound your difficulties.

Luckily, our new CFO, Aaron Ames, handled the situation expertly and with his direction we managed to get out of the

workout room and survive to make another deal. Aaron was an unusual CFO. He had some quirky habits. There would be moments when he seemed to lose it and just kept repeating that the company was going down; at other times, he patiently worked through our problems.

The first part of Aaron's job was to convince Toper and me that the company really was in serious trouble. He would get exasperated trying to make us understand the reality of our position. I got along well with him. I recognized that Aaron specialized in distress situations and was trying to help us find a solution. It's just that Toper and I were such optimistic people that we didn't see it right away. The truth was that we were in the middle of the biggest financial crisis since the Great Depression and we owed about eighty million dollars in Canadian funds at a time when the Canadian dollar had ballooned in value. It was a miserable moment, when we finally woke up to it, and we spent a few months trying to think our way through it.

Aaron advised shutting down money-losing parts of the business, so we closed a number of units as I racked my brains to find a way to get us to positive value. My contribution was deciding to focus all our efforts in becoming the leader at selling our library of kids' shows to streamers. At first, that business did not seem to be doing well in the downturn. Then Ken Locker, who headed up digital for us, brought in the first possible deal with Netflix. We had a large library of over six thousand television episodes and Netflix originally wanted to buy only one hundred of them. We worked with Netflix to convince it to increase its order, but the streaming business was just starting at the time and the company wasn't sure that the kids' demographic was going to be important to them.

## A VISIT TO THE WORKOUT ROOM

Things were complicated by the difficulties we faced in delivering episodes to Netflix. At that time, outside laboratories charged high fees to digitize and deliver libraries. It was more per episode than Netflix was prepared to spend. Aaron and our head of physical delivery, Matthew Haliniak, worked out a plan to buy the equipment that would allow us to do our own digitization and deliveries. With that equipment, we could digitize episodes for fifteen dollars apiece instead of spending hundreds of dollars per episode externally. This made our first deal with Netflix possible and grew our business to the point where we became cashflow positive again. We were then able to capitalize on our number-one hits in *Caillou, Johnny Test,* and *Doodlebops.*

Netflix was our first big streaming customer, and Love, owned by Amazon, was our next. We focused on identifying new players who would want to enter the streaming wars and focused our sales team on educating those players that they needed to buy bigger volumes to be competitive in the streaming world. I bought a giant gong in our local Chinatown and placed it in the boardroom. When we had a big sale we would hit the gong and everyone would get excited, whether they were calling in from London or Paris or LA. It helped to build up team confidence in our survival and eventual triumph. The gong was heard around the world. Our success in this direction saved our investment and turned the company around, so that in our last year of independent operation we generated about 12 million dollars of free cash flow with a forecast of 20 million for the following year.

Despite our success in turning the business around Birch Hill and **OMERS**, another of our private equity partners, were tired. They had been in the investment for twelve years, much longer than usual, and were looking for an exit. We had looked to partner

two years earlier with Classic Media, but their investors didn't buy into our story which, in fairness, was not yet fully proven. We eventually facilitated a deal with DHX Media to merge their business with Cookie Jar. Years earlier, DHX had pursued us for a business combination and we had no interest. Now we were ready.

DHX was an unusual environment. The company was started in 2004 by Michael Donovan, a leading Canadian producer, as the Halifax Film Company. Michael had previously co-founded Salter Street Films in 1983 and sold it to Alliance Atlantis in 2001. Alliance Atlantis closed Salter Street two years later. Michael bought back some of Salter Street's assets from Alliance Atlantis and hired some of his former employees to get Halifax Film Company off the ground. He then merged with Decode, the company started by Steven De Nure and Neil Court, which had originally hoped for the Corus sale that Nelvana got. The company went public as DHX and languished in the public markets. It had about 2,000 half hours with few recognizable brands and library value is all in recognizable brands, particularly so in the world of streaming. Reliable brands facilitate discoverability, which is a big problem in the streaming world with its flood of content leading to what has become known as the paradox of choice.

I got along with Michael. Like me, he had started in independent feature films and grown into television. We both perceived that a merger with DHX could be mutually beneficial. Cookie Jar had many more hours of content and many recognizable brands. And we had something else he needed: a story.

That story was based on hit shows and the fact that we were the biggest independent seller of children's shows to Netflix, Amazon, and other new streamers. Our biggest negatives were our $80 million debt load and our tired investors. DHX, for its part, had $20 million

in the bank that it had raised from investors. But it was burning cash and had no convincing narrative about its way forward. Every public company needs a story. By combining his company with Cookie Jar, Michael would be able to boast of positive momentum in the streaming age. It was a dream combination.

To help facilitate a sale, John Vandervelde and I worked on a ten-year forecast for our library sales to streamers. We had input from Toper Taylor and all of our sales team. It was a massive effort. I used the model to argue for holding out on the DHX deal to get a better split of equity with Michael, but our investors opted to take the deal. They thought our model was too bullish. Time proved that we nailed it. We had forecast that we would double free cashflow year after year and the company did. Streaming sales became the growth engine for DHX (now WildBrain) for the following five years.

DHX stock went shooting up on the announcement and continued to climb. Aaron Ames, our CFO was appointed our chief integration officer and worked hard to cut duplicative costs. Thirty days after the merger, when we announced that we had taken out the $10-million in synergy savings that were promised, the stock hit $3, up from eighty cents a share, the price it was trading at when we were negotiating our deal. Birch Hill eventually exited for close to $5.00.

I was still at the company in my capacity as executive chairman and had started the YouTube business which eventually evolved into Wild Brain. I invested some of my earnings from Birch Hill into DHX stock and saw the stock reach over $10. While I did not sell at the height, I did well with this second-tranche investment.

Today, the challenge of living in the cave is rearing its ugly head again. There is a lot of talk about the Metaverse, a media

universe in which people can live vicariously through their avatars in virtual or augmented reality, enjoying entertainment or playing games. This will lead once again to a failure to understand and appreciate what is happening the real world. We will have to watch this space critically to understand the ramifications on our daily lives.

I stayed on with the merged company as executive chairman, but I can't say I felt welcome there. I was given a shabby office which I never really fixed up. There were a lot of chiefs at DHX.

Projects from the DHX era included *Supernoobs*, Scott Fellows' follow-up to *Johnny Test*, as well as *Dr. Dimensionpants*, the brainstorm of Brad Peyton, based on a cartoon he created as a kid, and *Ella the Elephant*, based on a great children's book series. We presold *Ella* to Disney Channel in the US and during the early stages of production, there was turnover in the executive suite, putting a new person in charge of making production notes. The new executive wanted to change everything in the scripts that their predecessor had approved, which was strange, since we were following the pattern of the successful book series. But these things happen. Unfortunately, our production partner, Fremantle, decided to side with Disney and the production went through a shaky period in which our producer quit and we fired our head writer. The show did not change much as a result of these comings and goings, but everyone at least was on the same page moving forward. The show got finished and it delivered reasonably well. It had heart, but it lacked that certain something to make it a hit. We developed a new *Inspector Gadget* series for Netflix.

In my capacity as executive chairman, I made a decision to initiate projects that the company wouldn't have done otherwise. In the first instance, as mentioned earlier, I took on the building

## A VISIT TO THE WORKOUT ROOM

of what became our YouTube business. It was an extension of a deal that had been in negotiation at Cookie Jar. It closed some four months or so after the merger. At my urging, we had kept Toper Taylor on to close the YouTube deal, which he had been working on for a few years. YouTube was initiating a new premium offer for SVOD (subscription video on demand). We decided to launch ten channels around the world in multiple languages, so the net impact was to launch thirty channels in total. And we did that in one day. Prior to YouTube, a launch of this sort would have taken many years and a lot of capital. We were able to do it for a minimal outlay, using programs we owned and foreign language dubs we owned. We saw YouTube as manifesting the principle of the long tail, where old library content, in some cases forty years old, could earn us revenue. Unfortunately, YouTube was not successful with the launch and it generated no return. It appeared that the YouTube audience was used to the service being free and wanted it to continue that way.

Still, we fell in love with YouTube because it showed the value of the library we had at Cookie Jar. It effectively proved the theory of the long tail—that the Internet and new technology would produce new markets for older but still compelling content. Our library of 8,000 episodes, had a value that had been hidden until streaming generated the demand.

Having launched this initiative, I left this new business to Michael and Steven to run. They were the ones who rebranded that portion of the business as WildBrain, eventually headquartering it in London. WildBrain became one of the leaders in the preschool animated side of the business and today every toy company launching a new brand or supporting an existing one has a YouTube strategy. The platform, which was bought by Google soon after

it became successful, is now the largest network on the planet. More than 720,000 hours of video are added to YouTube daily, far more than any other platform. Pretty much all the content ever made lives on YouTube, whether music or video, pirated or not. I can find almost all my commercially distributed productions including the five early commercials for letters we did for Sesame Street, produced back in 1969.

Perhaps the greatest contribution YouTube has made is in the democraticization of content. Young and new talent now has a largely uncurated outlet where it can float ideas and post shows, attract a following, and and earn money for the effort. There has never been a better time to be a young film or video maker than now because of this direct connection to the audience.

There is even a silver lining to the problem of piracy on YouTube. While we were working with the platform, its people told Mark Northwood, a friend and industry executive who I had hired to launch our new initiative, that we could earn money collecting royalties from our content that had been pirated on YouTube. After seeing their projections of what they thought we could earn, I focused on proceding to claim that pirated income, but I faced opposition within the company. At the time, many of the owners of kids' animation programming were reluctant to collect anything from people pirating their intellectual property. I am sure our competitors had the same internal arguments we did. Our in-house lawyers and some of our executives felt that collecting this money would put us in violation of industry-wide privacy protection guidelines governing companies in children's entertainment on the Internet. It was not clear to our lawyers that our distribution contracts, which were made before anyone imagined programs being distributed through the Internet, gave

## A VISIT TO THE WORKOUT ROOM

us YouTube distribution rights to our library. So I met separately with Michael and Steven to get their support for my intention to ignore both the legal department and the marketing department. The three of us agreed to do it. This new found income stream generated six figures in the first year, seven figures in the second year, and eight figures the following year.

Having successfully initiated this YouTube enterprise, I decided to focus on what I thought would be the next big opportunity: China. Up until then, China was a minor market for us and the kids' entertainment industry, but that was about to change because the Chinese government had decided to open their market for more foreign films and TV programming. While at DHX, I was approached by Paul Conway, whom I had met years earlier when he was working at CIBC's NY investment bank and representing Elevation, a private equity investor that had made an unsuccessful bid for Cookie Jar. Paul told me he was now building a business placing cartoons on Chinese television and on the internet in China. He was working with a Chinese partner who invited me to Beijing to speak at a Chinese media conference.

I met many Chinese media people in Beijing, including a senior executive with China Central Television (CCTV). We began work on a deal that would have us partner with CCTV for the exploitation of the DHX library throughout China. It was not an easy trip for me. The air pollution was dreadful. When I visited Shanghai, it was not even safe to run outdoors after a rain, which I mistakenly thought would wash the impurities out of the air. I developed a cough. My skin felt like it was burning from acid, something that stopped immediately on leaving to go home.

Although I had met many animation producers and some early streamers in China, I decided to focus on making an overall deal with CCTV. That went on for a long time until we had a deal in principle. I then passed the opportunity to Steven DeNure. He was not a fan of it and was not prepared to invest in the opportunity to be CCTV's number one foreign partner in animation. That was that.

Management changes followed at DHX. Michael Donovan stepped up to chairman and CFO Dana Landry became CEO. I decided to leave the company and see what I could start next.

Bob Ezrin, the successful music producer who had moved back to Toronto from Nashville, reached out to me to see if there was something we could do together. We had first met back around 1970 through Bob's uncle John Ezrin, who sold me the archives and rights to the Canadian Whites.

After some discussion, Bob and I decided to see if we could make an acquisition work. We investigated buying *National Lampoon*. The two of us flew to New Orleans to meet with the CEO and had dinner with him at Emeril's. I also met and had lunch with Disney Channel founder Jimi Jimiro, one of *National Lampoon*'s board members, whom I had worked with when Nelvana produced *The Edison Twins*.

Our business thesis was to roll up great comedy brands under the *Lampoon* umbrella. If we got the *Lampoon*, we could try to add Second City and Just For Laffs. It was a fun idea but nothing ever happened.

What did happen was *Carmine Street Guitars*, a documentary feature film directed and produced by Ron Mann about a guitar maker on Carmine Street in Greenwich Village, New York. It was recognized as one of the best films of 2018, making many of the

## A VISIT TO THE WORKOUT ROOM

year-end top-ten lists. I provided Ron with a small loan to help finance the movie and was proud to be part of its production as an executive producer.

In thinking about my career, I have enjoyed my relationship with books . . . using them as the underlying material to adapt into TV series and movies. But eventually my interest in books led to my learning how to work with that industry. My experience with publishing started with The Great Canadian Comic Books, with finding a publisher Peter Martin Associates and negotiating a deal and then helping to market the book. Lesson was that it was hard to affect sales much if you are not the publisher.

Next experience was licensing the rights to Avon Publishing to do book versions of *A Cosmic Christmas* and *The Devil and Daniel Mouse*. Again the lesson was little control and little effect on sales.

With Babar I had the interesting experience where the books based on the TV series and movies we made outsold the de Brunhoff original book by a huge margin. While we had no control, we were able to coordinate our global sales effort for the TV show and movies to maximize sales of the books.

When we licensed the rights to the Franklin books from Kids Can Press I got to know the publisher and co-founder Valerie Hussey and we could see that *Franklin*, which had sold 14 million books by that point, was going to be a major success. I organized the acquisition of Kids Can and it became part of Nelvana where it remains to this day. Valerie Hussey remained with the company and Ricky Englander, her co-founder retired. By the time I left Nelvana in 2002, *Franklin* had sold over 40 million copies, in part due to the great popularity of the property in France which came from its successful airing on TF1.

Klutz was a great gift publisher based in Palo Alto, California. The company's publisher was one of its cofounders John Cassidy. He had started with one book, *How to Juggle* which was a juggling manual with three juggling balls included. Their books usually contained a toy or art supplies so that you could make things with the materials that were sold along with the books. I was a great consumer of Klutz books as birthday gifts for kids and Elaine and I would keep a small store of them in the house so we were always ready with an appropriate present when needed at the last minute. We were looking for an acquisition after the Golden Books merger failed. There were no other companies that we could find to acquire that made sense to us and so we joined the auction process Klutz initiated and we were the successful bidders. Klutz relied on specialty stores to sell their product and unfortunately soon after we bought them that sales sector started to fail and at least half our market was lost to us.

Soon after Corus bought us we sold Klutz to Scholastic for about half of what we had paid, which was a disappointing outcome.

Carson Delossa was a supplementary educational publisher started by Steve and Patty Carson and was headquartered in Greensboro North Carolina. It had been acquired by Cinar and when we successfully acquired Cinar, we gave Steve and Patty a chance to invest along with my group and aligned our interests. The business had done well at Cinar and did well for us for a few years, but as with Klutz our timing was bad. There were a lot of pressures on the supplementary eduational publishing business. As a supplementary educational publisher our primary offerings included posters, workbooks, art materials and holiday decorations for the classroom. Oil prices went shooting up and teachers who had habitually invested one thousand dollars a year in supplementary

materials for their classrooms didn't have the discretionary funds and so the market shrunk. Specialty stores that carried these materials continued to suffer and decline and so the business was under pressure. I worked with Steve and Patty to look at acquisitions that could add additional lines of business to replace the classic items under pressure. We acquired Summer Bridge, which was another publisher which produced workbooks to keep kids academic achievements alive during their long summer break. This acquisition proved to to be a success and helped expand our business.

High Reach was a supplementary preschool curriculum based in Charlotte, North Carolina. It was run by a couple who had founded it and was a standalone school curriculum for preschool and kindergarten. This business ran into headwinds when more and more states initiated state endorsement for preschool curriculum and we had to compete with larger companies and provide data that addressed the efficacy of our materials. These changes in this business put pressure on us and made us question whether High Reach could survive in the new marketplace.

We spent years trying to make our educational business better, but generally did not succeed. Our best effort was an online curriculum that we designed that would provide lessons in key areas such as arithmetic, language and science. In order to actualize our plan we would have had to raise capital to produce the content and support it on the internet. But we were not successful in that endeavor so Academy TV never took off. One of the elements that was hard to overcome in finding partners for ATV was free lessons aimed at the same age groups available on line. Teachers were enamoured with the notion of posting their lessons on line and that not only impacted our ability to finance Academy TV but also the sale of our standard supplementary educational materials.

When we merged our entertainment business with DHX, its executives were not interested in our educational business so that remained independent and was soon sold off separately in an auction by our Birch Hill partners.

## CHAPTER 23

# LIKE WOW!

*A new beginning in kids entertainment
attracts major players*

THE STORY OF WOW! UNLIMITED starts just after I left DHX. I met with Randy Lennox, whom I knew and had done business with while he was running Universal Music Canada. He had pivoted his career and moved to Bell Media as a senior executive. I had linked up with Bob Ezrin and Neil Chakravarti to look for new business ideas and asked Randy what we could all do together. He responded by asking me if we could build another kids' entertainment company that could grow as big as DHX Media. Without thinking I said "Yes." So we went down the path of discussing what that would look like—perhaps we could buy a channel from Bell and Lennox's employer could become a shareholder of our company.

As we were feeling this out, Bob, Neil, and I began to think we would have more traction if we started our company by combining several existing companies. Craig Graham, then CEO

of Rainmaker Entertainment, the CG animation studio, wanted to recruit me into his company, which he was trying to combine with Shaftesbury Films, a great film and television production company. But I was not interested in that combination at that time. I felt a pure animation play would work out better, but after the Shaftsbury deal fell through, I was interested in combining Rainmaker with Fred Seibert's company, Frederator Studios, a US television and YouTube animation producer. Our founding team included Neil Chakravarti, who had a financial background as a CFO and investment banker, and we did what amounted to a reverse takeover of Rainmaker and in the same deal raised money to acquire Frederator. The result was Wow! Unlimited Media, which kept Rainmaker's public listing. At the time, Neil and I would have preferred to take the combined company private, but that option was not available to us, as the Rainmaker investors required the continued public listing. Later, we recruited John Vandervelde, who had worked with me for about twenty years, to join us as CFO.

The biggest surprise was how hard it is to raise money as a small public firm. Our business plan was a victim of chronic underfunding—we were always chasing money. Friends tried to warn me about this and I did not listen. As usual, I did what I wanted and what I thought would ultimately work. When we first completed the transaction, there was Canadian investor interest in our sector. The market leader was my old company DHX Media, but shortly thereafter they faltered as a stock. The market didn't like that it had made a large acquisition of Peanuts, the classic family property based on the Charles Schultz comic strip, using debt rather than raising equity. Then the company reported a big miss on its quarterly financial results and the stock declined

sharply. That took down the entire Canadian film sector in the public markets and affected our stock price dramatically. We were disappointed that having Bell Media as an equity partner did not provide a halo effect for our stock.

Notwithstanding our lack of working capital, we got off to a good production start with a Netflix order for the Castlevania series which we coproduced with Kevin Kolde, our head of production at Frederator. Michael Hefferon, Mainframe's studio head, also got an order for a reboot of the series *Reboot*, which we partnered with Corus Entertainment. The original Reboot series was the first CGI series made for television and was broadcast on ABC in the US and YTV in Canada. So we were off to a good start. *Ukulele U* was a series Bob Ezrin and I collaborated on working with CBC's head of kids' programming, Marie McCann. Bob had learned of Melanie Doane's ukulele classes in Toronto from Gary Slaight. Melanie, a Canadian rock singer, was teaching 6,000 kids in Toronto's public schools how to play the Uke and how to sing along. Bob wanted to make a preschool show based on Melanie, which she hosted. Working together with Melanie we created the show. David Connolly and Andrea Nevitt, key members of my Doodlebops creative team, joined us to make the series.

We continued our service work, which contributed to covering our overhead, and took on more Barbie production for Mattel. While video sales were generally dropping, Sony commissioned a new special from us. When we had stepped into the Mainframe business, we recognized that we had to buy new computers for our artists to improve our efficiency and quality, and over the first few years of our management, we re-outfitted the whole company. Mainframe's management was led by Michael Hefferon, who had graduated from Sheridan and set up down the street from

Nelvana back in the late eighties. Hefferon eventually went to work for Catalyst, which was owned by Gullane Entertainment and produced the *Thomas the Tank Engine* series which made Thomas a household name worldwide. Michael's head of studio is Kim Dent Wilder who had worked with Mainframe for over twenty years and is a great collaborator for us all. Kim and Michael have subsequently produced Madagascar: The Great Wild, Octonauts, and most recently Unicorn Academy for Toronto based toy company Spinmaster. They have steadily increased the quality of our animation production work so that it is recognized as one of the best CGI studios producing for television in the world. I am proud of our efforts together in re-building the Mainframe brand.

Frederator produced three new series besides *Castlevania*. *Bravest Warriors* was produced in conjunction with my old studio, Nelvana, based on an original series that originally premierred on YouTube. *Bee and Puppy Cat*, created by Natasha Allegri, also premiered on YouTube and the newest series was produced and aired on Netflix. Fred Seibert and his team had launched *Bee and PuppyCat* with a funding raise through KickStarter that was the largest for an animated series to that date. The property grew its audience on YouTube and gained cult status.

*Costume Quest* was produced for Amazon Kids based on a video game and enjoyed one season before Amazon exited the kids business.

What's particularly interesting about the streaming business is that it is in its infancy and evolving quickly and we have to adjust along with it.

Frederator Networks was another division of Wow! It was growing at a fast rate, eventually reaching over 5 billion monthly

views of the thousands of channels we managed on behalf of third parties. Unfortunately our fastest growing and best performing channel was 5 Minute Crafts, which created a crisis for us when I was watching the Rachel Maddow show on MSNBC and she was drawing attention to its Russian ownership and its involvement in some possible misinformation programming. As a public company, we did not feel that we could survive getting drawn into a potential scandal, so we parted ways. The business that remained generated about a billion monthly views, down from the five billion we had previously enjoyed. But that was still a sizable YouTube business.

Over the last three years of Wow! Unlimited Media we grew at about a 30 percent growth rate and found that it was hard to attract the working capital to fund the business. Together with our board Neil, CFO John Vandervelde, and I decided to sell the business. We engaged our longtime advisors at Cormark, led by longtime friend and colleague Jim Kofman, and added Evolution Media for its US entertainment expertise and started a process. Early on, we had identified that my old friend and former colleague, Andy Heyward, was a likely candidate for an acquisition. After I acquired Andy's company, DIC, back at Cookie Jar, he had started a new production entity A2(Squared). Then he merged that company with Genius Brands, which was public. When Robin Hood investors discovered the stock, they drove it up from pennies to $10.00 and Andy had raised over one hundred million dollars through the sale of equity. Genius had liquidity for its stock, money in the bank, and needed some businesses to support its stock price. At this point, Wow! was looking to deliver eight million dollars of EBITDA and positive cashflow, which would add to the Genius story. Fortunately Andy and his board saw the benefit of the

acquisition and we joined Genius Brands (now Kartoon Studios). At the time of the combination, Wow! represented over 90 percent of Genius' total revenue. I stayed on to continue to run the same business divisions I had prior to the deal.

Neal left with the closing of the deal and John continued as an independent financial executive at the company.

We continued the build of Mainframe, taking it from 8 million dollars of EBITDA to $9.6 million. We also launched our Frederator show *Bee and Puppycat* on Netflix, supporting it with advertising buys on social media. Karen McTier, Kartoon Studio's licensing executive, secured a deal with Hot Topics to support the brand as we continue to build it.

Everything was going splendidly until we hit a major problem in the streaming community.

Netflix was the first to hit a wall with its first reduction in subscribers. This resulted in Wall Street redefining how it would value Netflix and its competitors.

While previously Netflix was valued on a per subscriber basis, now it was judged on profitability and a multiple of EBITDA. This resulted in Netflix cutting costs and freezing much of its commissioning of new programming. It was soon joined by Discovery Warner, facing a $50-billion dollar debt as a result of the acquisition. It cut costs massively and also froze the commissioning of new programming. Disney soon joined the effort when it reported a $1.5 billion loss in the quarter and Bob Chapek, the CEO, was fired and replaced by Bob Iger. Bob immediately cut costs and froze the commissioning of new programming. Paramount+, Peacock, Apple and Amazon followed the leaders. So while we were forecasting another 20 percent growth of EBITDA, our plans were decimated by the absence of new orders for the back half of

the year. Now instead of a $12.5 million EBITDA we re-forecast a $300,000 EBITDA for 2023. We were hopeful that the freeze would end soon and forecast a return to profitability in 2024. In the meantime, I began thinking about life after Wow!, wondering what I might do next. John and I left at the end of 2023 and continue to explore new opportunities.

# CHAPTER 24

# SCENES OF THE CRIME

*Pilgrimage to my father's
Nazi-inflicted hell: Auschwitz*

In the spring of 2015, Eli Rubenstein, Canadian head of the March of the Living, encouraged me to make the journey to Poland for the return to Auschwitz, celebrating the seventieth anniversary of the camp's liberation. After much deliberation, I decided to go. My father had never wanted to go back and he had advised me not to go either. But I had grown up with my father's stories about the camp and it became important for me to bear witness.

When I heard the stories as a child, I thought my father was talking about a period 100 years earlier. The pictures he showed me of his parents and his brothers and sisters, with the clothing they wore and their haircuts and beards, seemed like they were from the distant past. I experienced a shock when one day, at twenty-six years of age, I realized I was the same age as my father when he was liberated from the Nazis. It was a moment of identification

with him that put the timing of the Holocaust in context. The stories he told me were not stories of an earlier century, they were stories of yesterday.

Listening to my father's stories hardened me. As a child, I never felt I could complain about anything in my life. His life had been so much harder that everything I experienced seemed like nothing by comparison. This carried over into my adult life and gave me an ability to adjust quickly and effectively to crises. Almost nothing fazes me because no problem I have experienced seems important by comparison to the stories I grew up with. But I wonder if this has also made me appear callous and unsympathetic to other people's problems. Some friends and colleagues have noted that I can appear distant and cold. It may be because I have an extreme "norm" to compare things to.

I remember being enraptured by my father's stories. He was a hero. The Nazis had built the camps to exterminate Jews like him and he had survived to tell the tale to his children, just as he dreamed of doing. He had beaten the system and was victorious in my eyes.

When the war ended, my father and other prisoners were on a death march back from Poland to Germany. Rumors circulated that the war was over. The German soldiers threw down their guns and the Jews picked them up and marched the Germans. When word reached them that the war was not yet over, the

Jews threw the guns down and the Germans picked them up and continued their march. Meanwhile they would all take cover when Allied aircraft bombed the railroad trains and tracks. This continued until the war did end. Finally, the Jewish prisoners marched their German captors until they met up with an Allied army unit to turn them over.

My father was told to report to a displaced persons camp, but he and his friends did not want that. They were done with confinement and people ordering them around. They liberated bicycles from a German farmhouse and biked back to Belgium, anxious to restart their lives.

Once back home, my father was reunited with his sister, Gertie, her husband, Srulek, and their daughter, Sylvia, who, as mentioned earlier, had been hidden during the war while her parents were prisoners in a Belgian concentration camp. Sylvia, my cousin, told me that after Belgium was liberated and she was reunited with her parents, she would go with her mother to look at arriving trains, hoping to find my father, her uncle. She recently recounted to me her memory of coming home one day and her mother asking her to guess who was visiting in their house. Gertie opened the door and revealed my father in a bathtub, his body all covered in sores.

My father had other war stories. Earlier in the conflict, he had learned to ride a bicycle and used it to smuggle diamonds out of Belgium, bringing back furs and pelts to sell locally. He went to Vichy (then Free France) and subsequently travelled back and forth to Belgium, trying to persuade his mother and father to leave their Nazi-occupied home for unoccupied Europe. But his father, my grandfather, thought it best to hang in and wait for the war to end in Belgium. On one of those trips back to Belgium, my father was caught by the Nazis on a train and sent to Auschwitz. I was always in awe of his risk-taking during the war, putting himself in harm's way in an effort to save his family members.

When I first visited Cannes, my father told me that he hung out in Cannes during the war because it was part of Free France. I imagined my father at the Carleton Hotel, where I would sometimes stay. I thought about inviting him to visit with me

during one of the many markets I attended. It would have been great to hang out with him. But I would never invite him back to a place that could lead to him relive the war years. He had no interest in that.

My mother's wartime stories are less familiar to me. She usually remained silent while my father told his stories. Her maiden name was Tauba Cytau and she was affectionately known as Toby. She grew up in Brussels, where her father worked as a glovemaker. Her sister, Regina, married and moved from Belgium to Panama in 1938 before the outbreak of the war. Her brother enlisted and did not return. His wife and son, Charlie, survived and she married again. During my youth, Charlie and I exchanged letters as pen pals and I ran into him about ten years ago at the Waldorf-Astoria in New York, learning that he worked in the diamond industry. I tried to reach out to him a few times after that—the production of *Tintin* took me to Belgium on a few occasions, but I was never successful. He was part of a very Orthodox community and staying in touch with his non-Orthodox cousin did not seem important to him.

As best I understood my mother's wartime experience, she was hidden by the nuns, working in a crèche, taking care of little babies. In part because she was such a quiet person, there seemed to be a mystery to her experiences that I could never fully penetrate. Using the knowledge we have accumulated about PTSD, it seems to me that my mother suffered from it throughout her life. I have an agonizing wish to go back in time and get her the psychological help she probably needed to cope with her pain and loss and suffering. I wish I'd had the courage back then to ask her more about her experiences, but her sadness was a barrier I could not overcome. Nor did it make much sense to cause her more pain by asking her about subjects she did not want to revisit. Still, I have

always regretted not knowing more about my mother. I have many unanswered questions. My sister, Lily, recently told me that she felt the same way.

I don't really know much about my grandparents and aunts and uncles who died in the Holocaust, other than what I heard about them, but at a young age when I couldn't think to ask detailed questions or write down the answers. It was oral history told to a preschooler. When I went on the trip to Auschwitz in 2015, one of the shocking things I realized was that I did not remember my father's arm tattoo number, although for the first seventeen years of my life I saw that number almost every day. My father favored short sleeved shirts, even in winter.

The first stop on the trip was Warsaw, where I was able to visit the Museum of Polish Jewry that had recently opened. It documents the life of Polish Jews pre-Holocaust, the rich life we have come to know through books and musicals. We made the trip from Warsaw to Auschwitz by bus, a group of hundreds that included many celebrities and world leaders. I was not prepared for the sterile premises within the camp. The combination of time, sun, wind, and rain had made Auschwitz look like the barracks it was before the Nazis turned it into the world's most famous death camp. I recalled stories my father told, disgustingly recounting the smell of human decay, death, burning flesh, human urine and feces, that surrounded them at every moment. He would talk at great length about sleeping on a wooden platform with twenty other prisoners and waking up each morning to find two or three of them dead. The continuous smoke of human flesh from the crematorium became the norm, for not only the prisoners of Auschwitz, but the soldiers, town workers, and the town folk of Oswiecim. That smell has always defined Auschwitz for me.

The story of Auschwitz comes alive with the testimony of the survivors. One such person from Ottawa who was attending this anniversary event had been in the camps and assigned the job of extracting gold fillings from the teeth of murdered prisoners. He was working together with his best friend, who was about twelve at the time. The Nazi commandant in charge of them complained that the friend was working too slowly. He picked up the young boy and threw him alive into the oven. That story reverberated with me. It was so much more affecting than touring abandoned barracks, old boilers, and empty facilities that no longer contained the blood and human waste of my father's stories. There were no dogs that had been trained to kill people. There was no Mengele deciding who would live for a short while and who would die immediately. It was through the stories of the survivors that I really felt the experience.

Steven Spielberg, who was deeply involved in the Auschwitz event and who documented the anniversary with a television special that was seen worldwide, recognized the importance of survivor testimony. He founded the Shoah Foundation, which conducted video interviews with tens of thousands of Holocaust survivors and made that archive available to the public. The archive is one of the most important contributions to our collective memory of what transpired during the Holocaust.

My father testified about his wartime experience to an interviewer from the Shoah Foundation in 1995, some forty years after his liberation. He pursued the foundation when he heard it was conducting interviews nearby and felt fortunate to do his part to confront Holocaust deniers with his recorded testimony. When I first got the recording, I remember being upset with myself that I didn't know he was doing it and wishing that I had attended the

interview to remind him and the interviewer of some of his "best" stories that I remembered from my childhood.

Over time, I forgot about my father's interview. My sister Lily found the video cassette I had sent her with half the testimony he had recorded. At my suggestion, she found a small lab to transfer it to a digital file and shared it with the family. By that time, my father was gone. He died in 2004. When I look at the video, I find his testimony remarkable for his calmness, his recall of so many details, and his ability to tell his story in an engaging and deliberate manner. He breaks down and cries only once when speaking of the post-liberation period. After talking composedly and calmly about his father, Machel, and step-mother, Brajndla, his young siblings, Rachel (Rachma), Charlotte, Helene, Israel, Jenta, and Renee who were killed in Auschwitz, and his friends who died at the hands of Nazis and camp guards, and the starvation and illness, all his pent-up emotion was finally released in a moment where, having survived, he could cry. He was an incredible man who survived to tell his story and felt privileged to do so.

A couple of other things I noticed in the video. When my father is interviewed, my mother she sits silently beside him, a mute witness of horrors that she will not speak about. And my father showed photographs. There were shots of himself a few months after liberation with his newly issued identity papers, and others of my paternal and maternal grandparents. It is remarkable how much my son, Jonathan, looks like my mother's father. I seem to have his eyes, as well.

I feel that one of the direct ways the Holocaust affected me is that I never knew my grandparents. My father's biological mother died well before the war, but his father and step-mother died in Auschwitz. My mother's father died in a concentration camp after

being deported from Belgium and her mother died five years after the war's end, having lost her mental faculties. She never recovered from the horrors of the war and losing her husband and son. I grew up without grandparents and felt that loss all of my life.

At the end of the tape, my father shows and recites his tattoo number, 61968. After I visited Auschwitz, I looked for some record of that number—none of his children had ever written it down—and now we have it, thanks to the Shoah Foundation.

I was violently ill when I returned from Poland, the worst flu I ever had. I am sure that hearing these stories and recalling my father's stories contributed to the illness. It took me several weeks of rest to recover.

I am thankful that my father talked about his wartime experience throughout my childhood. It gave me a context for accepting him as he was. I could only think that I was fortunate that he had adapted so well to postwar life and focused on making a good life for his family and himself. Out of his experiences, he forged a number of lessons he shared with me. While they are basic and conform with common sense, they have behind them the misery and horror that was Auschwitz. My father believed in the power of repetition and emphasized the same lessons many times over.

The first lesson: don't hold grudges. Not what I expected to hear from a Holocaust survivor. But I think, for him, it came down to a life lesson—a choice that he made to focus his life on the future rather than be mired in the past or seeking vengeance. He also saw that it would do him no good to hold a grudge against all the German people. He could never forgive the criminals who committed atrocities against him and the Jewish people, but he would not hold their descendants responsible. He applied this idea more broadly in many little ways. When he went back to England

for the first time after moving to Canada, he knew that there had been a split in that side of the family, with half of his aunts, uncles and cousins not speaking to the other half. So he threw a lunch and invited both sides of the family and tried to build a bridge between them. He would often point out that they had forgotten what they were fighting about.

The second lesson: know what you want when you see it, and make up your mind fast. My father was a quick thinker who acted promptly on his decisions. I believe that was one of the character traits that helped save his life during the war. He tried to instill that decisiveness in me. If we were shopping and I liked something, he would encourage me to buy it because it might not be there when we came back. I tried to be decisive throughout my life and benefited from it often.

The third lesson was drilled into me as I grew up: there's a place for everything and everything in its place. I confess that this adage was lost on me. I was never neat and orderly. But I believe that I would probably have been more successful if I had been able to live up this maxim.

The fourth lesson: solve the puzzle. My father would rise to the challenge of whatever puzzle life threw at him. If a sewing machine would not work, he would take it apart and put it back together. When, later in life, he was stuck sitting in a wheelchair in a nursing home, suffering from dementia, constrained in his chair by a lap buddy device because he was recovering from a fractured hip, he stole a flatware knife from the cafeteria and took the lap buddy apart, screw by screw. His work was hidden by a blanket and he had a serene look on his face all the while, so the nurse at the desk had no idea he was escaping. He got up and went out the door of the dementia unit and started roaming the hospital.

A better example of his talent was the camp story he told over and over again.

The commandant of the tailor shop in Auschwitz told the prisoners that he wanted them to scrape together more fabric for him to sell in the black market in town. My father came up with an idea. The tailor shop was making winter uniforms for the German army on the Russian front out of a heavy flannel material. My father hit on the idea of making the uniforms with only one pant leg. When he told the story, he would first pantomime how to properly fold a pair of pants with one leg so that it passed inspection. He'd then go on to pantomime a German soldier on the Russian front in the dead of winter being told to get into his nice new warm flannel uniform. Then he would mime the soldier struggling to put on the one-legged pants. Whenever he told the story and got to the part where the German soldier fell over trying to wear the pants, my father would laugh so hard he sometimes fell over himself. I love to remember that laugh.

Evidently the one-leg gambit worked so well at the tailor shop that the Commandant smuggled the prisoners an extra loaf of bread each day. He also gave my father advice, telling him to volunteer for any work detail that involved leaving Auschwitz. "The only way out of here is through the smoke stack," he told my father, "so you can't lose by transferring elsewhere." My father volunteered and was transferred out of Auschwitz to a work detail in Warsaw in which prisoners were taking apart the Warsaw Ghetto brick by brick. Many of the prisoners doing this work died, including my father's cousin. The Germans shipped the bricks from the ghetto back to Germany. Afterward, my father was moved to another concentration camp, but he credited the commandant's advice with saving his life.

The story of the one-legged pants has loomed large in my life. I have laid awake nights wondering how the German commandant was able to smuggle bolts of flannel out of Auschwitz into the neighboring town or to Warsaw for sale on the black market. I have wondered how many other German soldiers and officials had to be paid off to make the scheme work. I wish that at a younger age, I had thought to track down the commandant and interview him to understand how he had the sangfroid to execute this treason against the Third Reich.

My father's fifth lesson: money is not everything in life.

He told me that when he was smuggling diamonds out of Belgium and bringing back furs and pelts to sell locally, he made a lot of money and acquired a fortune in diamonds. Some of those diamonds were the ones he gave to Aunt Gertie to hide Sylvia, but he hid the rest in the family house. At the end of the war, he returned to Belgium to retrieve the hidden jewels, thinking they would let him rebuild his life, but when he got to the house, he discovered the entire block had been bombed. There was nothing left but rubble. This image of my father digging in the rubble hoping to find his buried treasure has also stuck with me all of my life. He never did find his lost fortune. He decided to get on with life and not dwell on what he had lost. This ability to pivot and move on with things inspired me to keep going in my worst times which, of course, paled in comparison to his.

CHAPTER 25

# TAKING STOCK

*Mistakes made, lessons learned,
and thoughts on moving forward*

A S I LOOK BACK on my life together with Elaine, I know that we have been mutually supportive and contributed to each other's success. Over the years, as I've worked in the animation field, she has worked as a radio freelancer, TV producer and reporter, movie and television writer, music manager and now an artist, T. M. Glass, in photography and digital painting. She has always produced excellent work no matter what field she is in.

One of her gifts that always astonishes me is her ability to try something for the first time and nail it. This even extends to sports. When I left Nelvana in 2002, Elaine bought me some golf lessons to kickstart my retirement. I began at a driving range, learning how to hit golf balls, but I wasn't doing well. I could hit the ball straight, but I had difficulty getting loft on my shots. A lot of gophers and squirrels were victims of my ground shots. Elaine sat

watching another pro teaching a student. That pro invited her to hit a ball. Using what she had observed of the lesson, Elaine got up and started hitting 150-foot to 200-foot drives with great loft. The pro was certain she had been playing for years. It was her first time hitting a golf ball. The next time Elaine came to one of my golf lessons, Joe Ross was teaching me to chip. Elaine stood there and watched Joe. I kept flubbing it. She got up and with her first and only shot, hit the ball into a hole. Funnily enough, she never wanted to play golf. It was too easy.

My life has been less like a golf game and more like a train rushing forward, moving from project to project, company to company, with an urgent desire to make things work. Writing these memoirs has given me a rare opportunity to reflect.

The COVID pandemic happened while I was writing and it pushed a lot of us to reflect on what was important. Not everyone, however. One of the few people I knew who was prepared for sequestering and isolating at home was my oldest friend, Elia Katz. Elia was an outgoing and highly social person as a young man, but over time, he evolved into the most introverted person I know. He started to lead a hermit-like existence, rarely leaving his home and losing touch with many people. He stopped working and lived simply on his Writers Guild pension. He fit perfectly into 2020 because he did not feel the pain of loss that the rest of us were experiencing. He was already there and well attuned.

Throughout my period of reflection, I was very conscious of the impact my parents and Elaine had on everything I have done. I also see how friends have influenced me and helped me during this lifetime. Favorite books and movies have influenced me. As a student of philosophy, I have avoided overly analyzing my actions except from a strategic point of view.

# TAKING STOCK

With the benefit of time and reflection, I've distilled my business thinking. It comes down to the goal of winning in the long run by delivering high quality work to fill a demand. Throughout the life of Nelvana, then Cookie Jar, DHX Media, and Wow! Unlimited Media I always ask if there is a better way to do things. I know that if we don't get better and improve, someone else would and we would cease to matter as a company.

And it is crucially important to believe in what you are doing. I confess that in writing about the shows I produced during my years at Nelvana and Cookie Jar, I had to go back and view episodes and read IMDb credit lists to remind me of some of those shows. But at the time we were making them, each of those shows was incredibly important to me. We were investing our time, our staff's time, and millions of dollars of production funding to make each of those series.

Of course, these are business lessons. Personal development is another matter: learning how to be a better person, a better husband, a better father, and a better friend. These are all important and they have nothing to do with winning. One of the things I have learned is that it is not enough to love: you must make sure your partner and your children and your friends know they are loved. Without that extra communication of your feelings, you are failing your loved ones.

These values apply to business as well. I have learned over the years that it is important to listen to your colleagues and employees and think about what they are telling you. In the very early days at Nelvana, I thought that you needed to know where you are going and lead staff by telling them, by passing it down from the top. I prided myself on making snap decisions and sticking to them. But when you do that, you are wasting the huge human capital

every business possesses. In the animation business, where a studio employed hundreds of people, it was a huge waste. Over the years, I learned to be less arrogant and more open to listening to others and learning from them. I know that while we enjoyed success at Nelvana, we probably would have been more successful if we were better at learning from our studio team.

One thing I did get right was mentorship. As mentioned, I've benefitted over the years from great mentors, especially Don Haig, Jamie Kellner, and George Lucas. It has always been important to me to pass the lessons on to the next generation of industry leadership. My main technique for mentoring was to let young executives read all the contracts and business proposals that crossed my desk and encourage them to ask questions so I could share my theories and strategies with them. It is with great pride that I now follow the careers of Tom McGillis, Jennifer Pertsch, Vince Commisso, Neil Court, Jennifer Vaux, Alisa Bonic, Jocelyn Hamilton, Emanuelle Petry, Scott Dyer, Rodrigo Piza, Jennifer Dodge, and many others.

Early in the pandemic, I called George Massenburg because I had seen him in a documentary film about Lowell George, the lead singer of Little Feat. George had recorded many Little Feat albums and counted Lowell as a friend. When I spoke to George, he had just finished mixing a tune for Alicia Keyes that had been written by Ed Sheeran. George is typical of my friends (excepting Elia), many of whom have chosen not to retire. My generation, by and large, is addicted to work. Particularly those of us who love what we do.

I have been a workaholic because I have been super-focused on my goals, first on building an animation company in Nelvana, secondly on building an animation nation in Canada and helping

# TAKING STOCK

to foster our place in the global animation industry, and finally on working to build a great global animation industry. I have always thought that animation was a superior way of story-telling because animators control the whole frame, something that has been important to me ever since I wrote my manifesto. When I first saw digital streaming, it was clear to me that animation was a form of universal language. I have faith in the medium.

I've always had faith. Since the earliest days of Nelvana, I have never felt there was anything we couldn't do, any challenge we couldn't surmount.

Just starting out, never having produced or directed a documentary for prime-time network. No problem.

Buy a nationally important archive. No problem.

Design and curate a national art exhibition. No problem.

Edit and write a book about the archive we bought. No problem.

Produce animated openings for TV shows. No problem.

Create an educational curriculum program with video, slides and curriculum materials. No problem.

Produce and distribute an animated half-hour tv special. No problem.

Produce the first ever animation for *Star Wars*, the biggest movie hit in history. No problem.

Co-produce our first television series. No problem.

Produce and find distribution for a full-length animated movie. No problem.

Produce a hit animated movie on the lowest budget and shortest production schedule ever recorded. No problem.

Go from producing at most a half hour of content a year to 100 hours. No problem.

Produce two Hollywood studio movies. No problem.

Take the company public and run a public company. No problem.

Start our own distribution division. No problem.

Start our own merchandising division. No problem.

Grow the production slate to over twenty series in a year. No problem.

Retire. That's a problem.

# ACKNOWLEGEMENTS

When I started to write my memoirs, I thought it would be an easy task. Its my life. I lived it and I remember it. But like any other creative project I have done it is a much bigger job than one can imagine.

First I must thank Michael Levine my friend and agent who gave me advice and guidance throughout the process. Michael brought Ken Whyte my publisher to the table and Ken has been very thoughtful and helpful in guiding my manuscript through its many drafts with excellent editorial input, without which this book would not have reached your hands and eyes as a finished work.

I also must thank all my friends, family members and former colleagues who gave me the benefit of their recollections to help my process along. In this regard, I must acknowledge the help of Aaron Ames, Rachel Goodman Aspler, Jack Christie, Neil Court, Noam Goodman, Lenora Hume, Larry Jacobs, Elia Katz, Frank Nissen, Eli Rubenstein, Tom Sito, Ayala Wenner, and my son, Jonathan Hirsh. I would like to thank Divya Shahani for her wise counsel, and special thanks to Robert Sarner who helped me think through the organization of this book.

Most of all I have to thank my wife, Elaine Waisglass, who reminded me of the details of many stories in these pages. Elaine even offered to write footnotes to the book to present her version

of some of the stories so nothing would be lost in our search for what really happened.

As I have written, I could not have enjoyed success, without the assistance of my wife Elaine who made so many sacrifices on behalf of my efforts to build Nelvana, Cookie Jar, and Wow! Unlimited Media. These companies don't build themselves but need 200 percent commitment.

I also thank those who mentored me along the way, particularly Al Guest, Don Haig, Jamie Kellner, and George Lucas, who shared their thoughts and advice with me as I was just beginning on my journey to build a great company and a great Canadian industry.

Finally, I am grateful to those who I partnered with on this great journey: Jack Christie, Patrick Loubert, Clive Smith, Toper Taylor, John Vandervelde, Bob Ezrin, Fred Seibert, Neil Chakravarti, and my son, Jonathan. I couldn't have done it without partners, otherwise I would have. Partners balance my approach to business and creativity and add important contributions towards a successful outcome.

# INDEX

**A**

Abbey Road, 107
ABC network, 86, 110, 112, 116, 118–120, 144–146, 185
*Abes and Izzy*, 19
Abrahams, Robert, 165–166
Academy TV, 181
Adelman, Howard, 35
Adler, Lou, 89–90
Adobe Flash animation, 129
Aguillera, Christina, 83
*Aladdin* movie, 120
Al Capp, 145
Algarve, 65–66
*Alice in Wonderland*, 36
Alicia Keyes, 204
Allegri, Natasha, 186
Alliance, 124–125
Alliance Atlantis, 172
*The All-New Mickey Mouse Club*, 83
Amazon, 153, 186, 188
*American Graffiti*, 2
American Greetings, 76–77, 89, 91, 103, 165–166
Ames, Aaron, 169–170, 173, 207
Ammano Hashidate, 46
Amtoy, 103
Anderson, Einstein, 82
Anger, Kenneth, 19
Animation Production degree course, 49

Annecy market, 104
Ann, Judy, 130
Antioch College in Yellow Springs, 23
Apple, 188
Aradia, 108
Arbor, Ann, 27
*Archie*, 10, 165
Arc, Los Angeles studio, 73
Arnold, Tom, 110
*Arthur*, 140
Arts and Crafts movement, 106
Ascot Theater, 20
Asia, 149
*As It Happens*, 59
Aspler, Rachel Goodman, 207
*Assassination Generation*, 33
*As You Like It*, 20
*The A-Team*, 94
Atlantic Ocean, 18, 66
Atlantis, 55, 103, 124–125, 131
Atomic studio, 5
Auschwitz, 128, 190, 195
Avenue Road, 56
Avon Publishing, 179

**B**

*Babar*, 6–7, 99–104, 108, 136–137, 140, 179
Bachle, Leo, 54–55
*Back to the Future*, 52

Bahamas, 142
Bailey, Mary Anne, 106
Bakshi, Ralph, 42
Baldwin, Alec, 94
Balsam, Phil, 106
The Band, 69
Bank of America, 167
Banks, Syd, 42
Barbie production for Mattel, 185
Barenaked Ladies, 137–138
Barkely, Judy-Anne, 52
Bar Mitzvah, 9
Barr, Roseanne, 110–112
Bathurst Street, 13–14, 55
*Batman*, 10, 118–119
Bay Street, 127
Bear Stearns, 142
*Beatles* movie, 160
Beatts, Anne, 133–134
Beck, Harriet, 116–118
Bedard, Michael, 131
*Bee and Puppy Cat*, 186
Bee Gees, 91
*Beetlejuice*, 119–121
Belgian concentration camp, 192
Belgium, 192–193
Bellevue, movie theatres, 8
Bell Features, 47
   competitor, 48
Bell Media, 183, 185
*Berenstain Bears*, 132, 138
Berenstain, Jan, 132
Berenstain, Stan, 132
Bersani, Joey, 56
Besen, Joan, 83
Besen-Thrasher, Sunny, 83
Beta Taurus, 149
*Beverly Hills Cop*, 87
"Be Who You Are" song, 92

*Beyblade*, 149, 152–153
Bible Belt, 27
Bill Kopp, 121
Birch Hill, 159
   DHX stock, 173
   OMERS, and, 171–172
   private equity partners, 156, 167, 182
Birdsong, Jay, 28
Bishop Daddy, 44
Blackwell, Chris, 101
*Black Zero*, 32
*Blaste's Universe*, 145
*Blazing Dragons*, 121
*Blind Date*, 93
Bliss House, 102
Block, Lawrence, 93
Blondie, 72, 115
Blum, Stan, 94, 102, 111
Blyton, Enid, 7
Boat Rocker studio, 5
Boba Fett, character, 3–4
*Bob and Margaret*, 133
*Bob's Birthday*, 133
Bolex camera, 53
*Bondage in Medieval Times*, 110
Bonic, Alisa, 204
Bonzo Dog Doo Dah band, 43–44
Bookworm Bunch, 137–138
Borden Street, 6
Boston, 26, 75, 142
Bourgeois, Paulette, 148
*Braceface*, 147
Brakhage, Stan, 19
*Bravest Warriors*, 164, 186
Brazil, 161
Brinder, Steve, 84
British rock groups, 43–44
Britten, David, 38

# INDEX

Bromfield, Valerie, 133–134
Bronx Botanical Gardens, 19
Bronx High School of Science, 18, 75
Brooklyn Bridge, 34
Brooks, Walter R., 7
*Brundibar*, 138
Brussels, 193
*Buck Rogers* serial, 2, 8
Budd, Robin, 119, 121
*Burglar*, 93
Burns, Michael, 24
Burroughs, William, 33
Burt, Ben, 3
Burton, Tim, 65, 118–122
Bush, George H., 112
*Busytown Mysteries*, 159–160
*The Busytown of Richard Scarry*, 158

## C
Cabbagetown, 58
*Cadillacs and Dinosaurs*, 145
Caesar, Sid, 11, 56, 68
Cagnes Sur Mer, 114
*Caillou*, 159, 161, 171
Cal Arts, 119
California, 70, 117, 180
Callahan, John, 148–149
Calloway, Nick, 147–148
Campbell, Joseph, 87
Campus Co-Op, 35
Canada, 157
    Canadian Heroes series of stamps, 54
    Canadian Whites, book and movie projects based on, 54–55
    centres of animation art, 5
    film and animation, 49
    France, with, Canadian co-production treaty with, 99
    funds, 170
    scriptwriters, 141
*The Canadian*, 52
Canadian Air Force pilot, 30
*Canadian Magazine*, 49
Canal Plus, 97, 100–101, 104, 108, 132
Candy, John, 69–70
Cannes
    Croissette in, 105
    Mipcom in, 111
    trade show, 103
    TV and film festivals, 115
Cantor, 9
Canuck, Johnny, 54, 58
"Captain Wonder," 69
*Cardcapturer Katsura*, 149
*The Care Bears* movie, 76, 89–91, 103, 165–166, 168
Caribbean, 157
Caribbean Black culture, 147
Carlevale, Michael, 55–56
Carl, John, 136
Carmichael, Stokely, 19
*Carmine Street Guitars*, 178–179
Carmine Street in Greenwich Village, 178–179
Carol Pope, 43
Carson Delossa, 158–159, 180
Carson, Patty, 180–181
Carson, Steve, 180–181
Cartoon Network, 139, 150, 152, 162–163
Cassaday, John, 142–143, 146–147, 150, 152–153, 155–156
Cassady, John, 151
Cassidy, John, 180

Castle Rock, 94
*Castlevania*, 186
*Castlevania* series, 185
Catbug, 164
Cavallo, Bob, 67–68
CBC Telescope, 48
CBS educational content, 145
CBS *Star Wars* television, 1, 144
    cartoons, 4
Celestri, John, 62
Central Park in New York City, 105
CGI series, 135
CGI studio, 132
Chairman Mao, 47
Chakravarti, Neil, 183–184, 208
Chalopin, Jean, 80–81
Chalvent, Mireille, 101
Chambers, Jack, 31
Channel Four in England, 133
Chapek, Bob, 188
Charest, Micheline, 124, 141, 156
Charlotte, 181
Chateau le Cagnard, 114
Cheap Trick, 72–73
Chicago, 64, 95
*Chicago Tribune*, 95
Children's Public Library on
    St. George Street, 6
China, 177
China Central Television (CCTV),
    177–178
*Chinese Ball Game*, 57
*The Chinese Ballgame*, 28
Chinoy, Marc, 41–42
Christie, Jack, 30, 33, 41, 207–208
Christopher Columbus High School,
    17
Church Street, 55
CIBC Visa card, 53

Cinar, company, 81, 124–125, 128,
    140–142, 150–151, 156–157,
    158–161, 165, 180
Cinema Permanente Narcotique, 36
Cinera, 43
City College of New York, 23
CITY TV, 84
Clark, Brenda, 148
Classic Media, 171–172
Cleveland, 76
Cliffhangers, 164
*Clifford the Big Red Dog*, 77
Clintonites, 18
*The Clone Wars*, 87
*Close Encounters of the Third Kind*, 63, 77
Coach House Press, 54
Coburn, Bruce, 148
"Coffee Cantata," 108
Coleman, Stan, 92
Comedy Central, 133
Commisso, Vince, 204
Conestoga College, 37
Connolly, David, 185
Connors, Bruce, 19
Conway, Paul, 177
Cooke, John, 122
Cookie Jar, 158–160, 162–163,
    168–169, 172–173, 175, 177,
    203, 208
Cooper, Alice, 115
*Corduroy Bear*, 147
Cormark, 187
Corus Entertainment, 146–147,
    150–153, 155–156, 172, 180,
    185
*A Cosmic Christmas*, 1, 4, 54–55,
    62–64, 67, 70, 114, 179
*Costume Quest*, 186
Cote D'Azure, 115

# INDEX

Could and Chicken Little, 56
Court, Neil, 103–104, 115, 118, 151, 172, 187, 204, 207
Cousteau, Jacques, 79
COVID-19 pandemic, 26
Crawley Films in Ottawa, 39–40
Credit Lyonnais in Rotterdam, 97
Crestani, Bob, 123
Cronenberg, David, 32
Crumb, Robert, 42
Cuckoo's Nest, 90
Cullen, Trish, 43–44
Cullins, Trisha, 73
*Curious George*, 7
Curnoe, Greg, 31
Cyberchase, 113
Cytau, Tauba, 193

## D

*Daily Express* newspaper, 109
Dallas, 64
Daniels, Anthony (C3P0), 4
Danko, Rick, 69
Dauphitex, 102
de Brunhoff, Jean Laurent, 6–7, 100–101
Decode company, 118, 151, 172
Defoe, Daniel, 157
Delacorte Theater in Central Park, 20
Deluxe Films, 39
Deluxe Laboratories, 128
Dembroski, George, 126
De Nure, Steven, 151, 172, 178
de Souza, Steven E., 145
Desputeaux, Helene, 161
*The Devil and Daniel Mouse* (Television), 1, 4, 67, 114, 179
Dewdney, Peter, 31, 41, 62

Dewhurst, Colleen, 20
De Witt Clinton High, 18
Dewitt the Frog, 146
DHX Media, 172, 174, 183–184, 203
Diefenbaker, John, 16
Diefendollar, 167–168
*Die Hard*, 145
Dingle, Adrian, 54
Disco, 92
Disney company, 70–71, 81–84, 91, 119, 122, 131, 139, 160–161, 174, 188
Disney+ streaming service, 4
Doane, Melanie, 185
Dodge, Jennifer, 204
Dodgers, 112
*Dog City*, 104
Domesday book of 1086, 107
*Donkey Kong Country*, 132
Donner, Richard, 145–146
Donovan, Michael, 118, 172
*Doodlebops*, 159–161, 171, 185
Drabinsky, Cyril, 39, 128
*Drats*, 71
*Dr. Dimensionpants*, 174
*Droids*, 86–87
*Drop In*, 47
*Dumb Bunnies*, 145
*Dungeons and Dragons*, 162
Dyer, Scott, 132, 135, 204
Dylan, Bob, 33–34, 63

## E

Earth, Wind and Fire, dance song, 72–73
*Easter Fever*, 68
Eastern European Jewish mouse, film about, 124
Edison, Tommy, 83

213

*The Edison Twins,* 82–83, 178
Ed Mirvish, 14
Ed Sheeran, 204
Edwards, Blake, 93
*Eek the Cat,* 120–121
Egg Company, 92
Eisner, Eric, 71
*Ella the Elephant,* 174
*Elliot Moose,* 148
Emperor Tojo, 47
*The Empire Strikes Back,* 2, 4
*Encyclopedia Brown,* 82
Ende, Michael, 149
*Energy Conservation for the Future,* 61
Englander, Ricky, 179
*The Eraser,* 33
Evolution Media, 187
*Ewoks,* 86–88
*Express,* 109–110
Ezrin, Bob, 48, 178, 183, 185, 208
Ezrin, John, 47–48, 178

F
The Family Channel, 98, 128
*Family Dog,* 121–122
*The Famous Five,* 7
F.A.O. Schwartz, 137
Fecan, Ivan, 84
Feldman Agency, 161
Feld Organization, 161
Fellows, Scott, 163, 174
Festival of Underground Theater (FUT), 44
Fields, W. C., 48
*Fievel's American Tails,* 124
Film Arts sign, 55
Filmation, 89
Filmmakers Cinematheque in NYC, 119

The Filmmakers' Distribution Center, 57
Fine, David, 133
First Choice, 80
Fisher, Carrie (Princess Leia), 4
Fisher Price toy line, 150
*Five Easy Pieces,* 24
Flash Gordon serial, 2, 8
Flying Bark Studio, 145
*Flying Rhino Junior High,* 145
Foley, Dave, 133–134
Fordham, Denise, 71
Fordham Road, 20
Ford, Harrison (Han Solo), 4
Fothergill, Robert, 32
The Four Tops, 20
Fox Kids Morning series, 146
Fox Network, 121, 144
France, 30, 79
    Canadian co-production treaty with, 99
    trade show in, 103
Francis, Charlie, 105
Frankenstein Dr., 92
*Frankenweenie,* 119
*Franklin,* 148, 179
Franklin books, 179
*Frank! The Musical,* 92
*Freddy the Pig* series, 7
Frederator studios, 184–188
Freeman, Don, 147
Fremantle, 174
French Bank Credit Lyonnais, 97
French channel Antenne 2, 101
Fresh studio, 5
*Fritz the Cat,* 42
Fry, Michael, 133–134
The Fugs, musical group, 34
*Futz,* 36

# INDEX

## G

Gabriel, Peter, 63
Gammill, Tom, 70
Gap Clothing, 77
*Gargoyles*, 139
Gastou, Anne, 101
Genius Brands, 187–188
*George and Martha*, 137
George, Lowell, 204
*George Shrinks*, 138–139
*Gerald McBoing Boing*, 162
Gerard, Michel, 115
Germany, 30, 149
Gerrard, Jim, 36
Gertner, Rabbi, 13
Get Along Gang, 77
*Ghostbusters*, 84
Giacomelli, Marc, 106
Gibb, Barry, 91–92
Gibb, Maurice, 91
Gibb, Robin, 91
GI Joe, 76
Giler, David, 145–146
Gilliam, Terry, 44
Ginsberg, Allen, 34
Glass, T. M., 106, 201
Global TV Network in Canada, 94–95, 133
Gluskin, Ira, 127
Gluskin Scheff, 127
Godard, Jean-Luc, 32
*The Godfather*, 17
Goetzelman, Vladamir, 43
Goldberg, Whoopi, 93
Golden Books, 130, 180
Golod, Jerry, 69
Goodman, Noam, 207
Google, 175–176
Gordon, Shep, 115

Gosling, Ryan, 83
*Gotta Catch Santa*, 162
Gottfried, Gilbert, 113
Graham, Craig, 183–184
Grand Concourse, 20
*The Great Canadian Comic* books, 179
Great Depression, 170
Greek mythology, 7
*The Greeks Had a Word for It*, 28, 57
Green Park in London, 105
Greensboro North Carolina, 180
Grimm's fairy tales, 7
Gross, Yoram, 145
The Group of Seven, 54
Guest, Al, 42, 46, 208
Gullane Entertainment, 185–186
Gund toy company, 137
Gypsy Rose, 13

## H

Hahn, Steven, 90
Haig, Don, 38–39, 48–49, 55, 115, 153, 204, 208
Halfpenny, John, 71
Halifax Film Company, 172
Haliniak, Matthew, 171
Hamill, Mark (Luke Skywalker), 4
Hamilton, 63
Hamilton, Jocelyn, 204
*Hamlet*, 20
Hanna-Barbera, 3, 89, 150
Harari, Sasha, 145
Harbord Bakery, 57
*A Hard Day's Night*, 160
*The Hardy Boys* series, 7, 113
Harrison, Michael, 75, 130–131
Harry, Debbie, 72
Hasbro, company, 76
Hassan, Cheryl, 160

Hastings, Ron, 114
Haughton, Michael, 28
Hautes de Cagnes, 114
Hawkins, John, 27
HBO, 80, 101, 108, 137
   series, 145–146
Hedgehog, 165
Hefferon, Michael, 185–186
Helluva hallucinatory experience, 26
*Henry the Fifth*, 20
Henson, Jim, 104, 118
*Herself the Elf*, 76–77
Heyward, Andy, 79, 165–166, 187
High Reach, 158–159, 181
Highway 61 song, 33–34
*Hill Street Blues*, 94
Hill, Walter, 145–146
Hiroshima, 46
Hirsh, Jonathan, 207–208
Hirsh, Michael
  Active Mike, as, 52
  animation production company, 42
  Anne Miles death, 26
  "at bats" theory of television and movies, 124
  Aunt Gertie, 11–12
    advice, 7–8
    Sylvia daughter, survived in war, 12–13
  Belgium
    Canada to, moving, 7
    father's business, in, 10
  Bob Ezrin, introduction to, 48
  books, relationship with, 179
  call from Lucasfilm, 86
  Canada
    father's downtown factory, 10, 16
    kids, and, 9

Canada Council money grant, 41
Cannes visit, 192–193
casting for
  Abraham, 34
  Abraham's wife, Sarah and son, 34–35
childhood memories, 11
Chinese acupuncturist, 105
COVID pandemic, after, 202
family name, change in, 8
father
  interview, 196
  lessons, learned, 197–200
  shows and recites, 197
  stories, 191
  work, 51
favorite memory of Antioch, 28
French partner Canal Plus, 97
George Lucas, relationship with, 70
German army, and, 199
Hasbro visit, 166
Holocaust, affected, 196–197
Jack Christie, work with, 33–34
Japan, visit, 134
Jewish identity, 10
John Cooke, phone call from, 122
journey to Poland, 190–191
Kindergarten and First Grade, fond memories of, 9
library in Toronto, 14
meeting with Tim Burton, 119
Melvana Communications, company, 61
mother
  personality, 65
  wartime stories, 193–194
Nelvana
  life, with, 203

# INDEX

life without, 155
  motive in starting, 51
  story of, 3
psychotropic drugs, beginning, 21
schooling, 17–18
Shopsy, at, 8
teen-aged crush, 21
television shows, 11
Third Reich, 200
Three Stooges, 61
Tokyo, journey, 45–47
trip to Auschwitz, 194
TV series and movies, 179
Uncle Charlie, visit to, 13
Virginia city, visit, 98
visit to, George Lucas, 2
voice sessions in Los Angeles, 4
wedding, 65–66
wife Elaine's
  help, 82
  mutually supportive, 201
work as orderly, 24
worked on light shows, 28
Hit Entertainment, 166
Hofsess, John, 32
Holland, Savage Steve, 121
Hollywood, 92, 136
Hollywood Hills in LA, 105
Holocaust, 65, 138, 190–191, 194, 196–197
  education, 13
  survivors, 9–12, 195, 197
Honest Ed, 14
*Hootenanny*, 43
Hopalong Cassidy, 13
Hot Docs Festival, 153
Hot Wheels, 77
Houghton, Michael, 23–24
Houle, Jerry, 102

Howard's "Creative Capitalism" schemes, 36
*How I Learned to Stop Eating the Planet*, 4
"Howl" poem, 34
*How to Juggle*, 180
Hudnut, Rob, 150
Hume, Lenora, 62, 80–81, 207
Hunter College in Bronx, 19
Hurlant, Metal, 135
Huron Street, 56, 68
*Hurray for Huckle!*, 159–160
Hussey, Valerie, 179

I
Ice Capades, 161
Iger, Bob, 112, 188
Iggy Pop, 72
"I like Boobs A Lot" song, 34
Image Comics book, 145
*Inspector Gadget*, 79–80, 88, 119, 121, 165, 174
*Intergalactic Thanksgiving*, 4
Inuit goddess, 54
Investor Relations, 131
Isaacs, Av, Toronto art dealer, 48
Island Records, 101
Iwata, Naomi, 134

J
Jack Rabbit, 68
Jacobs, Larry, 61, 207
*Jacob Two-Two*, 129
Jacques, Brian, 148
Jaffelice, Ray, 80–81, 136, 148
*Jake and the Kid*, 114
Japanese cartoon series, 152
Japan Sea countryside, 45–46
Jaume, Pierre Bertrand, 100–101

217

Jekel, Gertrude, 107
Jim Henson production, 41
Jimiro, Jimi, 178
John Hopkins University, 25
*Johnny Test*, 163, 171, 174
Johnson, Ben, 105
Johnson, Brown, 136, 147–148
Johnson, Joe, 3
Johnston, Frank, 54
Jones, James Earl, 20
Jones, Spike, 44
Jones, Terry, 121
Joyce, Bill, 135, 139
*Julius Caeser*, 20
*Jumpin' Jack Flash*, 93–94
J. Walter Thompson advertising company, 63–64

K
Kahn, Jenette, 118
Kamei, Hiko, 46
Kandoo personal care products, 146
Kanter, Nancy, 160–161
Kao, Kitty, 20
Kaplan, Mary, 34–35
Kartoon Studio, 188
Katz, Elia, 19, 25, 34, 94, 202, 207
Keaton, Buster, 20
Keaton, Michael, 118
Kellner, Jamie, 64, 67, 69, 84, 120, 123, 204, 208
Kelly, Vince, 35
Keltz, Marty, 76
Kennedy, John F. President, 18, 33
Kennedy, Kathleen, 121
Kennedy, Robert, 35
Kenner, company, 76
Kenner Toys, 77

Kensington Market, 14
Kent, Sally Moyer, 131, 135
Kernaghan, Ted, 75
Kesey, Ken, 21
Kidder, Margot, 113–114
Kidman, Nicole, 94
Kids Can Press, 148
Kidsco, 166–167
Kierkegaard, Soren, 33
"Kill for Peace" song, 34
King, Don, 96
*King Lear*, 20
King Street West, 52
Kirk, David, 147
Kirsch, Jeffrey, 64
Kitchener, Ontario, 37
Kitchen Sink Press, 145
Klutz, 142, 180
Knight, Andy, 121
Knightsbridge, 119
Kodansha, Japanese publisher, 149
Kofman, Jim, 187
Kolde, Kevin, 185
Korea, 89, 162
    studio, 90, 150
Krantz, Steve, 42
Krawagna, Rena, 55
Kuhn, Michael, 130
*Kung Fu Dinosaur Posse*, 162–163
Kupferberg, Tuli, 34, 36–39
Kurosawa, Akira, 70
Kushner, Tony, 138
Kuwait, 112
*Kwaidan*, 46

L
Ladd, Alan Jr., 92
Ladd Company, 92–93

# INDEX

Lafcadio Hearn, ghost stories, 45–46
Laff Arts, 42
  salary, 47
  wind down, 49
Lakefield, Ontario, 35
LaMarche, Maurice, 68
Landry, Dana, 178
Lane, Nathan, 137
Lankershilm, 92
Lanois, Daniel, 63
La Pierre, Laurier, 141
La Pierre, Thomas, 141
Larson, Eric, 145
Lasseter, John, 88
Leary, Timothy, 26
Lee, Jim, 145
Lehr, Bob, 18, 23
Lennon, John, 72
Lennox, Carl, 160
Lennox, Randy, 183
Lescure, Pierre, 97
*Let's Sing Out*, 42–43
Letterman, David, 70
Levine, Michael, 129, 207
Levitz, Paul, 118
Levy, Eugene, 133–134
Lewis, Jerry, 8
L'Heureux, Christine, 161
Lieberman, Lisa, 94
*Li'l Abner*, 145
Lippincott, Charlie, 78
Lisbon, 65
*Little Bear*, 136–137
Little Engine, 56
Little Feat, 204
Little Golden Books company, 130
Little Rosie, 110–112
Locker, Ken, 35, 170
Loh, John, 167

London, England, 7, 97, 105, 109, 119, 121, 171
London, Ontario, 31
Loomis, Bernie, 77–78
Looney Tunes, 150
*Lord of the Rings*, 53, 132
Los Angeles, 43, 64, 79, 81
  voice sessions in, 4
Loubert, Patrick, 3, 31–32, 41–44, 47, 49–50, 52–56, 61–62, 66–67, 71, 73, 75, 78, 80–82, 90–91, 95–97, 99, 118, 123–126, 130–131, 135, 150, 153–154, 208. *See also* Hirsh, Michael
Lucas, George, 1, 63, 65, 70, 86, 92, 204, 208
  Academy Awards, nominated for, 2
  author, and
    conversation with, 3
    mentor to, 5
    potential client for, 2–3
    story of Nelvana, 3
Lucas Valley Ranch, 70
Lumley, Skip, 84
Lundgren, Astrid, 149
Lydig Avenue, 17
Lynch, Merrill, 156

## M

*Macbeth*, 20
MacGilvray, Carole, 77–78, 89
*MacGyver*, 83
Madagascar, 186
Madison Square Gardens, 161
*Maggie and the Ferocious Beast*, 147–148
*The Magic School Bus*, 77, 112
*Magi-Nation*, 162

Mahal, Taj, 88
*Maidens in Uniform*, 110
Mainframe brand, 186, 188
Mainframe studio, 185
*Malcolm in the Middle*, 146
*Malice*, 94
*The Mandalorian*, 4
Manhattan, 16
Manitoba, 59
Mann, Ron, 178–179
March of Remembrance, 128
March of the Living, 190
Marin County, 70
Marshall, Bill, 44
Marshall, Frank, 121
Marshall, James, 137
Marston Meysey, 107
Martin, Andrea, 133–134, 137
Martin, Dean, 8
Martin, Peter, 48
Marvel, 74
Marvin Gardens cinema, 2, 8
Marvin Melnyk Associates, 61
*Marvin the Tap Dancing Horse*, 138–139
Massachusetts, 137
Massenburg, George, 35, 73, 204
Massey College, 32
Mateo, Lino, 156
Mattel, company, 76, 150
Matthews, Marmaduke, 106
*Maus*, 138
*Max and Ruby*, 153–154
Maya software, 132
McCann, Marie, 185
McCartney, Paul, 109
McCaw, Scott, 167
McCormick, Kevin, 92, 99, 116
McGillis, Tom, 204
McLuhan, Marshall, 25–26, 108, 164

McMaster Film Board, 32
McMaster University filmmaking
    group, 32
McNabb, Jerry, 57
McPhail, Marnie, 83
McTier, Karen, 188
*Medabots*, 150
Media Lab, 132
Mediterranean Sea, 115
*The Medium is the Message*, 25
*Mega Force*, 162–163
Mekas, Jonas, 39
Melvana Communications, 61
Mercury studio, 5
Merrill, Judy, 36, 45
Merv Stone, 55
MGM/United Artists, 74
MGM/ Warner Bros, 150
Mideke, Mike, 23–24, 28
*A Midsummer's Night Dream*, 20
Miles, Anne, 107
    died of COVID-19 pandemic, 26
Miles, Francesca, 107, 109
Miles, Ian, 107
Milky Way Cartoons, Japanese
    company, 134
Mills, Richard, 161
Minarik, Else, 136
Minneapolis, 132, 135
*20 Minute Workout*, 84
Mipcom, 103
    conference, 111
    screenings, 159
Miss General Idea Beauty Pageant,
    44
*Miss Spider's Sunny Patch Kids*, 147
Mitchell, W.O., 114
Moebius, French graphic artist, 3
"Monday Nothing" song, 34

# INDEX

Monet's water lilies, 20–21
*The Monkees*, 24, 160
Montana, 89–90
Montreal, 81
Monty Python paper animation, 44, 121
*Moonlighting*, 93
Morris, Garret, 68
Morris Park Avenue, 17
Morris, William, 106, 110, 123
Moss, Peter, 129
Moulin de Mougins, 115
*Moville Mysteries*, 146
*Mr. Microchips*, 84
"Mr. Pencil Draw the Line," 54–55
Mr. T, 94–96
Muller, Romeo, 77–78
Muniz, Frankie, 146
Murdoch, Rupert, 146
Murphy, Eddie, 87
Murray-Tateishi, Sheila, 126
Museum of Modern Art, 20–21
Museum of Polish Jewry, 194
My Little Pony, 76
*My Pet Monster*, 77, 103
*Mythic Heroes: Guardians of the Legend*, 145

N
Nagasaki, 46
Namath, Joe, 43
*Nancy Drew*, 7, 113–114
*Nancy Drew and Daughter*, 113
Nashville, 178
National Association of Television Program Executives (NATPE) convention, 96
National Film Board, 40, 61, 115
National Film Board of Canada, 5, 38
National Gallery in Ottawa, 48

*National Lampoon*, 178
National Museum of Man, 48
Nazi-occupied Czechoslovakia, 138
*Ned's Newt*, 121
Nelvana studio, 1–2, 5, 103–106, 110, 118, 122, 127–128, 132, 135, 140, 150–153, 155–156, 160, 162, 165, 172, 179, 185–186, 201, 203–205, 208.
    See also Hirsh, Michael
  acquisition, 146–147
  *Babar* feature film, made at, 39
  change to, 123
  comedies, produced at, 120–121
  development, 13
  *The Edison Twins* produced at, 178
  Hattie Reisman, role at, 131
  investors, 151–152
  Japanese anime show, 149
  Patrick's share, 130
  public to, IPO, 126
  Ron and Micheline, invest in, 142
  story, 3
  success, 139
  worth, 130
Netflix, 153, 163, 170–171, 174, 185–186, 188
*Neverending Story*, 149
Nevins, Sheila, 101
Nevitt, Andrea, 185
New Line Cinema, 39
New Orleans, 96, 178
New Orpheum Restaurant on Queen, 55
New York City, 16–17, 64, 72, 158, 161, 178–179, 193
  cultural events, 20
  film festival event at, 32
  *Tubby the Tuba* in, 62

*New York* magazine, 92
New York's Anthology Film Archives, 39
*New York Times*, 63
Nicholson, Jack, 21, 118
Nickelodeon company, 82, 84, 139, 150
   Geraldine Leybourne, 123
   Nick Junior, 136
   owned by General Electric, 131
Nick Jr. Mickey, 147–148
Nick Junior, 136
Nine Story studio, 5
Nintendo game, 132
Nissen, Frank, 81, 207
*Nobody Waved Goodbye*, 20–21
Noggin, 150
*Noonbory & the Super 7*, 162
North Carolina, 181
Northwood, Mark, 176

O
*Oddballs*, 32
O'Hara, Catherine, 133–134
Ohio, 23, 76, 166
Olmstead, Eleanor, 118, 126
*One Flew Over the Cuckoo's Nest*, 21
Ontario, 31
Open Studio, 58
Orion, 69
Osaka, 46
Oscars, 162
Ottawa, 195
Owen, Don, 20–21, 38
Oxford region of England, 106

P
Palo Alto, 180
Panama, 157, 193
Paragon, 124–125

Paramount+, 188
Paramount company, 121
Paraskevas, Betty, 147–148
Paraskevas, Mickey, 147–148
Paris, 7, 105, 135
Parskevas, Mickey, 139
Patton, Rick, 23–24, 27
PBS Bookworm Bunch, 132, 138, 147
Peacock, 188
Peanuts family property, 184
*Pecola*, 134
Pelham Parkway part of Bronx, 16
*Pelswick*, 148–149
Pertsch, Jennifer, 204
Peter Bent Brigham Hospital on Mass Avenue, 24
Peter Martin Associates, 179
Petry, Emanuelle, 204
Petry, Emmanuele, 135
Peyton, Brad, 174
Picasso's "Guernica," 20–21
*The Pied Piper of Hamelin*, 71
Pilkey, Dav, 145
The Pilot, 69
*Pink Flamingos*, 39
Pinkney, William, 35
*Pippi Longstocking*, 149
Pixar, 70–71, 88
Piza, Rodrigo, 204
*Plastic Man*, 10
*Pogo*, 42
Poland, 190, 197
Poler, Charlie, 13
*Police Academy*, 93
Polish Jews pre-Holocaust, 194
Pollocks, Jackson, 20–21
Polygram, 130
Portugal, 65

# INDEX

Portuguese Riviera, 65–66
*Postcards from Buster*, 162
Prairie Oyster, 83
Pressler, Paul, 77
Prime Access Syndication, 64
Procter and Gamble, 146
Pross, Max, 70
*Puff the Magic Dragon*, 121

## Q
*Quads*, 148–149
Quan, Betty, 136
Quebec, 125, 142, 156–157
Quintex, 97–98

## R
Rabbi, 9
Rachel Maddow show, 187
Rafelson, Bob, 24
Raiffe, Rita, 137
Rainbow Bright, 76
Rainmaker Entertainment, 183–184
RAI Uno Kids, 104
Rappaport, Tony, 108
RCA Selectavision, 75
*Reboot*, 185
Red Hill, 19
*Redwall and Corduroy Bear*, 138, 148
Reed, Lou, 72–73
Reid, George, 106
Reid, Mary Hestor, 106
Reisman, Hattie, 131
Reitman, Ivan, 32
Republic Bank, 126
*Rescue Heroes*, 150
*Return of the Jedi*, 87
*Revenge of the Nerds*, 18
Reverend Ike, 44
Revolting Theater Group, 34

Richler estate, 129
Richler, Mordecai, 129
Ridley, Merle Anne, 160
Riley, Ted, 103
Ringling Brothers Barnum and Bailey Circus, 161
Robbe-Grillet, Alain, 33
Robin Hood investors, 187
Robinson, Claude, 125, 141, 157
*Robinson Sucroe*, 125, 141, 157
Robinson, William, 106, 107
Rochdale College, 35, 57
   CIBC branch at, 53
*Rocket Boy*, 69
*Rocket Robin Hood*, 42, 49
*Rock & Rule*, 68, 71–72, 74–75, 78, 79, 84, 89
*Rolie Polie Olie*, 135, 160
Rolling Stones, 38
Roman Candle, 142
Romanelli, Dan, 119–120
*Romeo & Julie-8*, 4, 69
*125 Rooms of Comfort*, 54–55, 63
Rooney, Mickey, 89
Rosen, Abigail, 34
Rosen, Carole, 101
*The Rosie O'Donnell Show*, 148
Ross, Clifford, 99–101
Ross, Joe, 105, 202
Rothney, Bruce, 126–127, 142–143
Rough Trade, 43
Rowe, Peter, 32
Roxy Theatre, 89–90
Rubenstein, Eli, 128, 190, 207
Ruby-Spears, 116
*Rupert and the Frog Song*, 109
Rupert Bear, 109
Rwanda genocide, 128
Ryerson University, 147

S
Saban, Haim, 146
Sabiston, Andrew, 83
Sabrina, 165
Salter Street Films, 172
Salvation Army on Richmond Street, 43
*Sam & Max*, 146
Samuel Goldwyn Company, 90
Sam, Yosemite, 87
Sandoz laboratory LSD, 26
San Francisco, 1
San Rafael, 2
Sans Souci, 16
*Santa Claus Brothers*, 131
*Saturday Night Fever*, 92
*Saturday Night Live*, 68
Sauder, Peter, 71, 78, 80–81
*Savage Dragon*, 145
Scarry, Huck, 158
Scarry, Richard, 158, 159–160
Schaefer, Joan, 80
Scholastic Productions in NYC, 76
Schott, Dale, 81
Schultz, Charles, 184
Scott, George C., 20
*Scrooge McDuck*, 10
Sebastian, John, 56, 67–68, 89
Second City Fire Hall Theater, 70
Second World War, 47
Seibert, Fred, 70–71, 184, 208
*Seinfeld*, 70
Selznick, Arna, 89
Sendak, Maurice, 136–137
Seoul Olympics, 105
*Sergeant Bilko*, 11
*Sergeant Pepper's Lonely Hearts Club Band*, 92
*24 series*, 83

Sesame Street, 150
*Sesame Street*, 41–42
*Seven Little Monsters*, 137–138, 138
Seventh Avenue, 161
Shaftesbury Films, 183–184
Shahani, Divya, 207
Shaw Communications, 130
Shaw, Heather, 142–143
Shaw, J. R., 130
Shaye, Bob, 39
Sheridan College, 49, 185–186
  animation program, 61
Sherman, Debbie, 21
Shoah Foundation, 195, 197
Shooter, Jim, 74
Sidney Poitier, 28
Siegal, Jerry, 39
Silver, Joel, 145–146
Silvers, Phil, 11, 69
Silverstone, Alicia, 147
Simpson, Peter, 103
*The Simpsons*, 70
Sito, Tom, 62, 207
Skywalker Ranch, 70
Slaight, Gary, 185
*Small Star Cinema*, 54
*S&M in the Middle Ages*, 110
Smith, Clive, 3, 43–44, 49, 52, 54–55, 61, 63, 66, 69, 72–73, 75, 80–81, 124–125, 130–131, 153–154, 208. *See also* Hirsh, Michael
Smith, Dan, 81
Smith, Eden, 107, 127
Smith, Jack, 19
Smith, Lillian, 6
Snooks, Susan, 81
Snowden, Alison, 133
Snyder, Dick, 130

# INDEX

Snyder, Stu, 156
Sonic, 165
Sorkin, Aaron, 94
*South Park*, 70–71, 133
Spadina, 6
Spain, 104, 161
Spears, Brittany, 83
Sperry, Stephan, 100–101
*Spider Riders*, 162–163
Spiegelman, Art, 138
Spielberg, Steven, 65, 77, 85, 122, 124, 195
Spinmaster, 186
*Sprockets*, 52
*Square Pegs*, 133–134
*Star Trek*, 3
*Star Wars*, 58, 63, 70, 74, 86, 88, 90
    toys, 77
*Star Wars Holiday Special*, 123
*The Star Wars Holiday Special*, 4
State Street Fund, 142
Steele, Robin, 146
Stein, Chris, 72
Stevie Wonder, 20
*Stickin' Around*, 146
Stigwood, Robert, 92
Stram, Daniel "Danny," 17
Stram, Richard "Dickie," 17
*Strawberry Shortcake*, 76–78, 165–166, 168
Student Nonviolent Coordinating Committee (SNCC), 19
Stuerm, Marilou, 66
Sucherman, Stuart, 130–131
Sultana Avenue, 13–14
Summer Bridge, 181
*Super Joe*, 43
*Superman*, 10
Super Mario Brothers, 165

*Supernoobs*, 174
The Supremes, 20
Sutherland, Donald, 83
Sutherland, Kiefer, 83
Svensk Film, 149
Swanston, Jimmy, 58
Sweden, 149
Switzerland, 158
*Sydney Iwanter*, 146
Syrinx local band, 52

T
Taiwan, 89
*Take Me up to the Ball Game*, 69
*Tales from the Cryptkeeper*, 145
Tapestry album, 89–90
Taylor, Toper, 123–124, 135–136, 138, 144, 146–148, 152, 156, 158–161, 170, 173, 208
Teletoon, 128, 142, 146, 148–149, 162–163
*The Tempest* and *Othello*, 20
The Temptations, 20
Theatre Passe Muraille, 36
Thibedeau, Cheryl, 105
*The Thief of Always*, 121
Thomas, Dave, 69–70
*Thomas the Tank Engine*, 185–186
Thornton, Billy Bob, 161
Those Characters From Cleveland (TCFC), 77
Thrasher, Dave, 61, 83
*Thumpalump*, 20
Tik Tok, 164
Timberlake, Justin, 83
*Time* magazine, 36
*Timothy Goes to School*, 138–139, 153–154

*Tiny Toon Adventures* and *Animaniacs*, 85
*The Today Show*, 161
Tokyo
   Asian business out of, 149
   density, 45–46
   modernization, 45
Tom & Jerry libraries, 150
Toon Boom, 132
Topp, Sylvia, 34
Toronto, 6, 107, 117, 119, 178, 185–186
   author, in, 7
   college street, 2
   cottage north, 34
   provincial city, 8
Toronto Botanical Gardens, 107
Toronto City Hall, 65
Toronto Dominion Capital Private Equity Partners, 156
Toronto International Film Festival (TIFF), 44
*Toronto Star*, 48, 52
Toronto Stock Exchange, 44
Tourtel, Mary, 109
Tower of Babel, 42
Towne, Harold, 48
Townsend, Natalie, 156
Toy Fair, 102, 159
Transformers, 76
Treas, Jennie, 116
Treehouse TV, 150
Triad Agency, 123
*The Trumpet of the Swan*, 121
*T & T* series, 94–96, 103
*Tubby the Tuba*, 62
Turkey, 161
Turner, Ted, 150
Turner Video, 156
Tyson, Sylvia, 63

U

*Ukulele U*, 185
*Ulysses 31*, 79
Unicorn Academy, 186
Union Square, 20
Universal company, 122
Universal Music Canada, 183
University Cinema on Bloor Street, 90–91
University of Michigan, 27, 31
University of Toronto, 25
Unlimited Media, 184, 187, 203, 208
US broadcast networks, 139–140
US entertainment, 187
US networks and studios, 5
Utopian English village, 108

V

Vader, Darth, 86
Vandervelde, John, 140, 156, 173, 184, 187, 208
*Variety*, 134, 140
Vaux, Jennifer, 204
Ventura Blvd, 92
Vergé, Roger, 115
Viacom, 64, 69, 83, 103, 114, 131
Victory Burlesque house, 8
Vietnam, 47, 135
*The Village Voice*, 34
Virginia city, 98
Voorheis, Wes, 157
*Voulez-Vous Coucher Avec God?*, 38, 44

W

Waese, Jamie, 160
Waisglass, Elaine, 56, 207
Waldorf-Astoria, 193
Walker, Allan, 48, 52

# INDEX

Walt Disney Company, 112
Wang, James, 90
Ward, George, 35–36
Warhol, Andy, 28
Warner Bros., 70, 93, 118–119, 122, 159, 163, 188
Warsaw Ghetto, 199
Washington, 64
Waterloo University, 62
Waters, John, 39
Weinberg, Ron, 141, 156
Wells, Rosemary, 139, 153–154
Wenner, Ayala, 207
Werner, Tom, 112
West Side Highway, 16
*West Side Story*, 22
Wetherford, Jim, 149
*Where the Wild Things Are*, 137–138
White Plains Road, 17
Whyte, Ken, 207
WildBrain. *See* DHX Media
*Wild C.A.T.S.*, 145
Wilder, Kim Dent, 186
Wildstorm Productions, 145
*Will and Dewitt*, 146
Willenson, Seth, 75
William Morris Agency, 123
Williamsbridge Road, 17
Williams, Harland, 121
Willis, Bruce, 93

Wilson, Hugh, 93
Wilson, York, 106
Windlight, 132, 135
*WKRP in Cincinnati*, 93
*The Wonderful World of Disney*, 100
Wow Unlimited Media, 48, 70–71
Wrinch, Mary, 106
Writers Guild pension, 202
Wychwood Park, 99, 106–108, 127

X

Xanthoudakis, John, 156

Y

Yarrow, Peter, 127
Yeshiva in Chicago, 13
*Yes Minister*, 100
Yetnikoff, Walter, 71
Yomiko, 134
York University Film Club, 32
York University's Glendon College, 30
Young People's Theatre, 129
*Your Show of Shows*, 11
YouTube, 161–162, 175–177, 184, 186–187

Z

Zander, Rick, 73
Zemeckis, Robert, 145–146

NICKELODEON

kids

great ideas